Men before 10 am too !!!

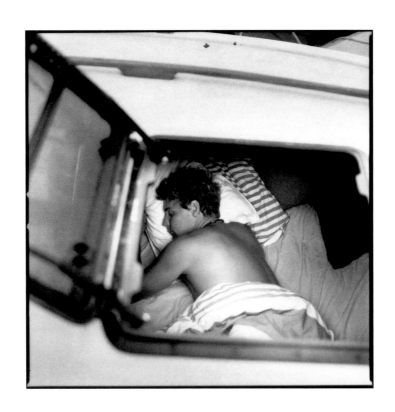

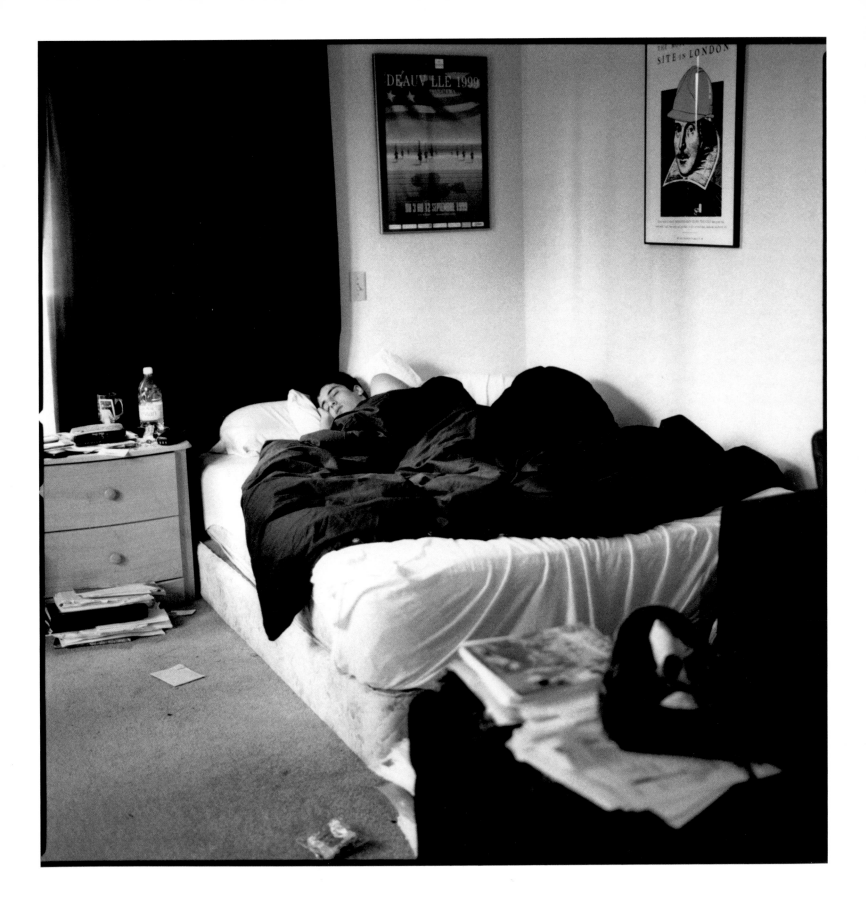

Jason Biggs 7.47 am

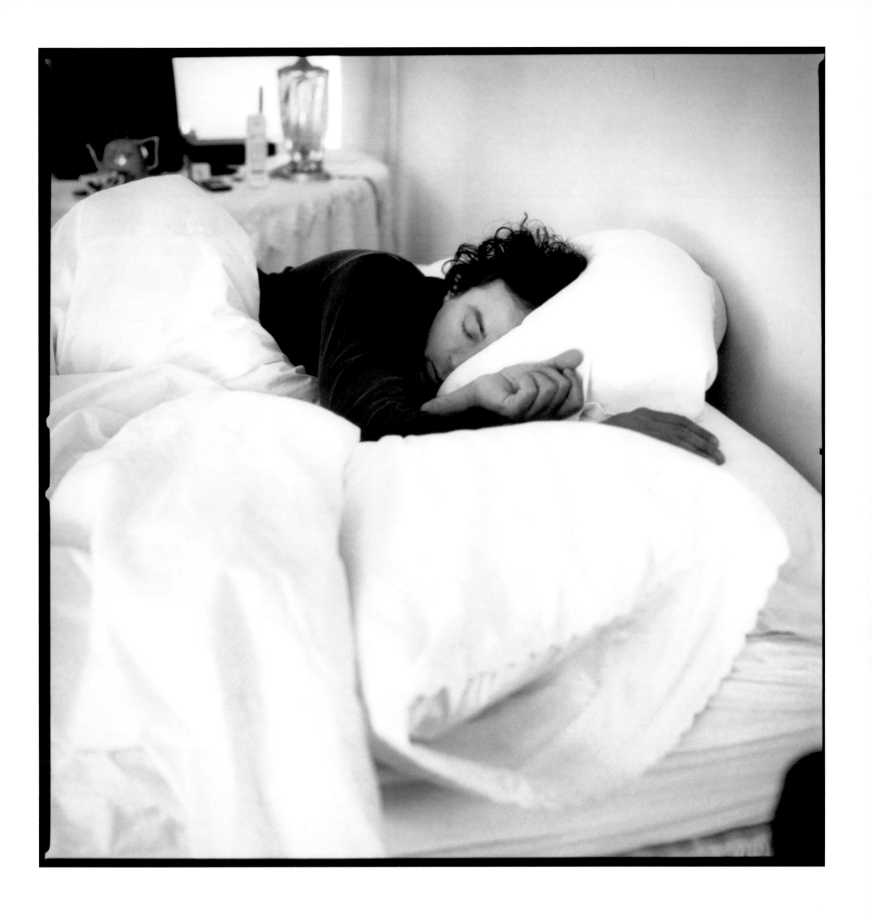

Darius Khondji 9.30 am

Men before 10 am too !!!

Photographs by Véronique Vial

Foreword by Jennifer Beals

powerHouse Books New York N.Y.

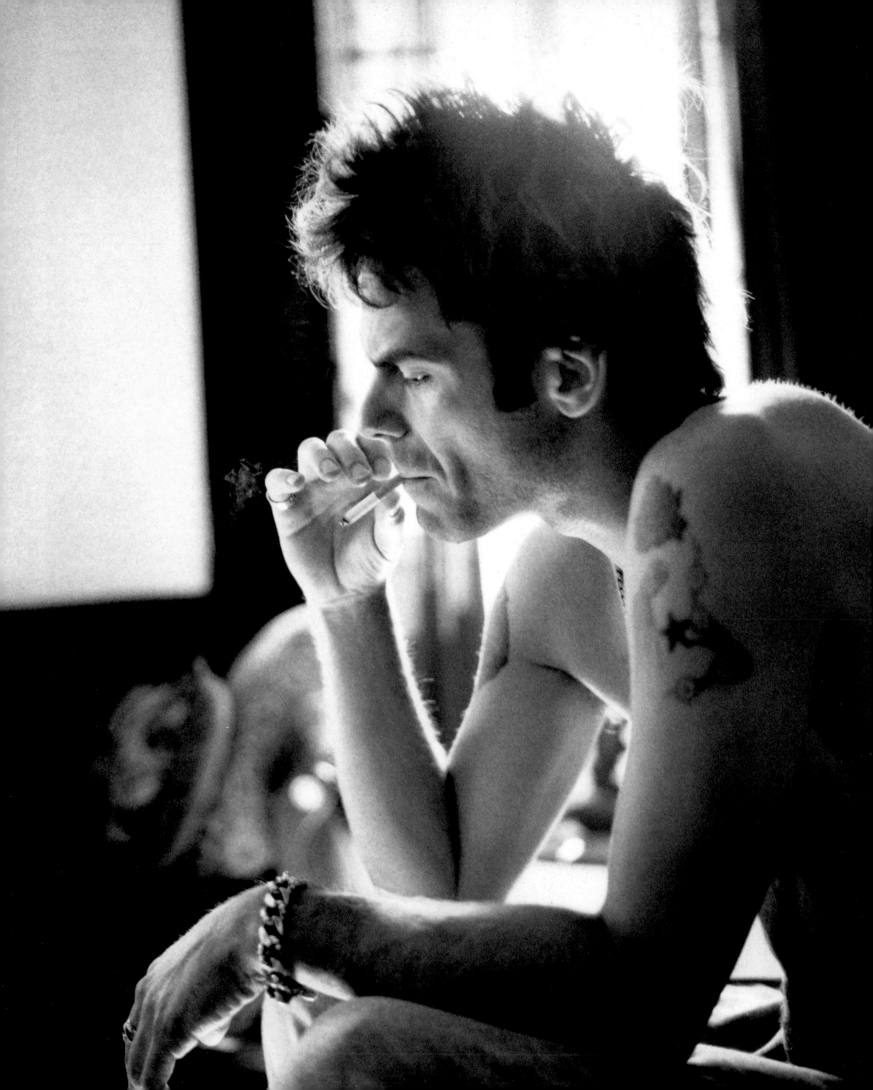

foreword

It is not that easy to be photographed because it is not always that easy to allow oneself to be seen. Interestingly, what we wish for above all else is to be seen clearly, with the hope that what is there is somehow beautiful simply by virtue of its sheer existence. We hope that someone else's vision of us will be commensurate to our experience of ourselves. Surely this possibility is most precarious in the early hours of the morning when we are passing through dream's gates back into the world of "reality." When we are coming back from that place—sleep—a place that is so intimate, second only to death or perhaps birth, who could presume to see us in all our subtle, unguarded complexity? Would we even want a stranger to greet us at dream's door when we are so thoroughly ourselves? How do we emerge into the world? Through the gate of ivory or through the gate of horn? What rituals or happenstance take us into the day's embrace? And who is there to greet us...and would we want them to have a camera?

When Véronique asked to photograph me for her book *Women Before 10 a.m.*, I was undoubtedly the happiest I had ever been. I had just been married the week before in a small town in Michigan, and my husband and I decided to extend our honeymoon at a hotel not far from our house in Los Angeles. I was told Véronique wanted to photograph women before ten in the morning, without assistants, without hair and makeup, and without the usual armaments which guard the public persona like the Great Wall of China. How exciting. How utterly terrifying. Did I even want people to see me? I then thought about how important it was to circumvent the fantasies created by magazines, and I agreed.

The night before Véronique arrived, I could hardly sleep. I felt like it was the night before the first day of school. I do not love being photographed, but I do love photography. I love the truth within the fiction. Sometimes when I see a fine photograph, it is so palpably sweet I can taste it in my mouth. By fine I don't mean it is necessarily hanging in a museum, ordained by the latest curator. I mean fine as in true—as in it has life and God and a sound to it, a vibration all its own. That thing is indescribably delicious. And so, knowing I was embarking on a journey with someone who sought the truth of the thing rather than the publicist's fiction, I was excited. And unable to sleep. What would she be like? Would she be an insatiable hunter, like so many of the photographers

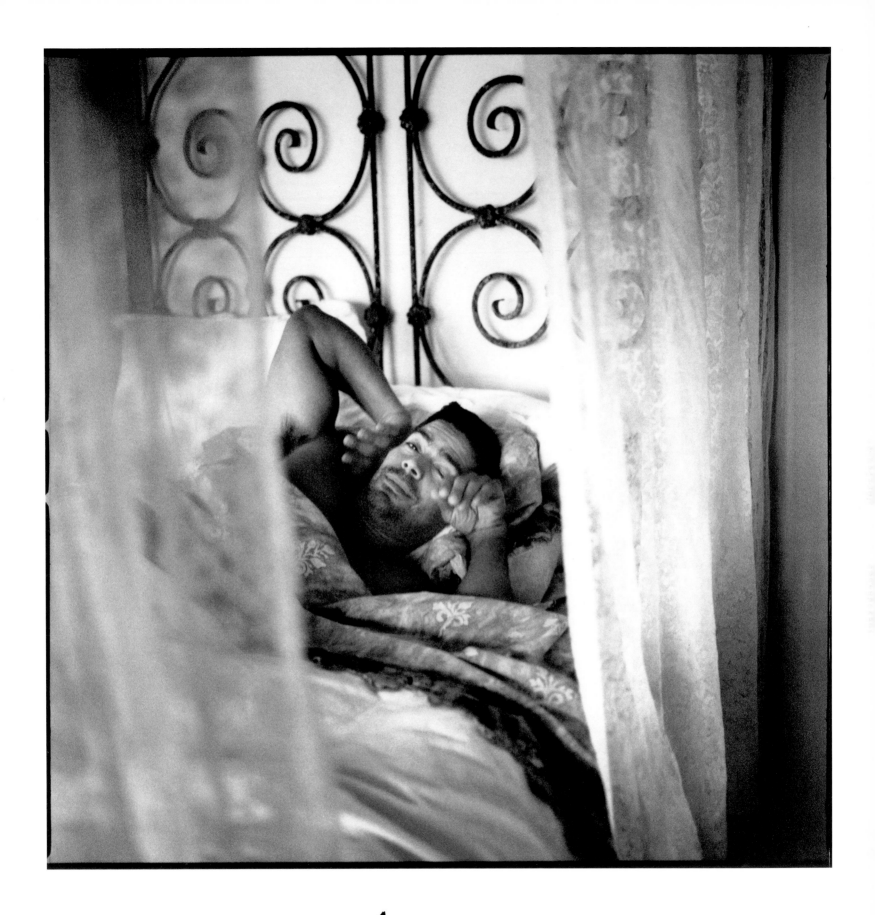

Esai Morales 8.24 am

I had met? Or would she be impenetrably silent, like so many others? I knew she was French, and I thought she must be an intrepid soul.

I don't remember what time she said she would arrive, but I was up by 6 a.m. I am an early riser, but not that early. So I waited. And waited. I felt like I was on a first date. I remember my cat Pushkin was with me. My husband lay on the hotel bed sleeping. I took out my own camera and photographed them, and did a few self-portraits in my wedding veil. Still no Véronique. I pulled on my sweat pants and went to the hotel gym and ran. And ran some more. And kept running. I like to run, but not that much.

I left the gym sweaty and only slightly wired, and there in front of me appeared a beautiful woman with long dark hair, a camera, and an exquisite sense of calm usually reserved for Persian cats. I felt such relief. Trust was born in an instant, because in that instant I realized she wasn't a voyeur, but an explorer.

The "session" took less than half an hour. I took a shower, put on my robe, and filled with the exhaustion of relief got back into bed. Véronique saw my veil hanging on the chair and asked if I minded being photographed in it again. No, not at all. That was my life at that moment, and though redonning the veil was a fiction, it was a fiction filled with truth. My marriage and my joy was how I was emerging from dream's gate into life—and maybe Véronique sensed that. The only thing missing from the beautiful photograph she took is how wonderful my love smells in the morning.

What follows in this book is how these group of men emerge from that intimate place of darkness into the day on the particular morning Véronique came to photograph them. Some, still sleeping, gaze at death's amorous side; unencumbered by manhood, they look like boys. Some you see playing with Véronique, delighted she is there, delighted they are being regarded. Others are shy; some are deeply grounded, confident that they need not present themselves to the camera, knowing it will find them. They are all beautiful.

One of the questions the photographs seem to answer is, how do we prepare for the day? How do we prepare for life? In the smallest actions we create who we are. I love looking at the smallest detail, the smallest action—an old balloon lying on the couch, the way someone washes his hair or holds his cup. It reminds me of what the director Carl Franklin once said to me: The camera is not interested so much in acting; the camera is interested in you. Véronique Vial is lovingly interested in it all, and she finds the truth in the fiction time and time again, like a seeker who knows where the grail is hidden.

Jennifer Beals
June, 2001

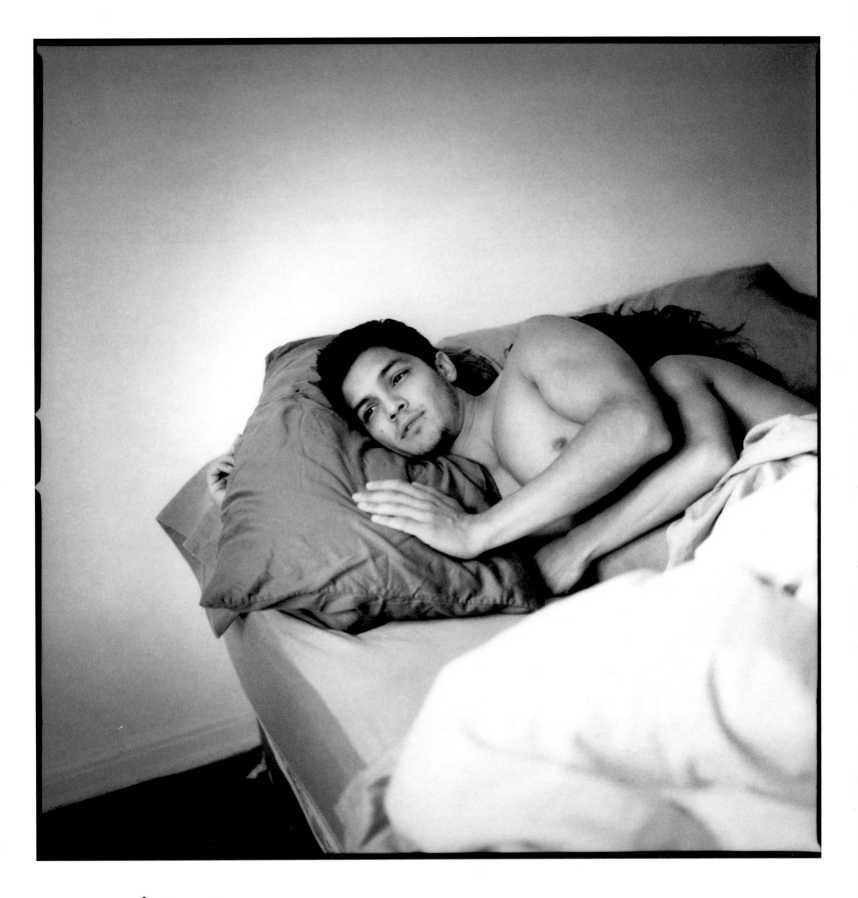

Nicholas Gonzalez 9.15am

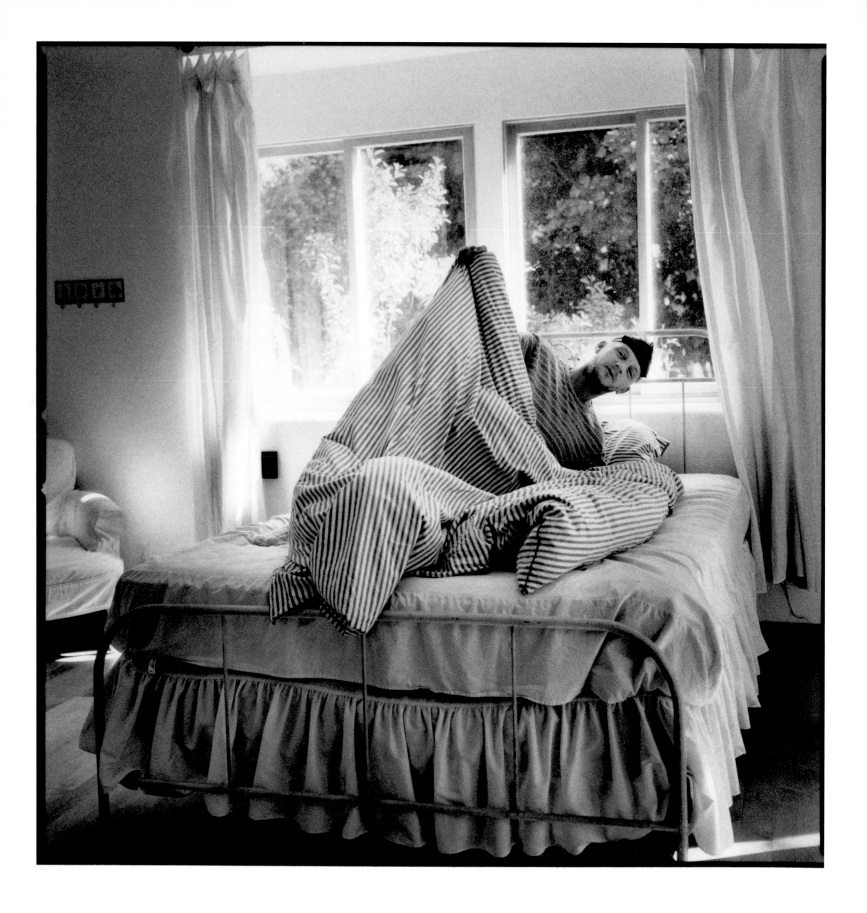

Sönke Wortmann 9.39 am

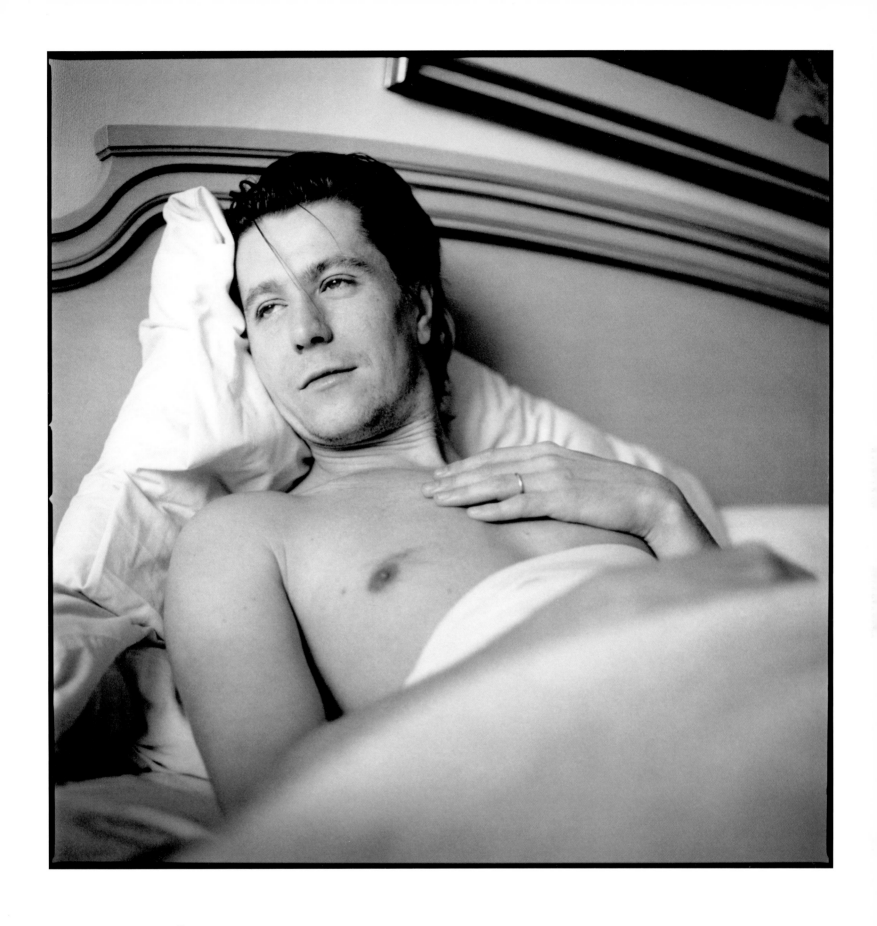

Gary Oldman 7.06am

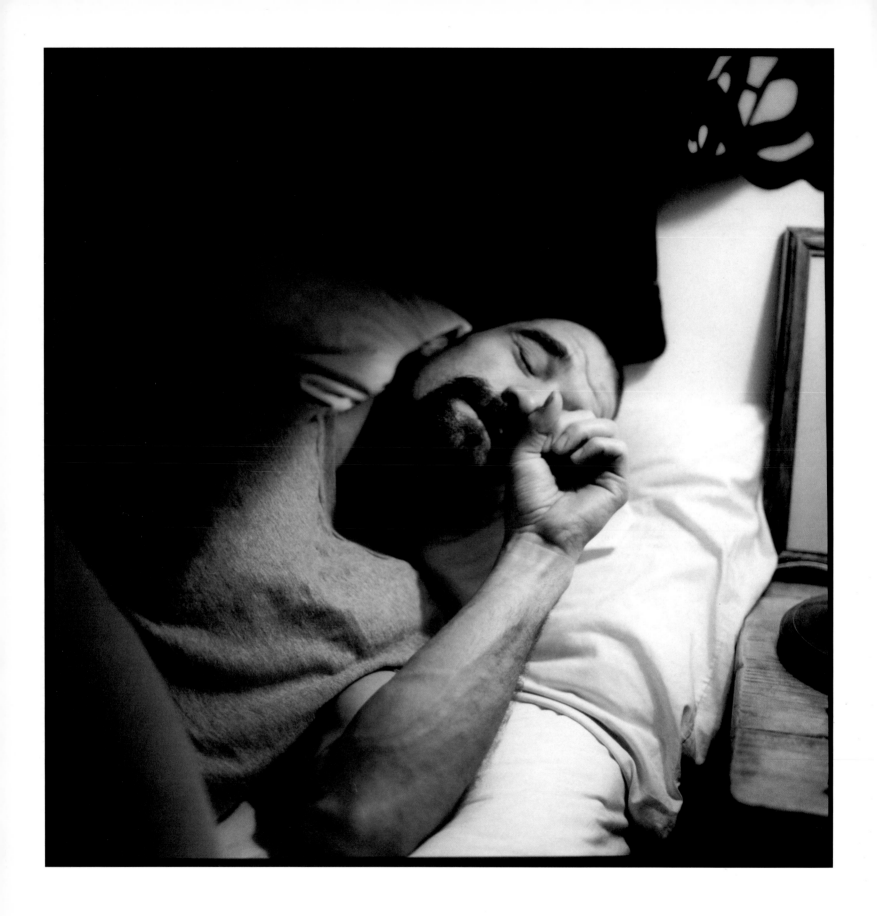

Elias Koteas 9.00 am

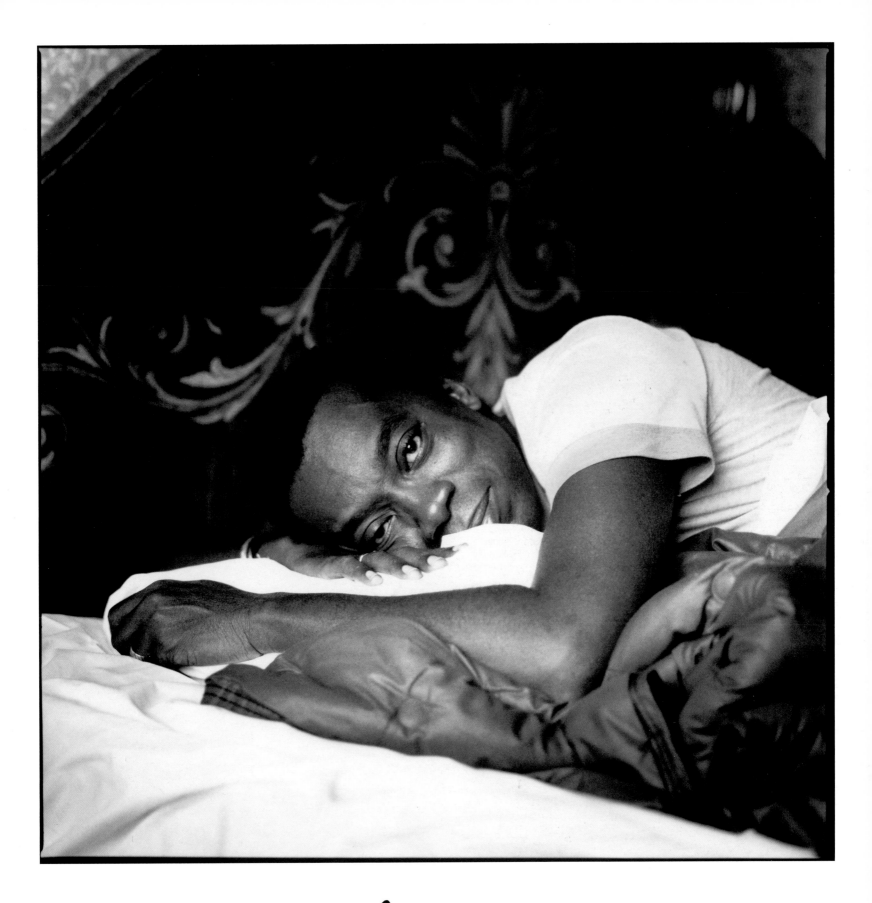

Milton Nascimento 9.50 am

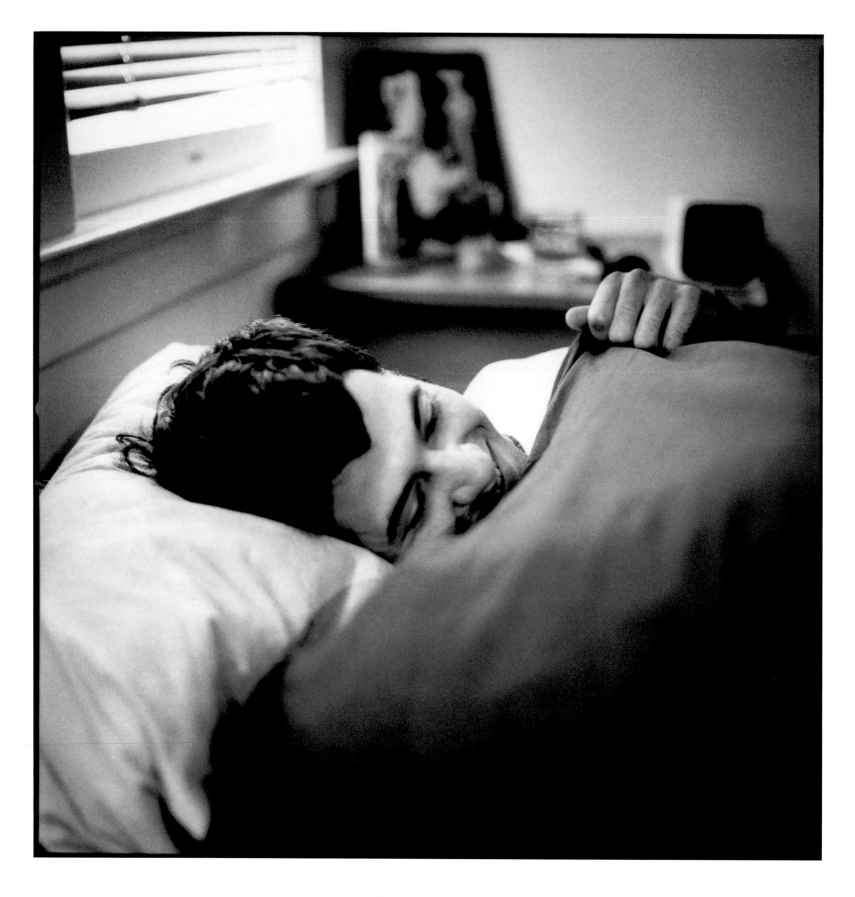

Troy Garity 9.03am

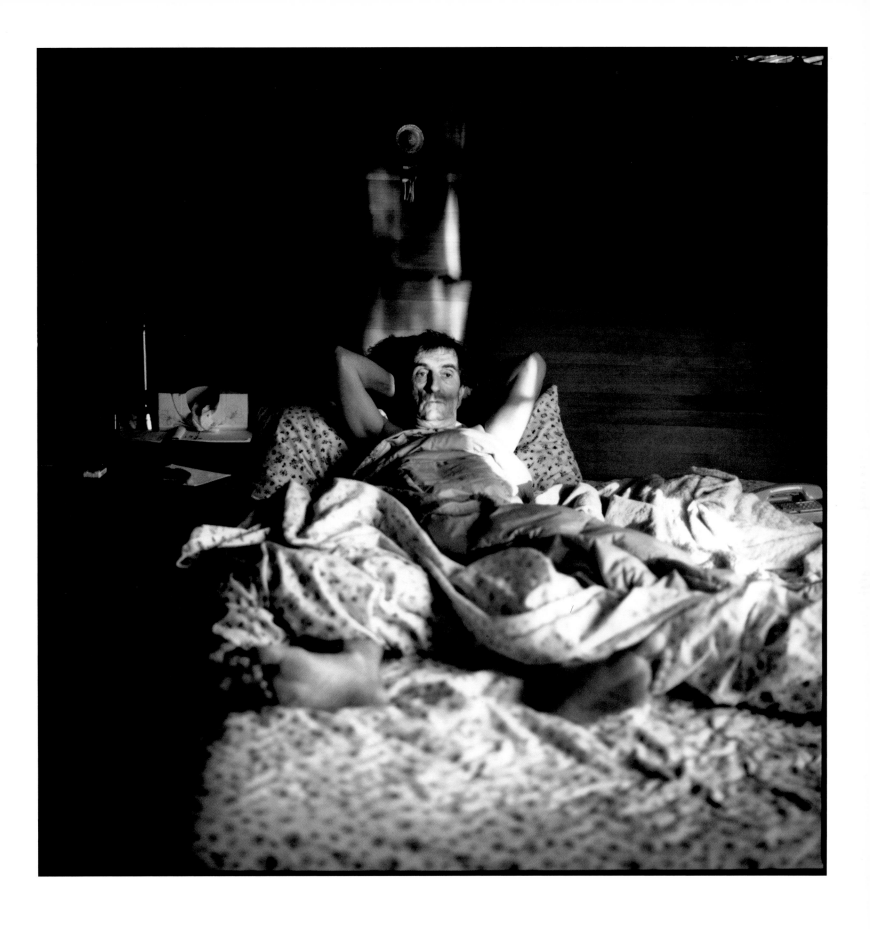

Harry Dean Stanton 9.35 am

It was minus 20°C when Arne woke up
in the beautiful igloo he designed
and built north of the Artic Circle
in Sweden, the "Ice Hotel".

Arne Bergh 9.00 am

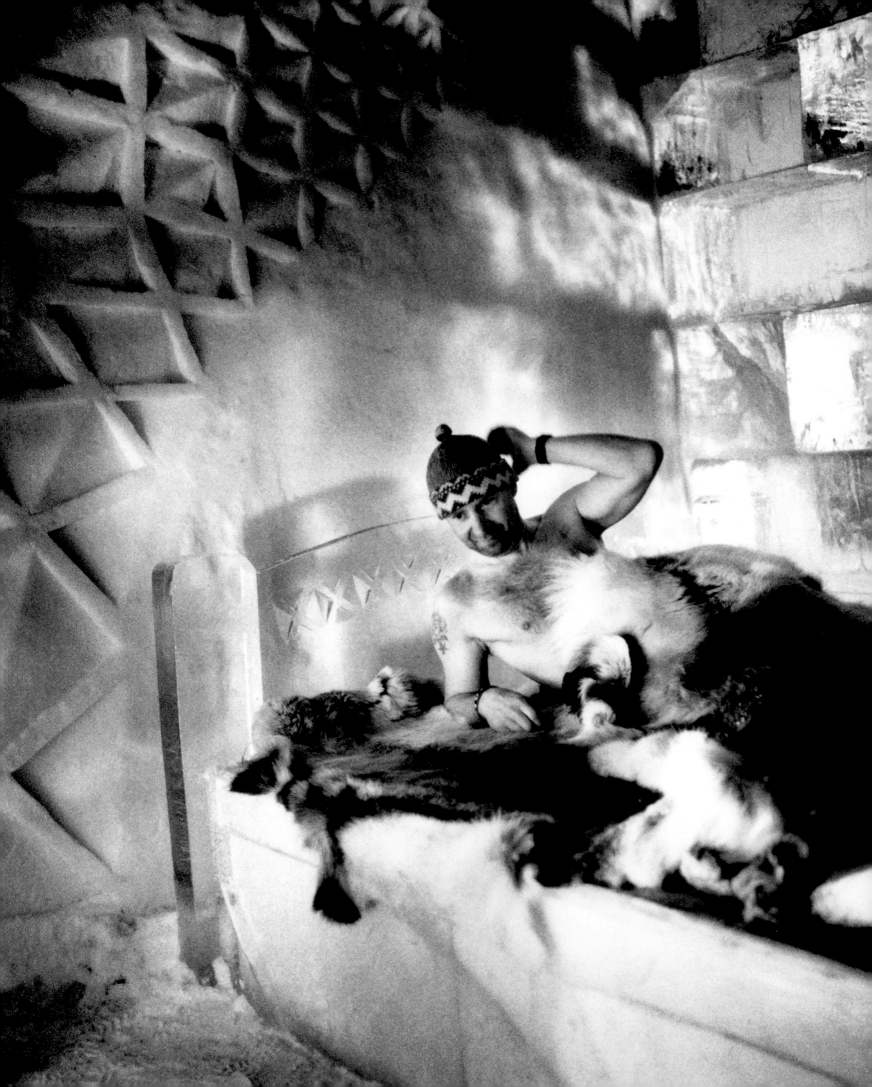

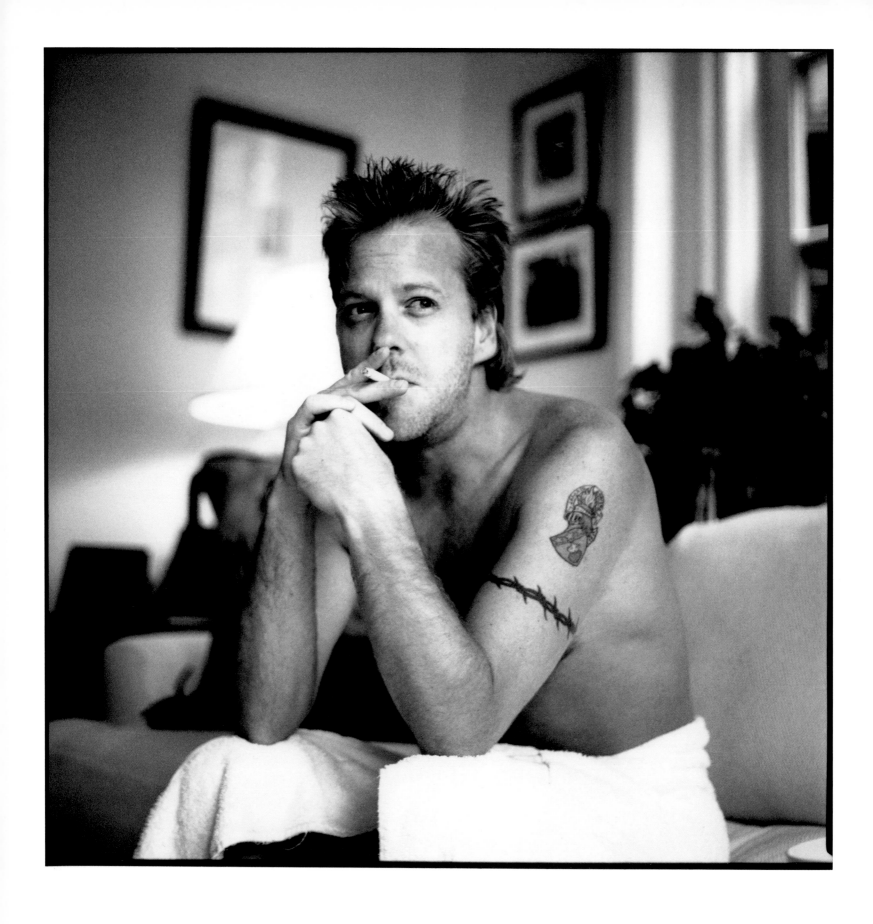

Kiefer Sutherland 9.37am

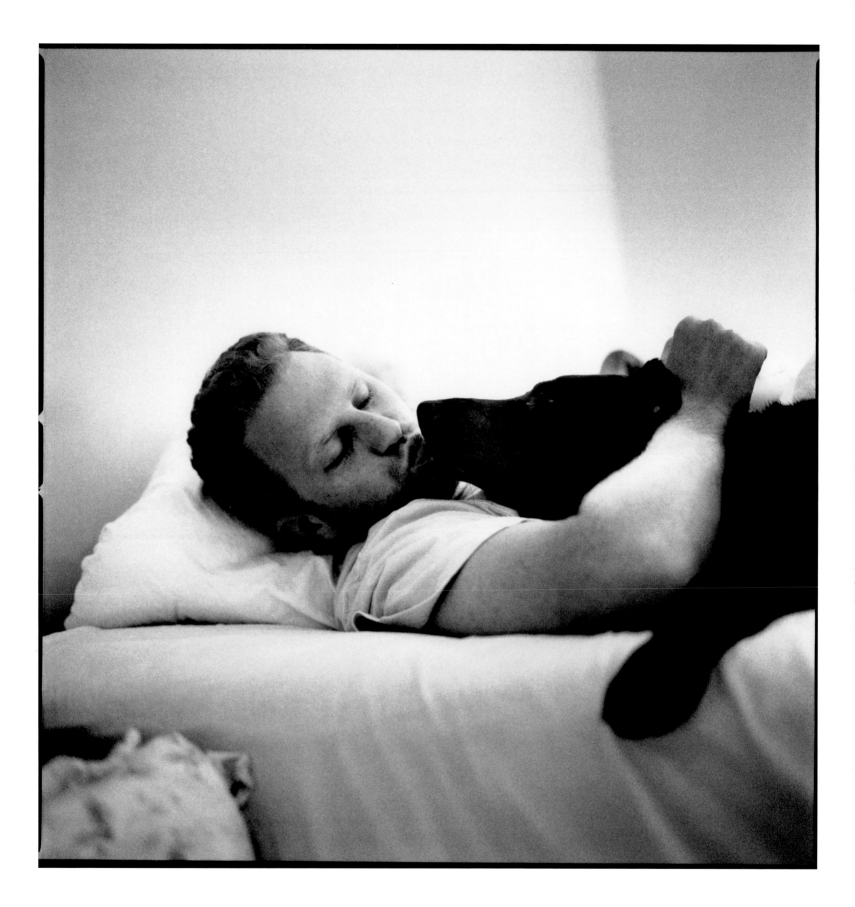

Michael Rappaport 9.01 am

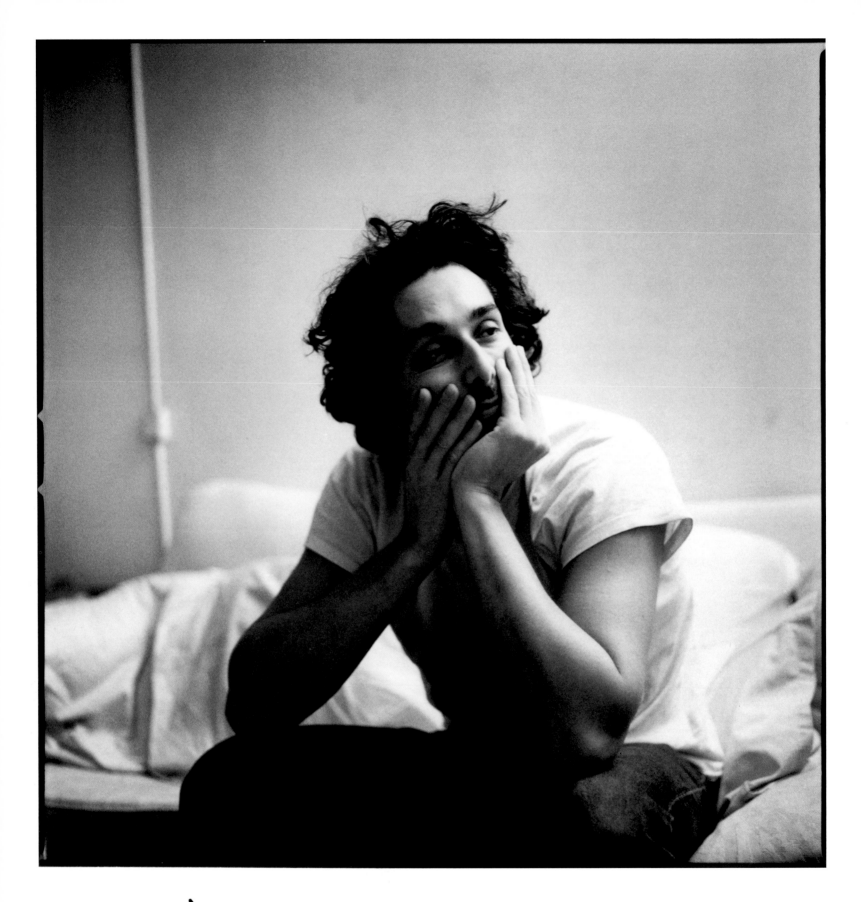

Vincent Elbaz 8.58am

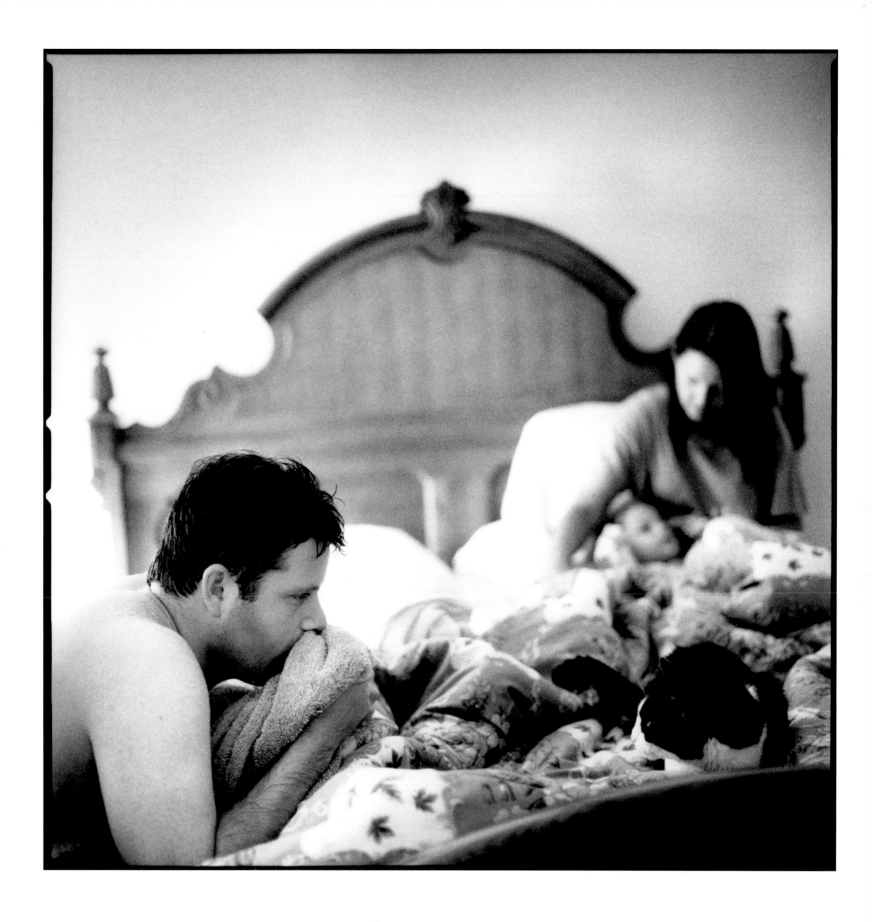

Sean Astin 9.10am

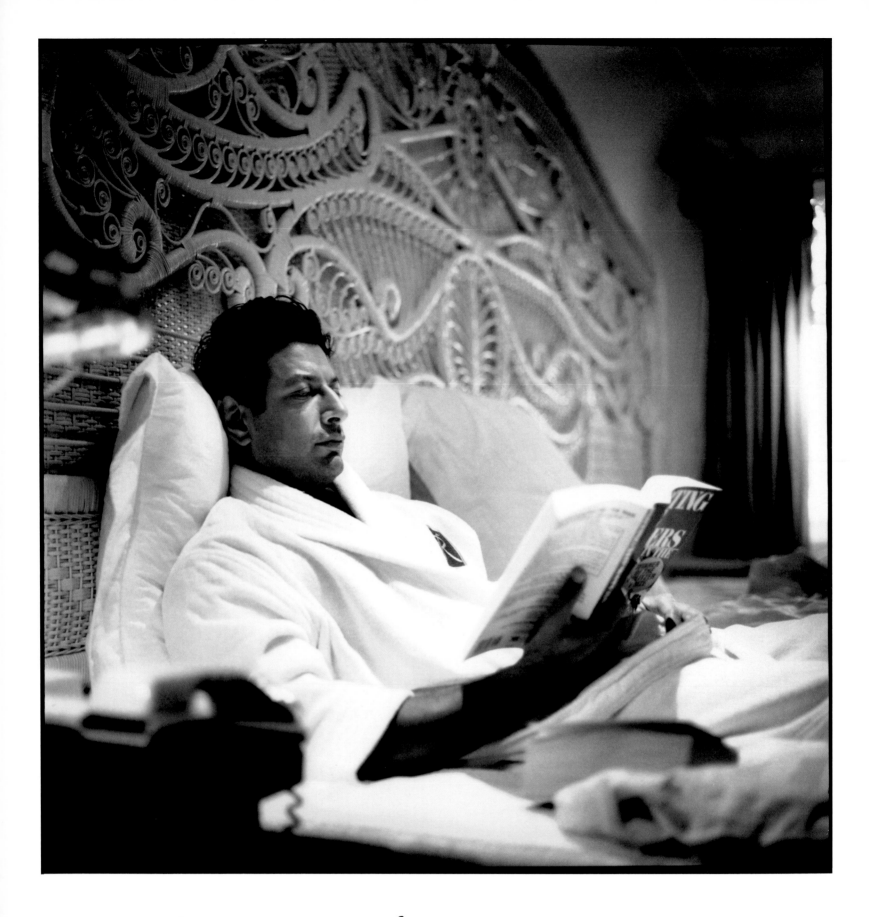

Jeff Goldblum 9.00 am

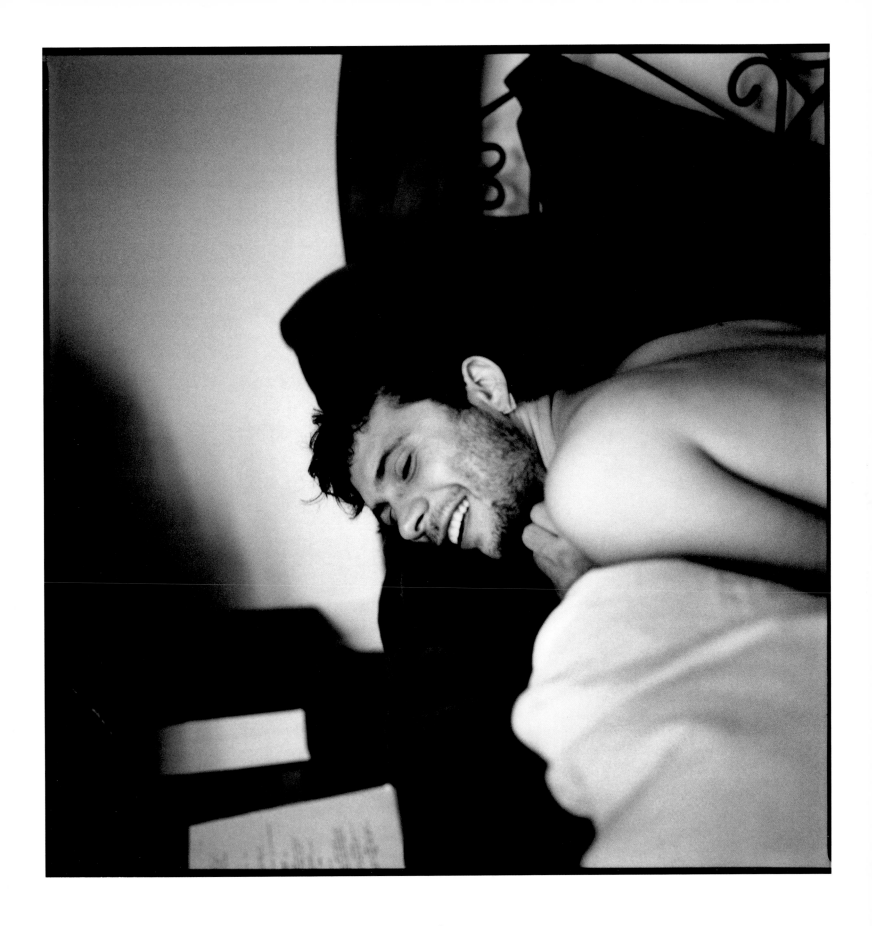

Jeremy Sisto 8.50 am

Bert was in bed with identical twins
and his magnifying glass
so he could tell them apart!

Bert Stern 9.01 am

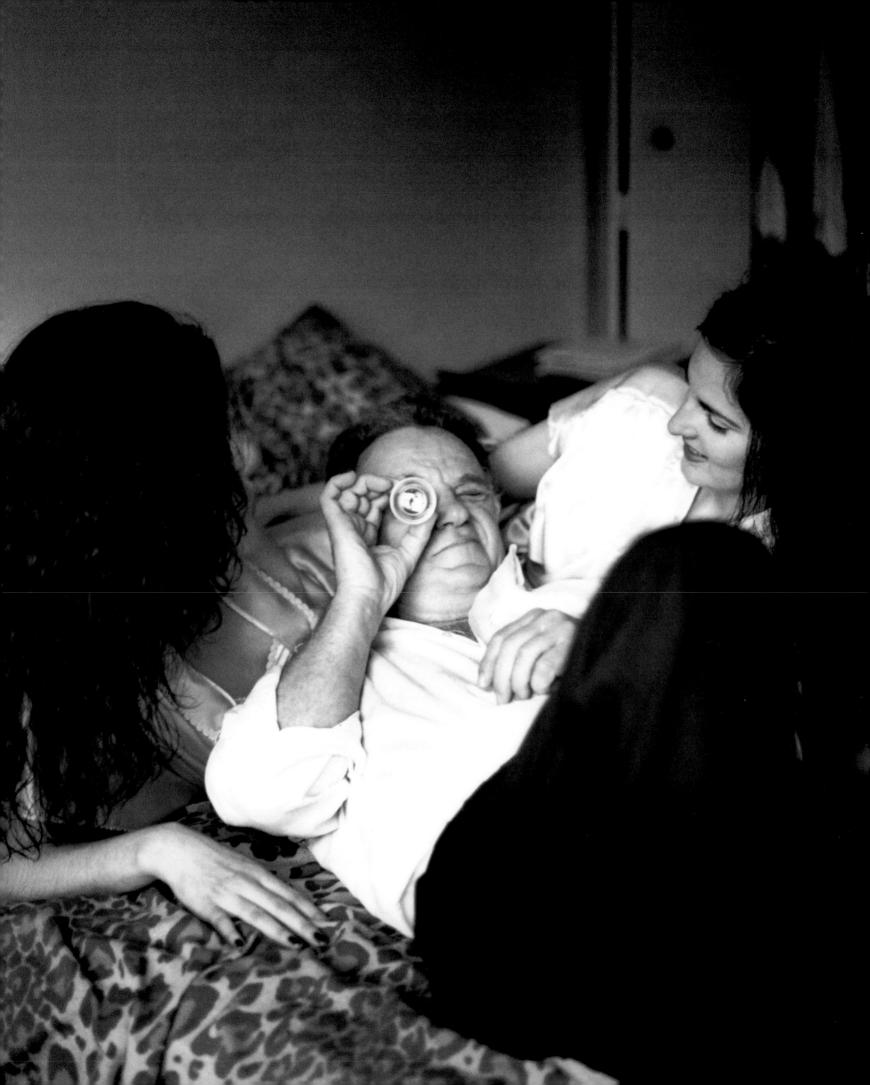

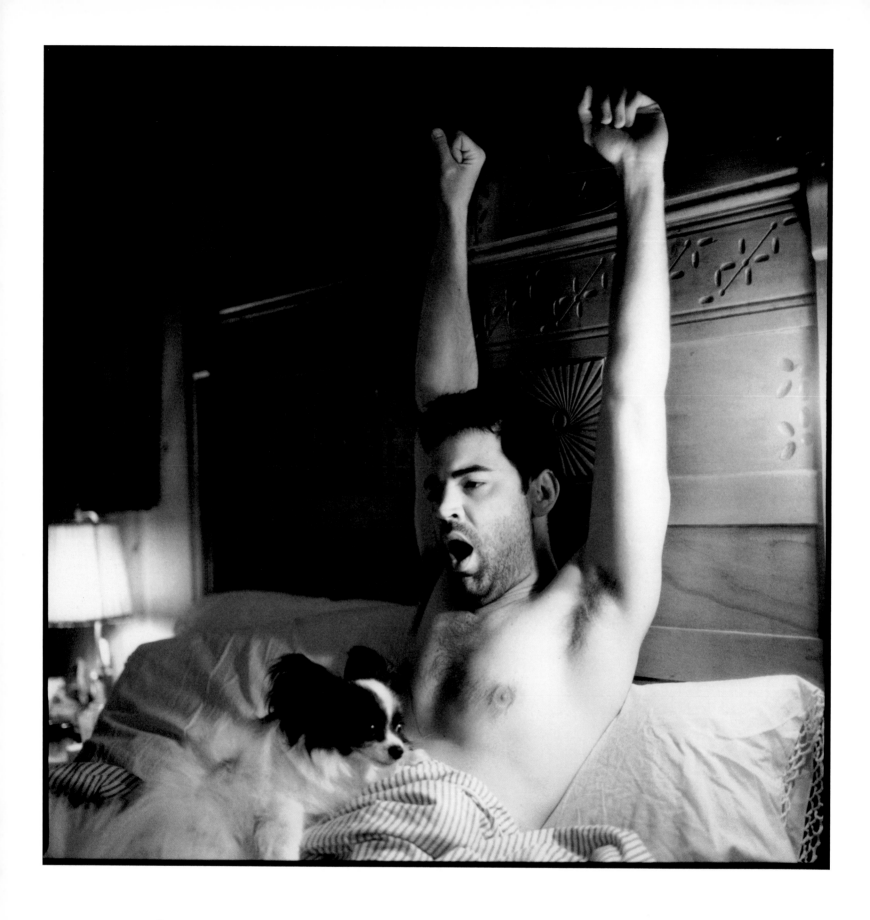

Ron Livingston 8.15am

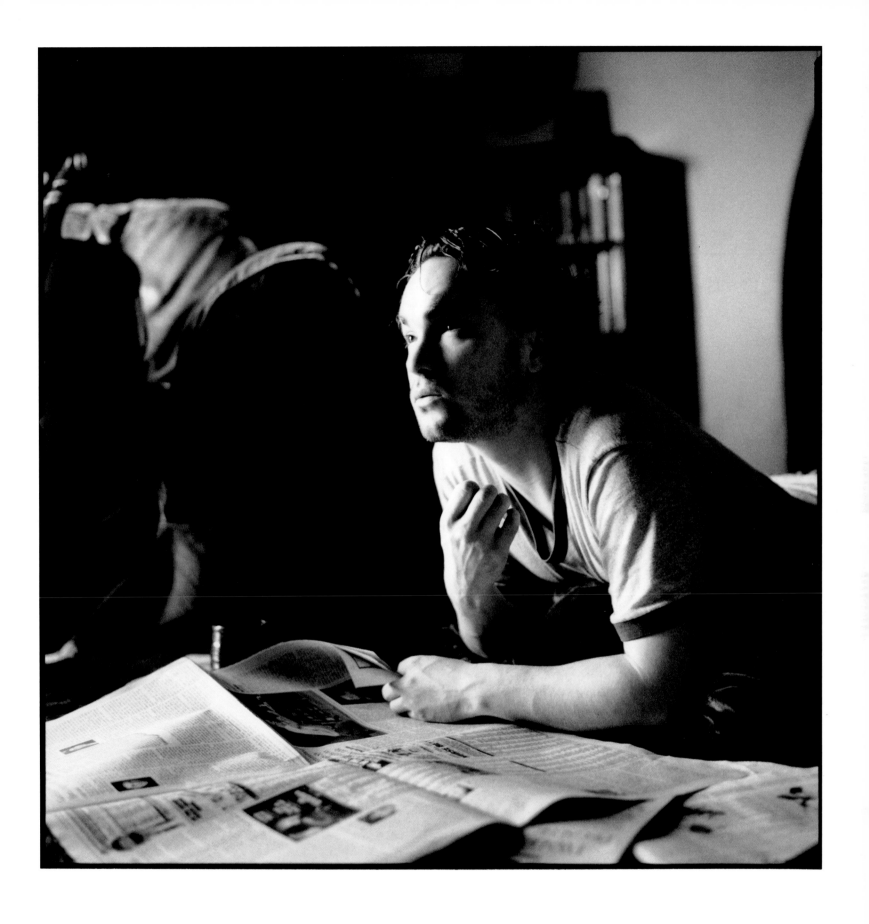

Johnny Galecki 8.20 am

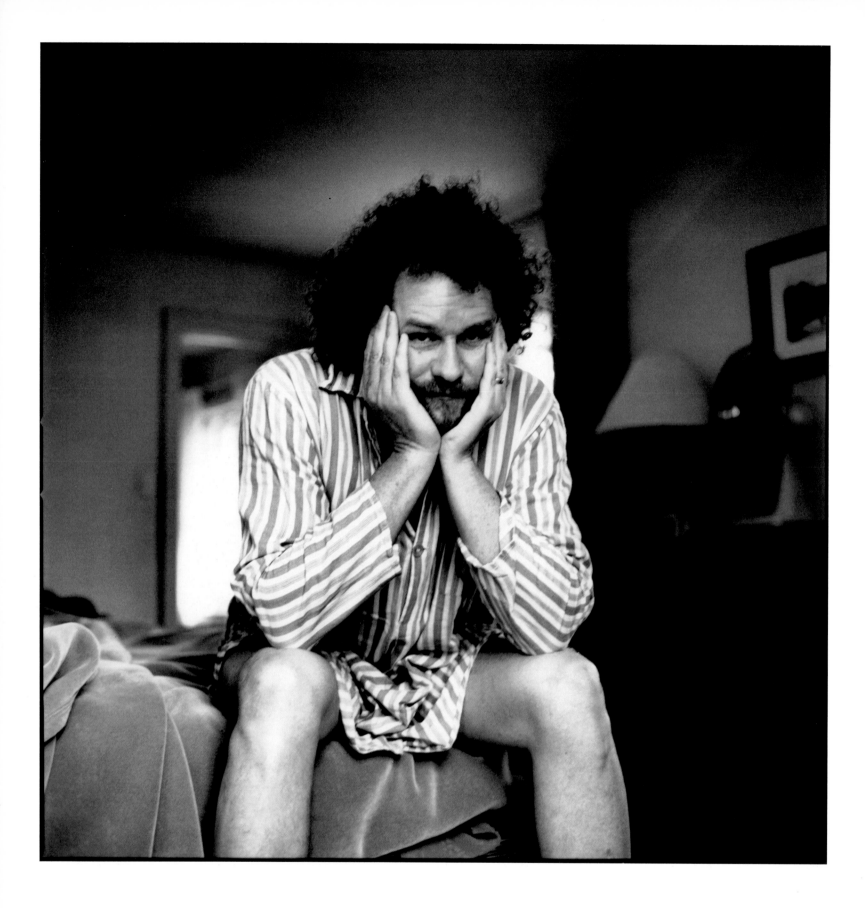

Mike Figgis 9.01 am

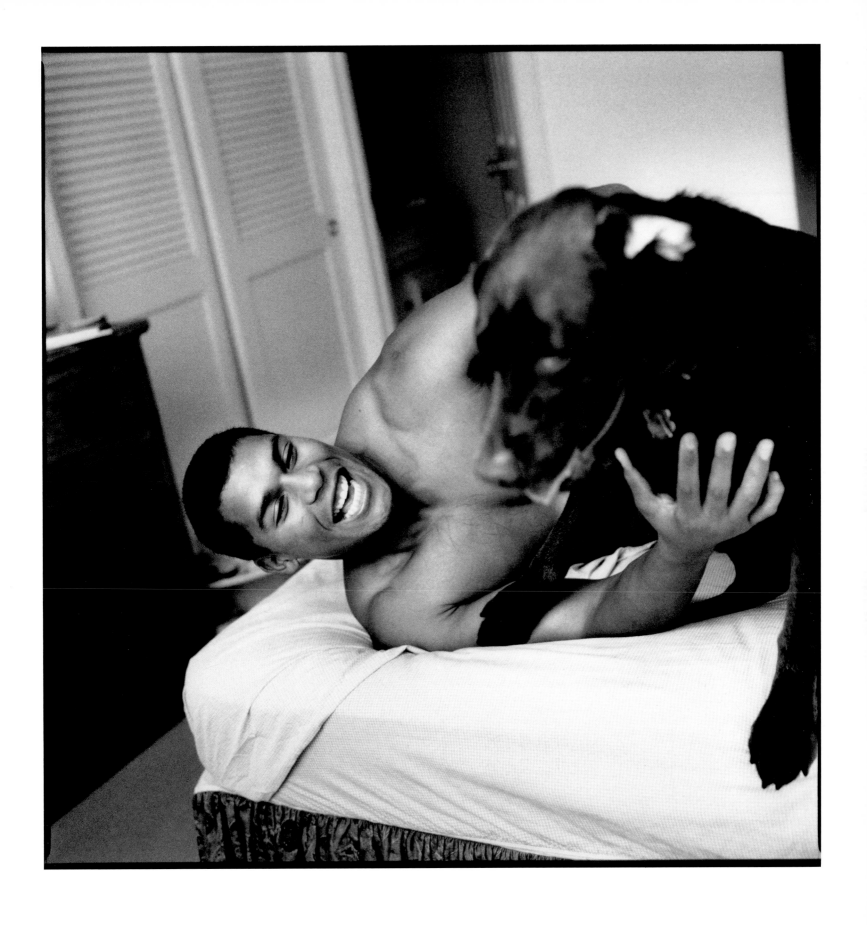

Donnie Edwards 8.56 am

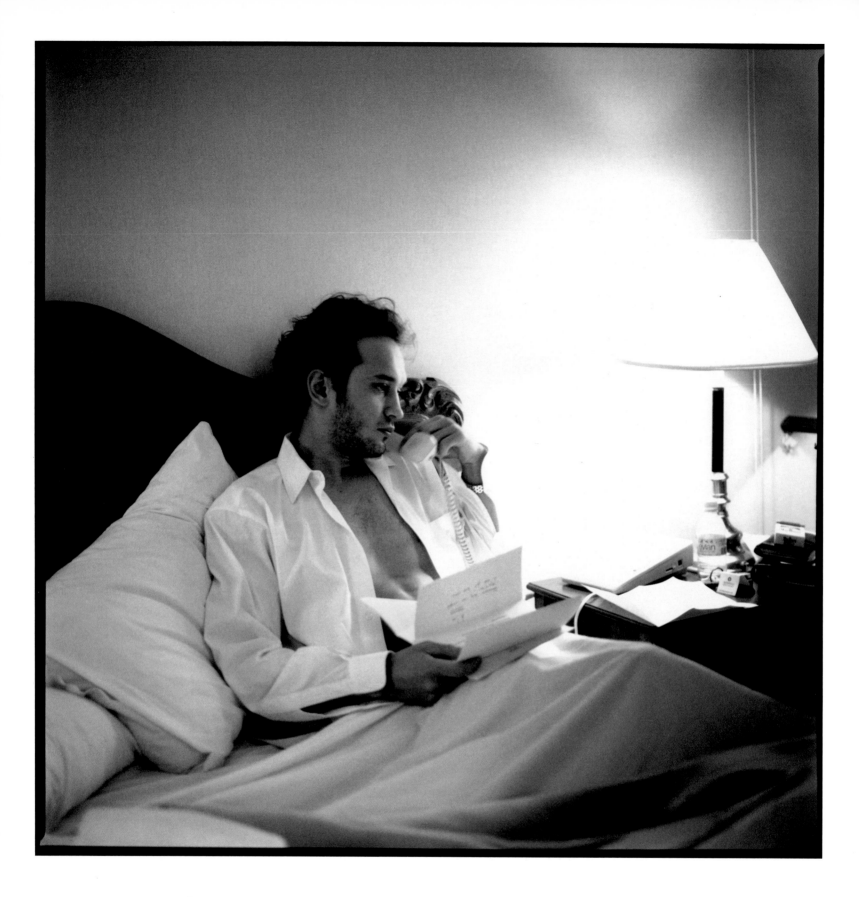

Vincent Perez 7.00am

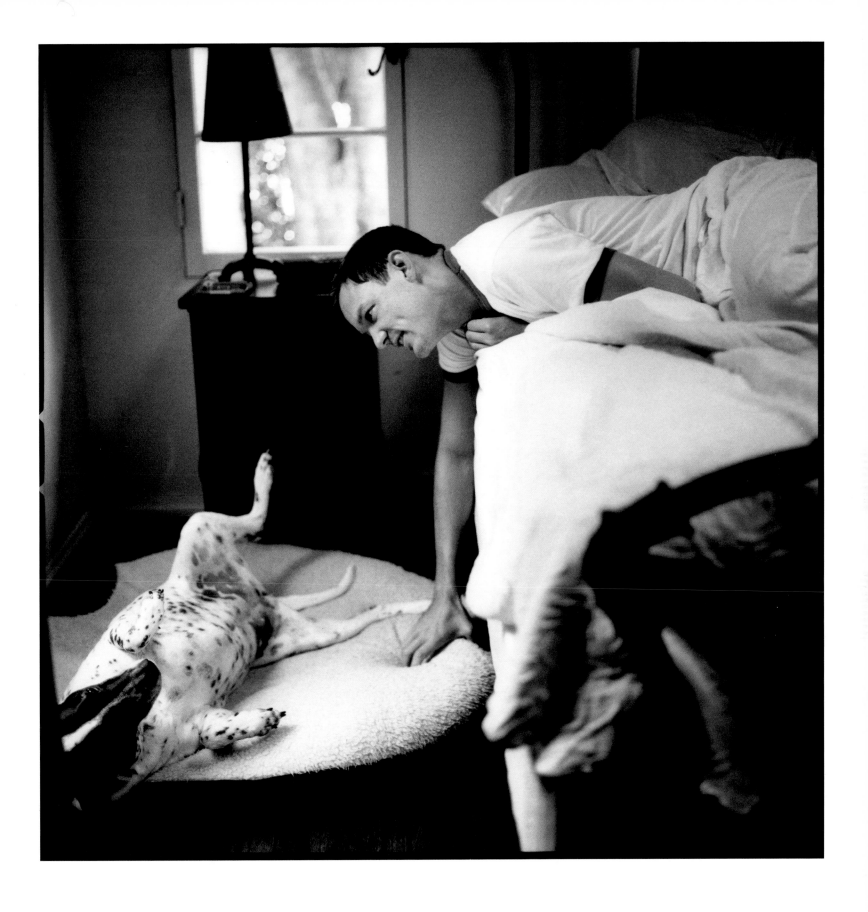

Matt Lillard 8. 48 am

Bernard-Henri Levy

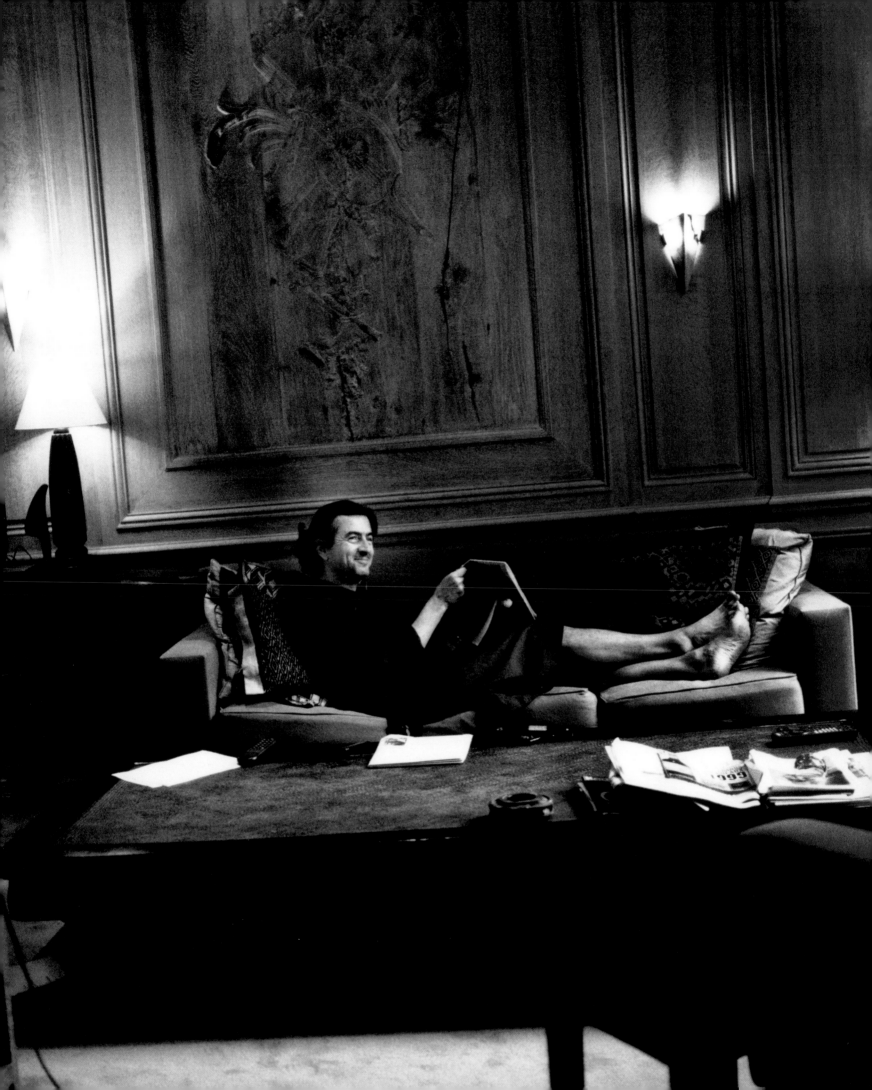

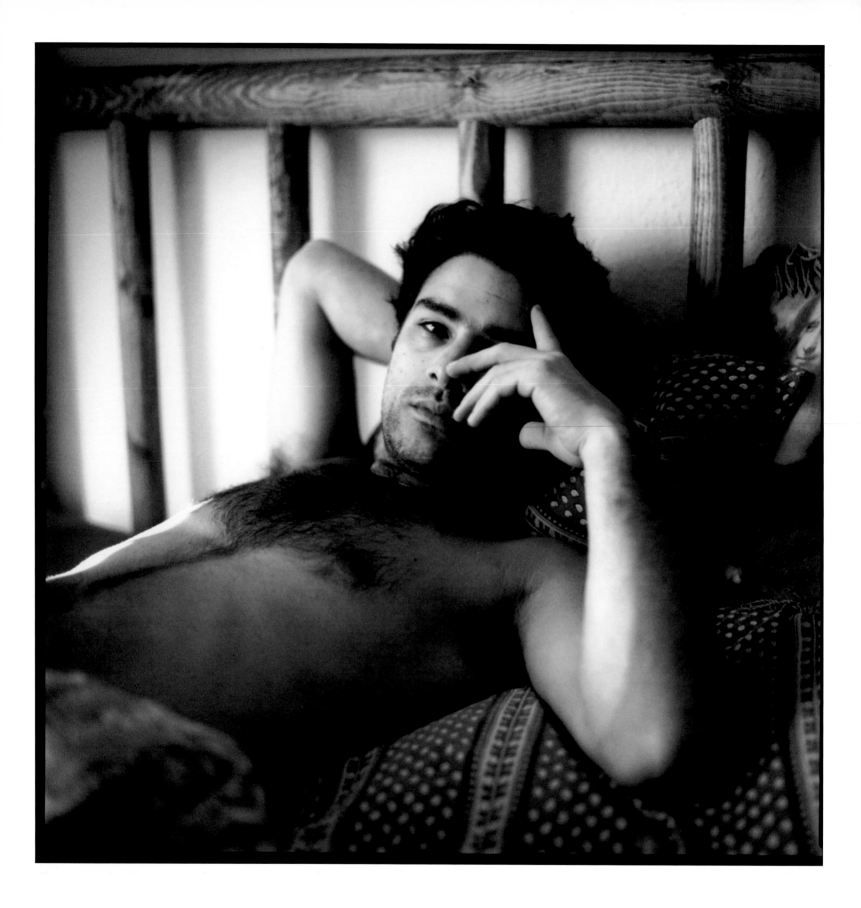

Marco Leonardi 8.59am

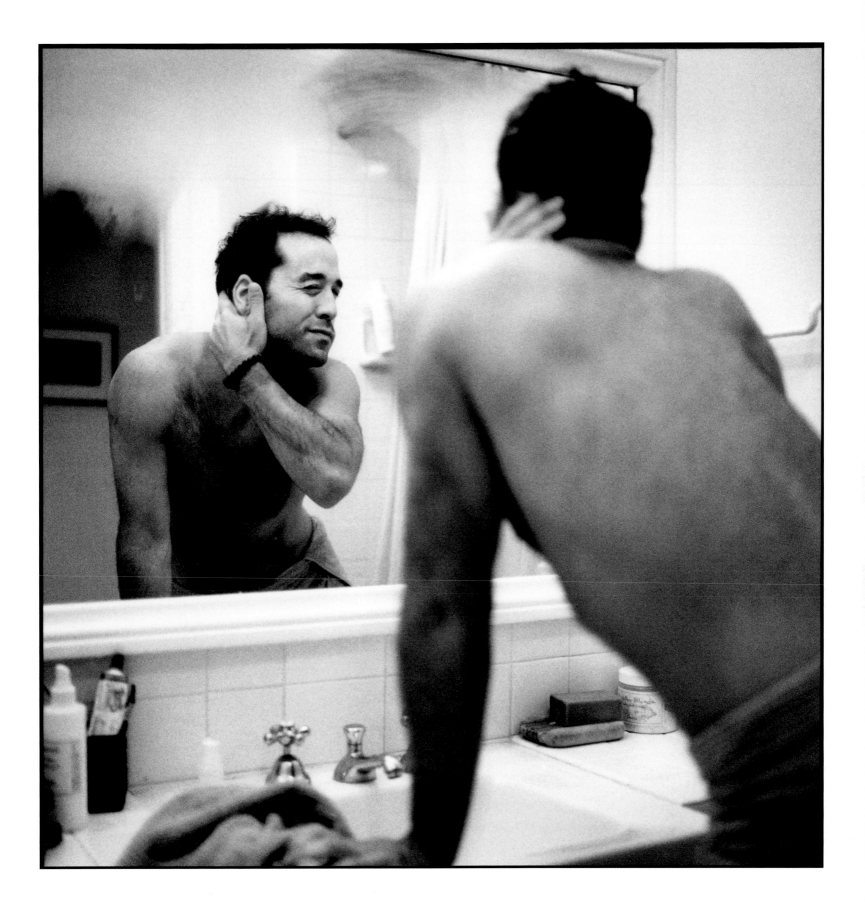

Jeremy Piven 8.59 am

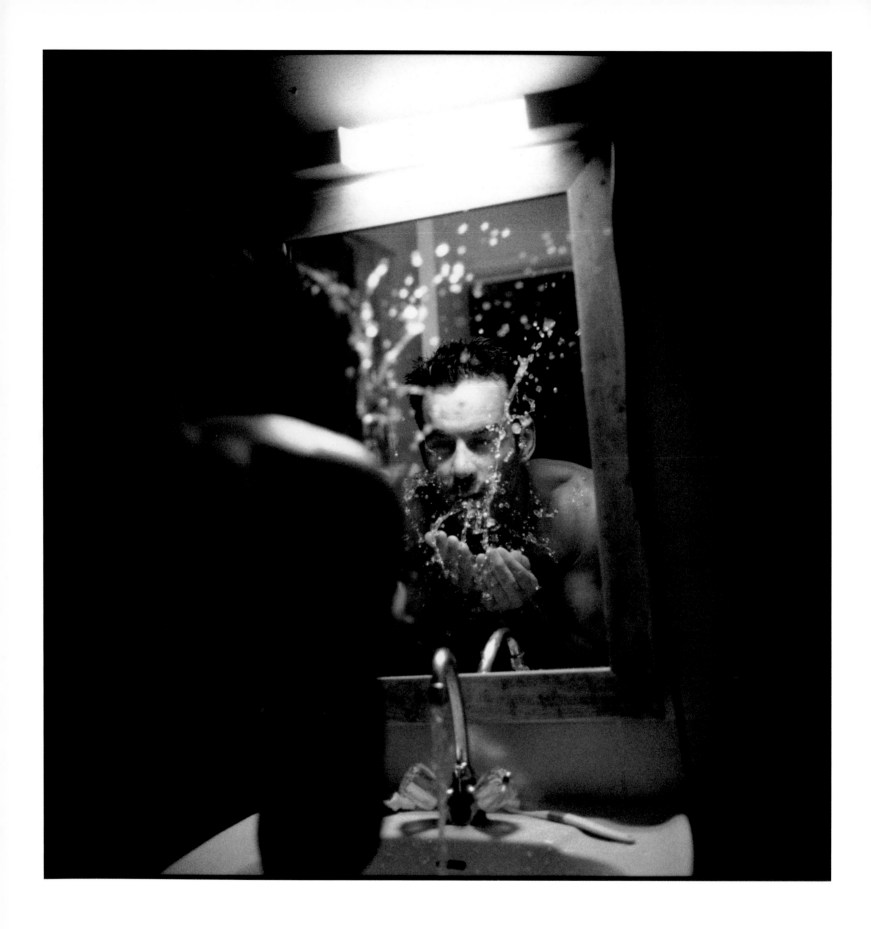

Pierre Cosso 8-39 am

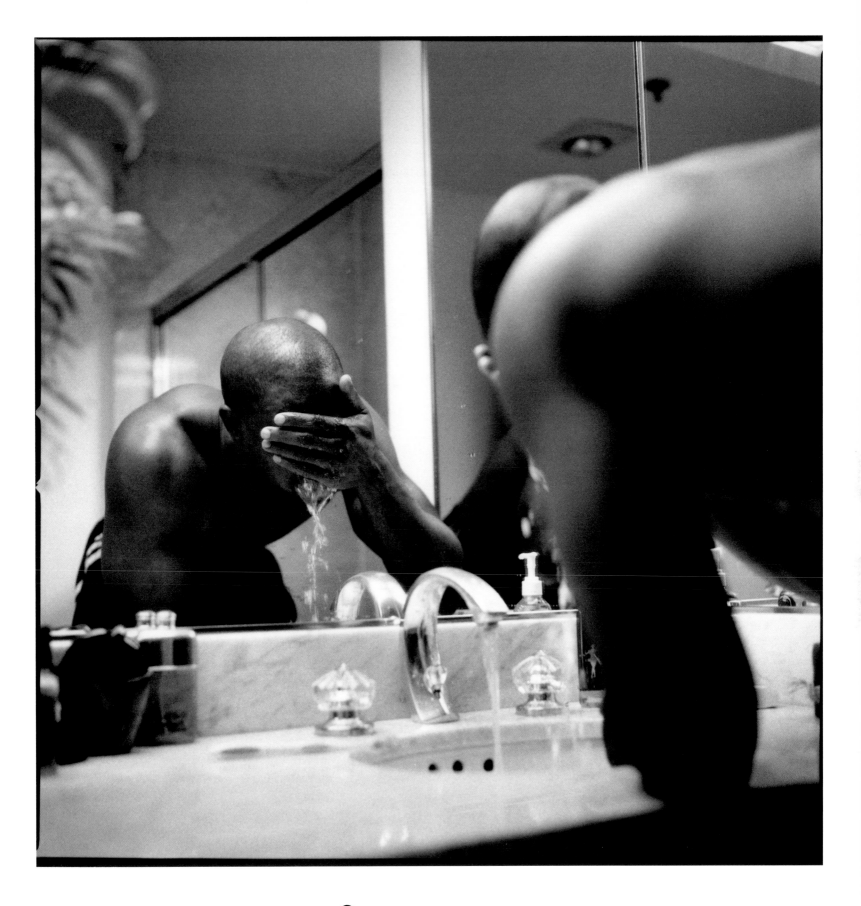

Djimon Hounsou 8.58 am

Jean Baptiste was very generous
asking me if I
wanted to shoot him pissing
...I would never ask !!!

Jean Baptiste Mondino 7.58am

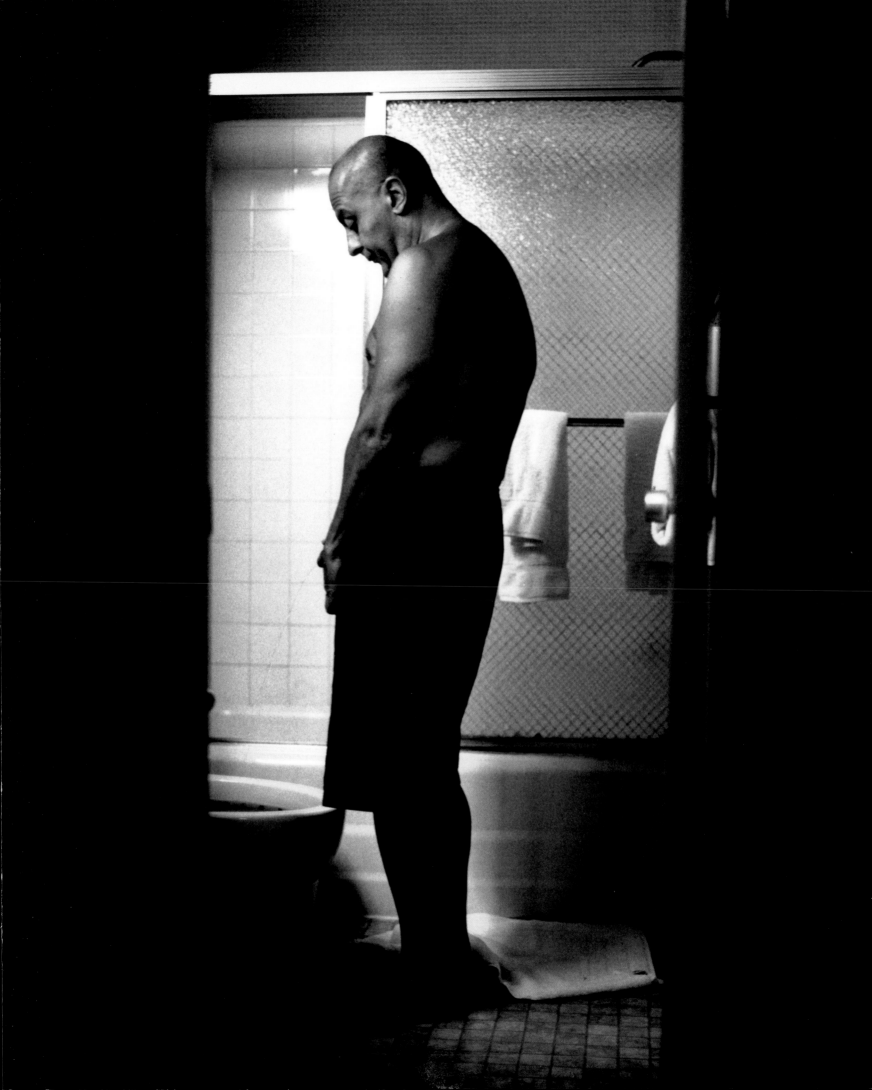

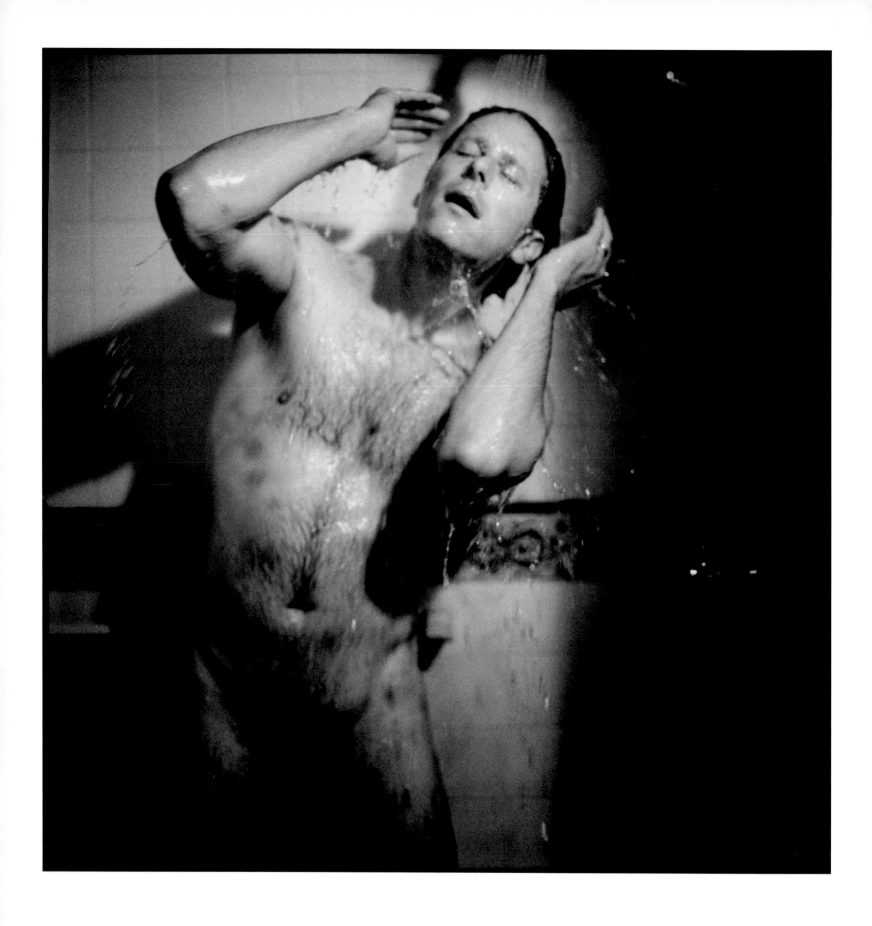

Steven Weber 8.50 am

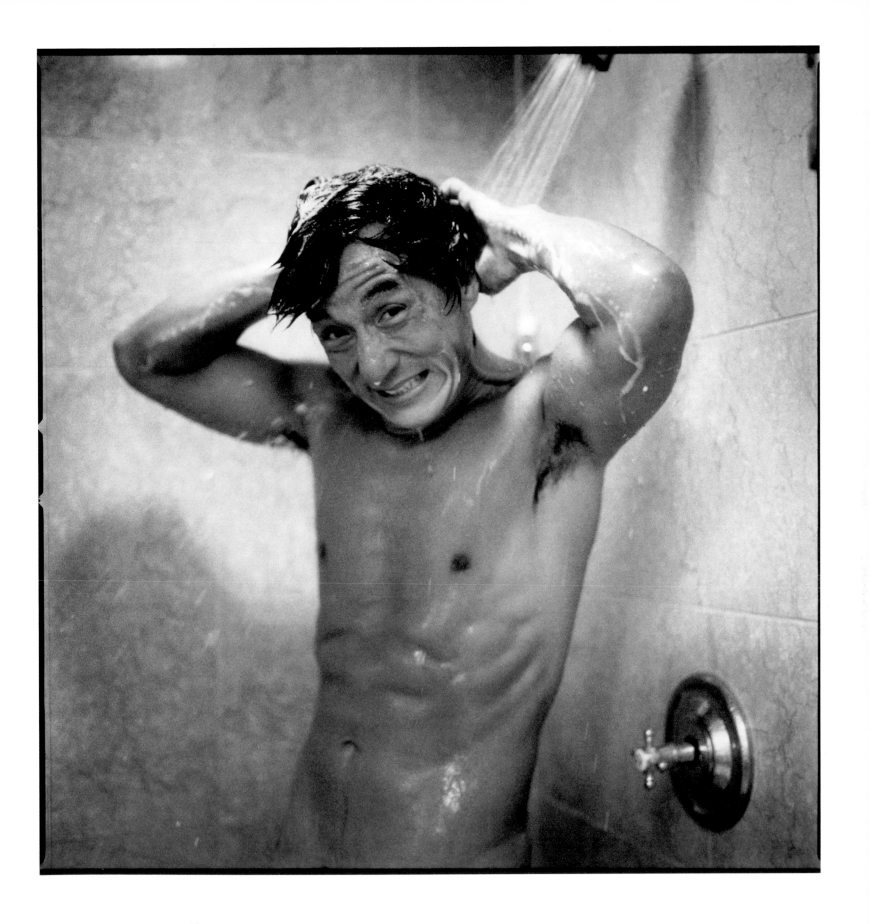

Jackie Chan 9.27am

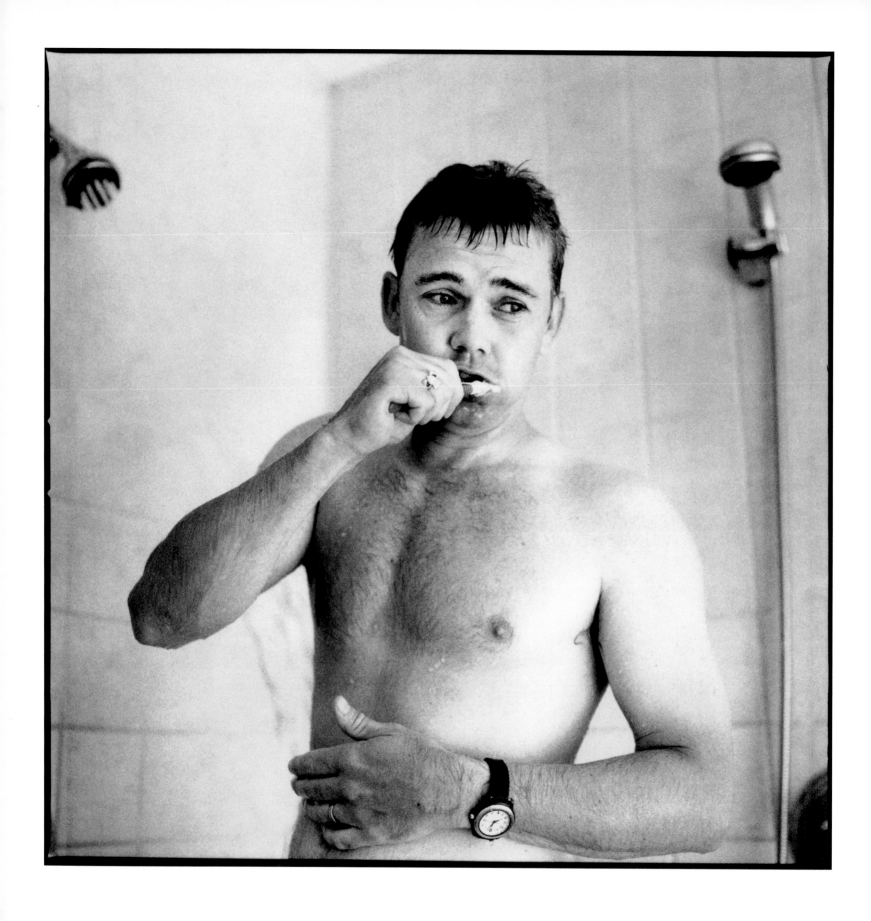

Rick Schroder 8.03 am

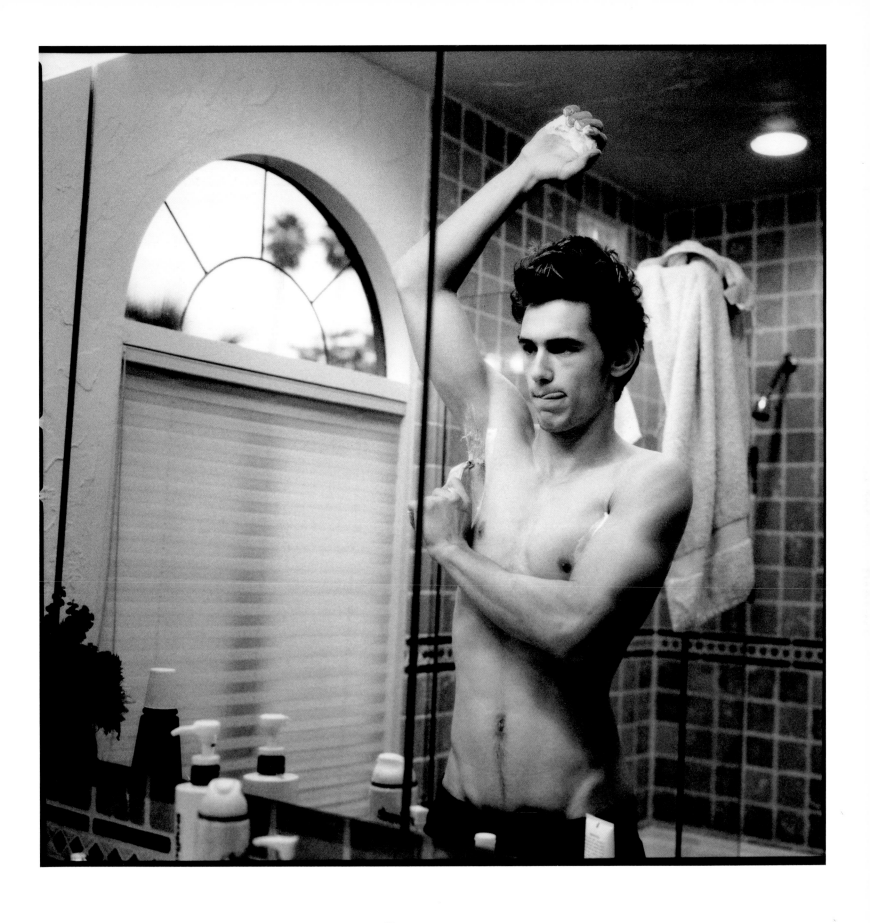

James Franco 6.5gam

Tom was, like always charming, funny, wild, sexy.... almost irresistible!

Tom Sizemore 9.10 am

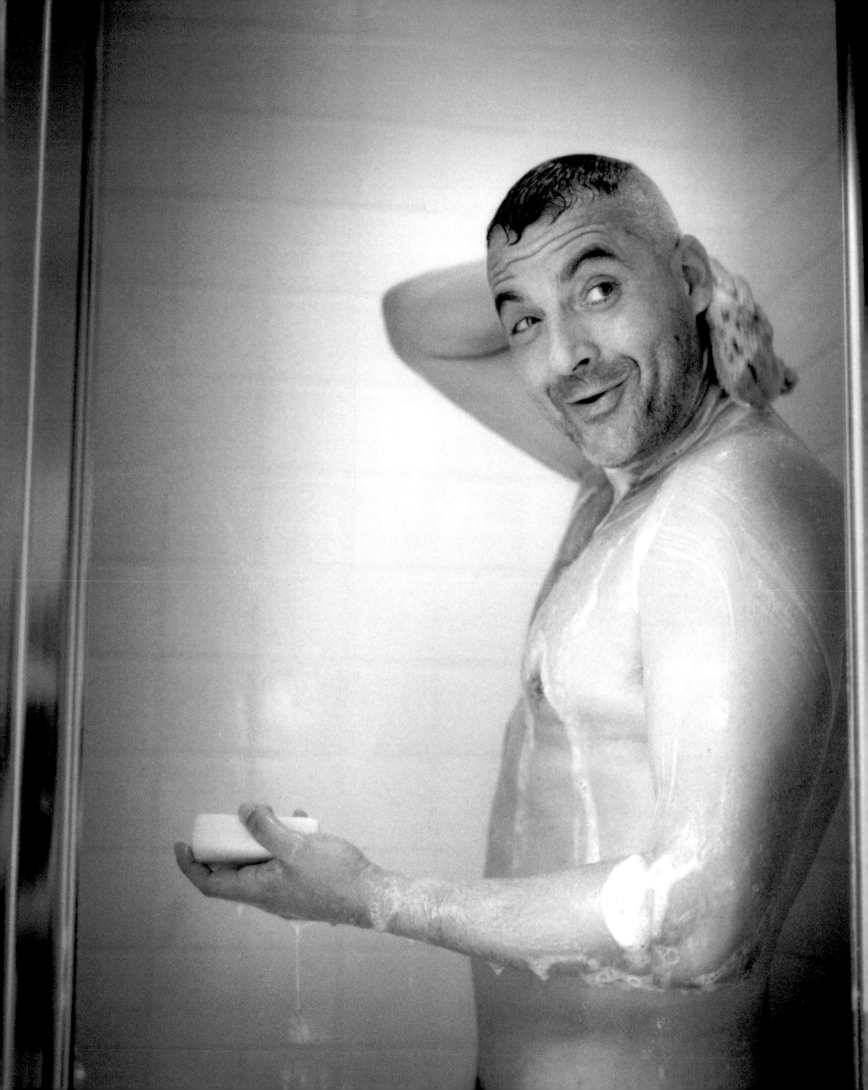

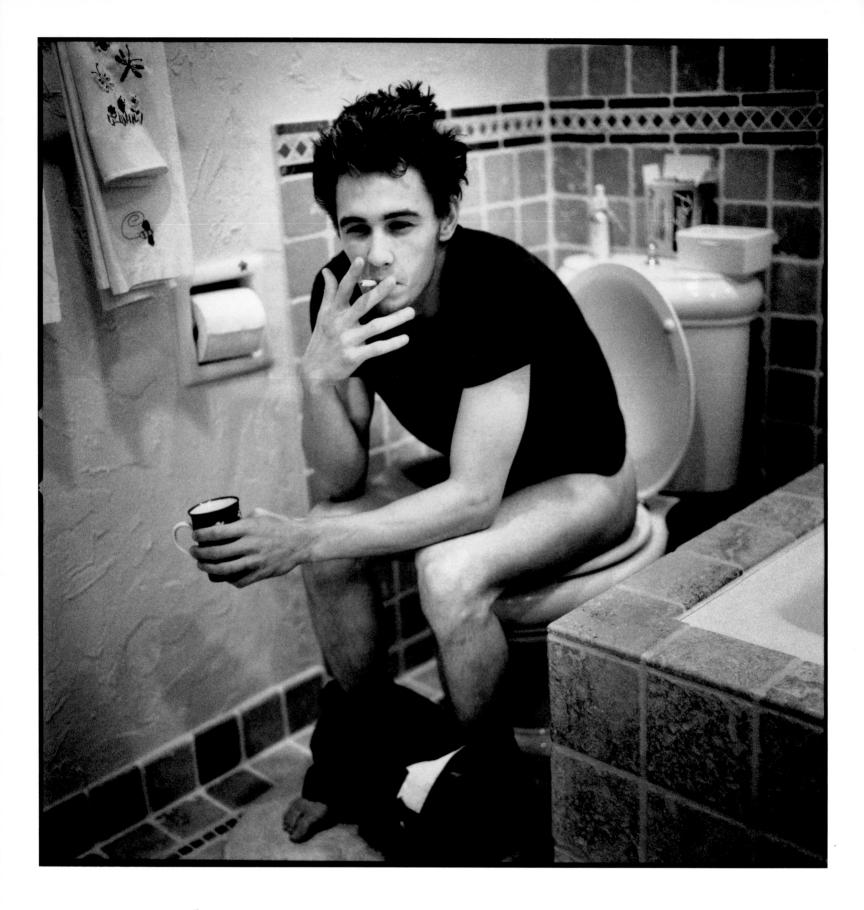

James Franco 6-58am

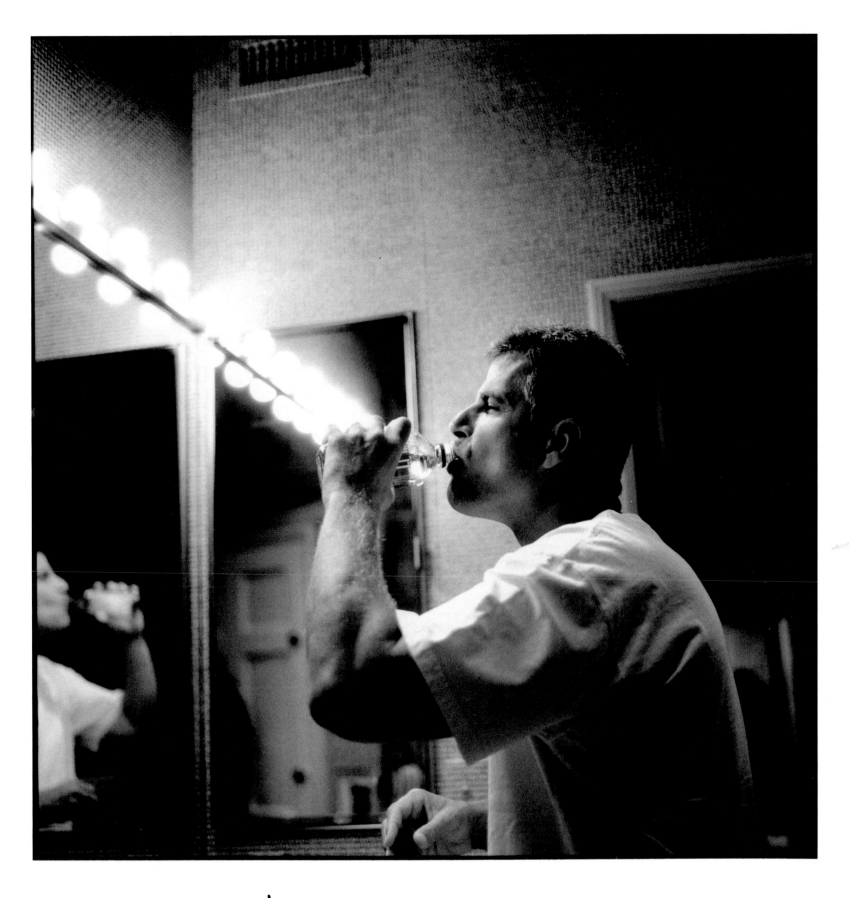

Mark Spitz 8.00 am

Vin Diesel 9.37 am

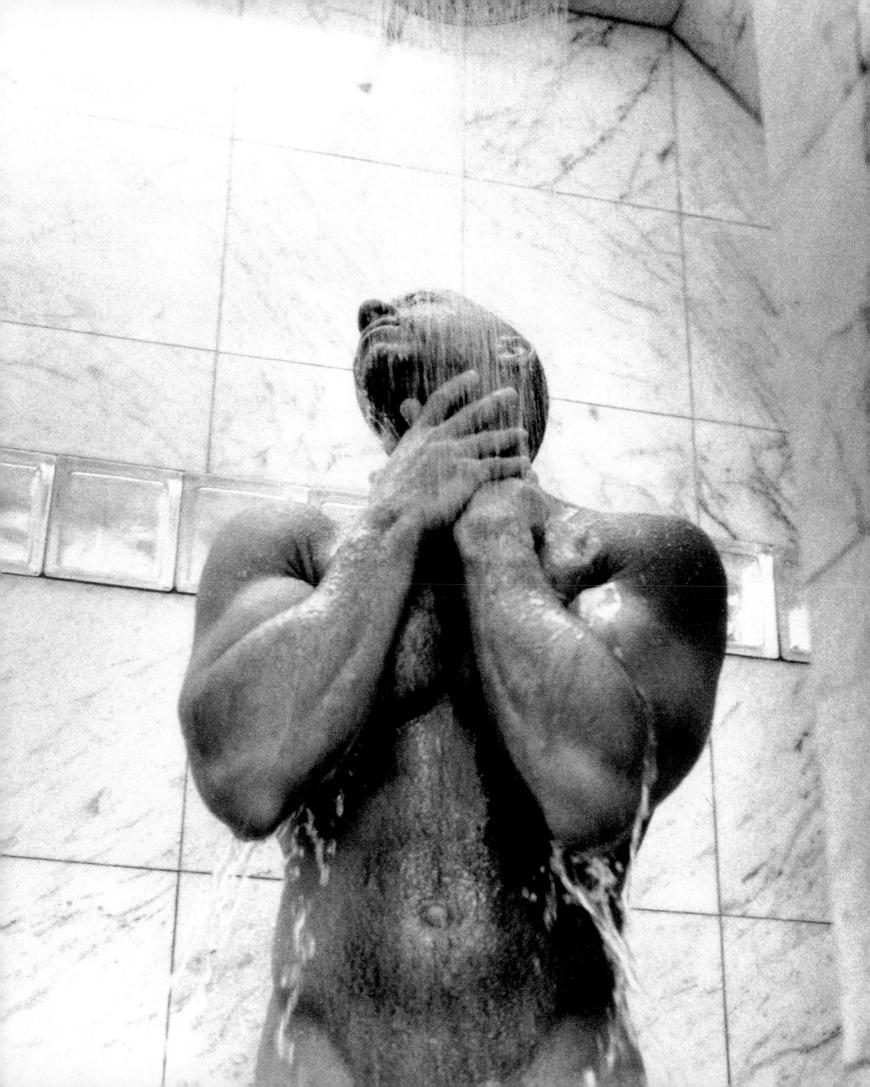

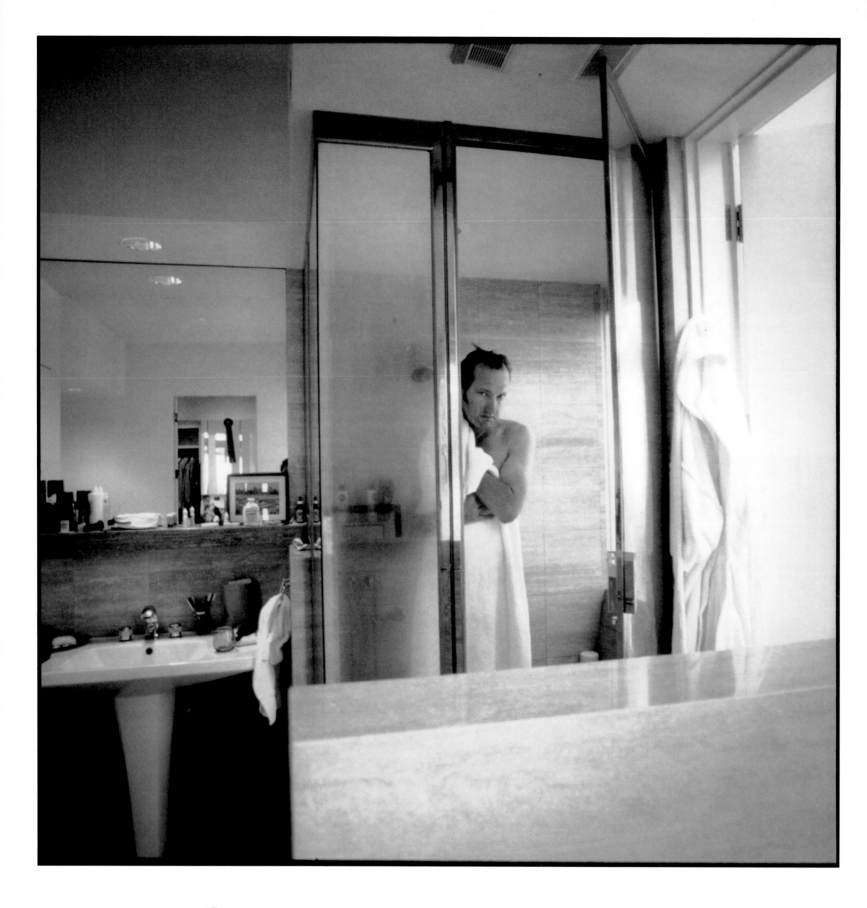

Randy Quaid 8-40am

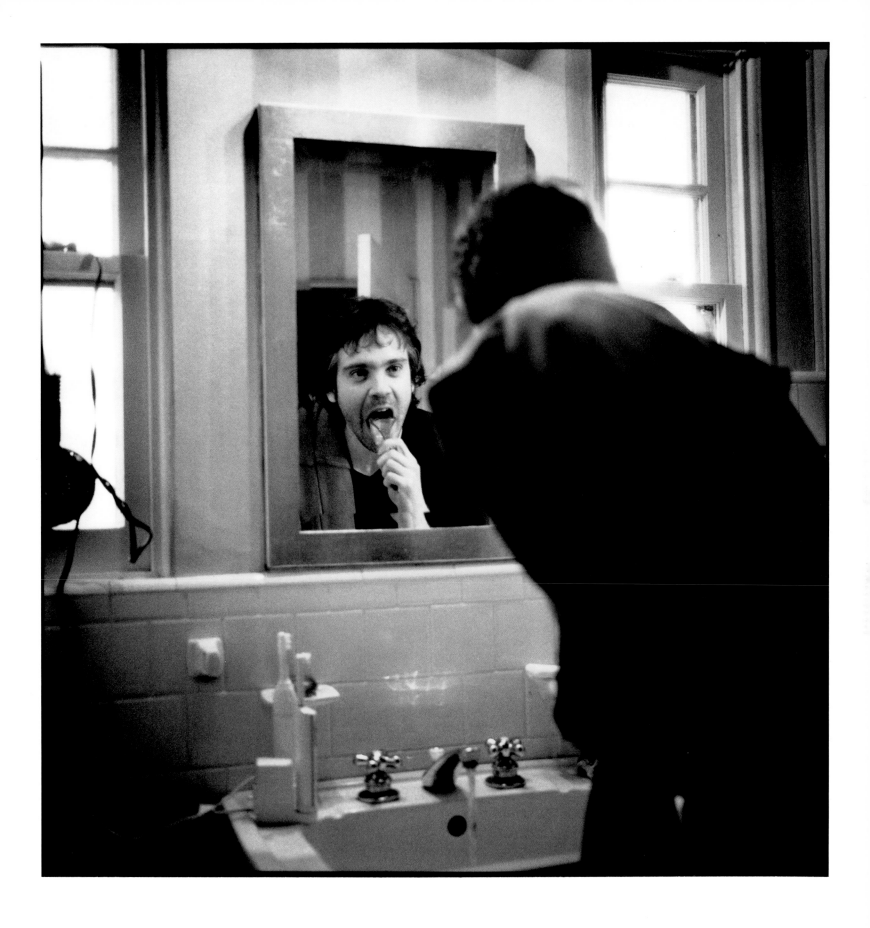

Brannon Braga 9.00 am

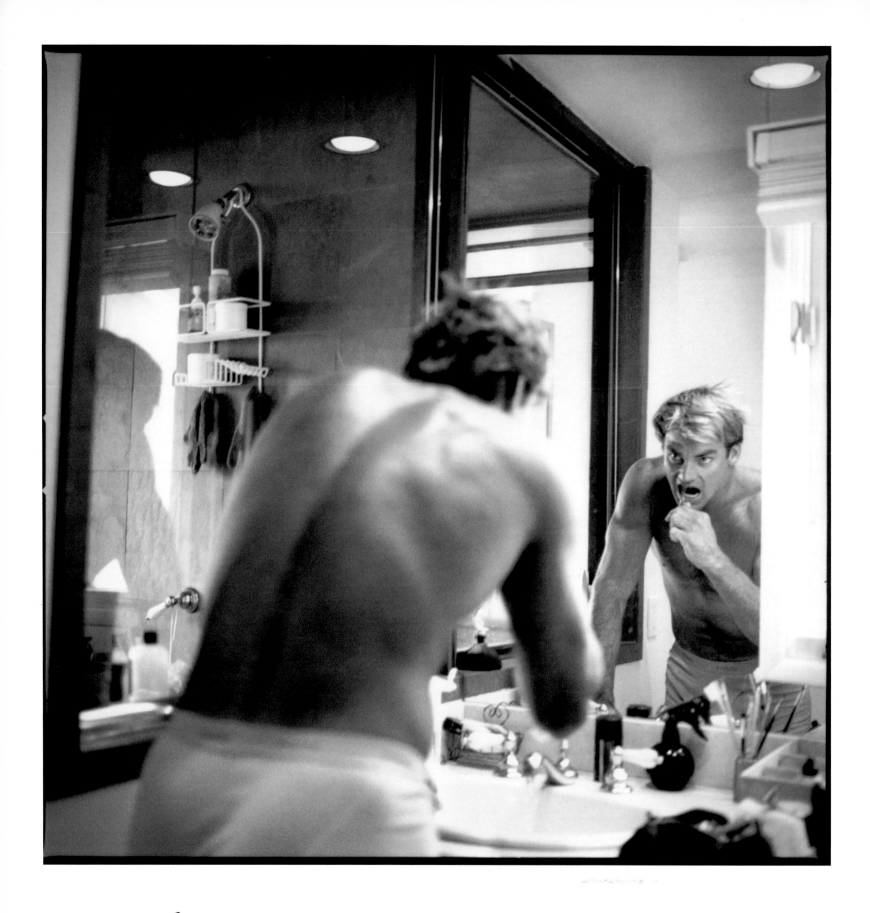

Laird Hamilton 9.04 am

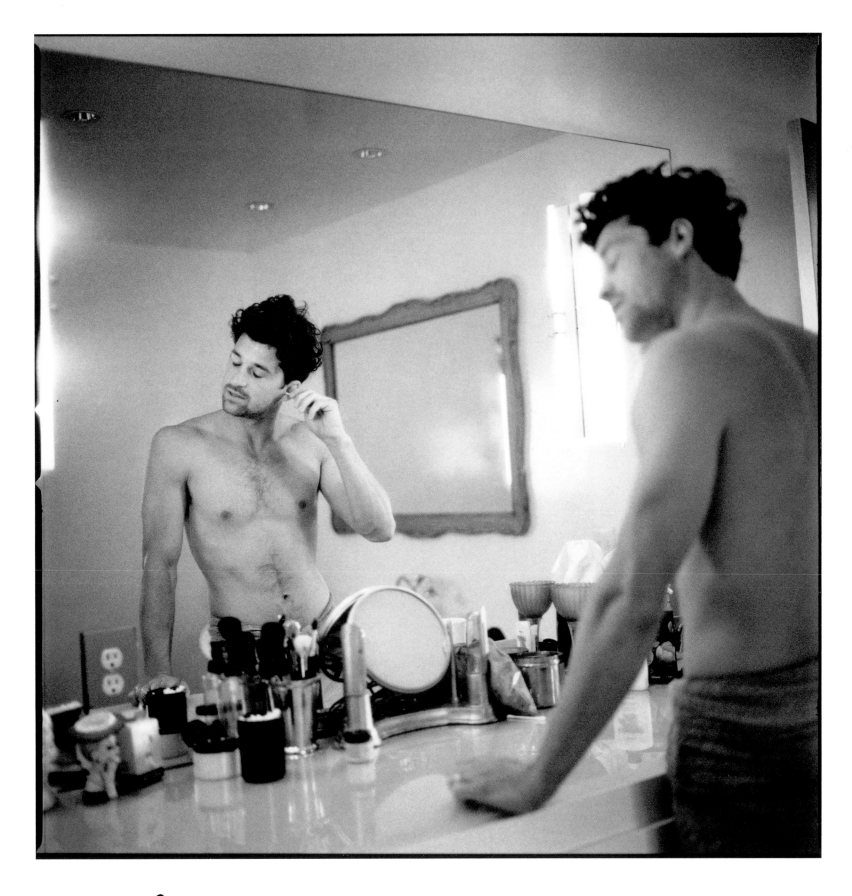

Patrick Dempsey 7.00 am

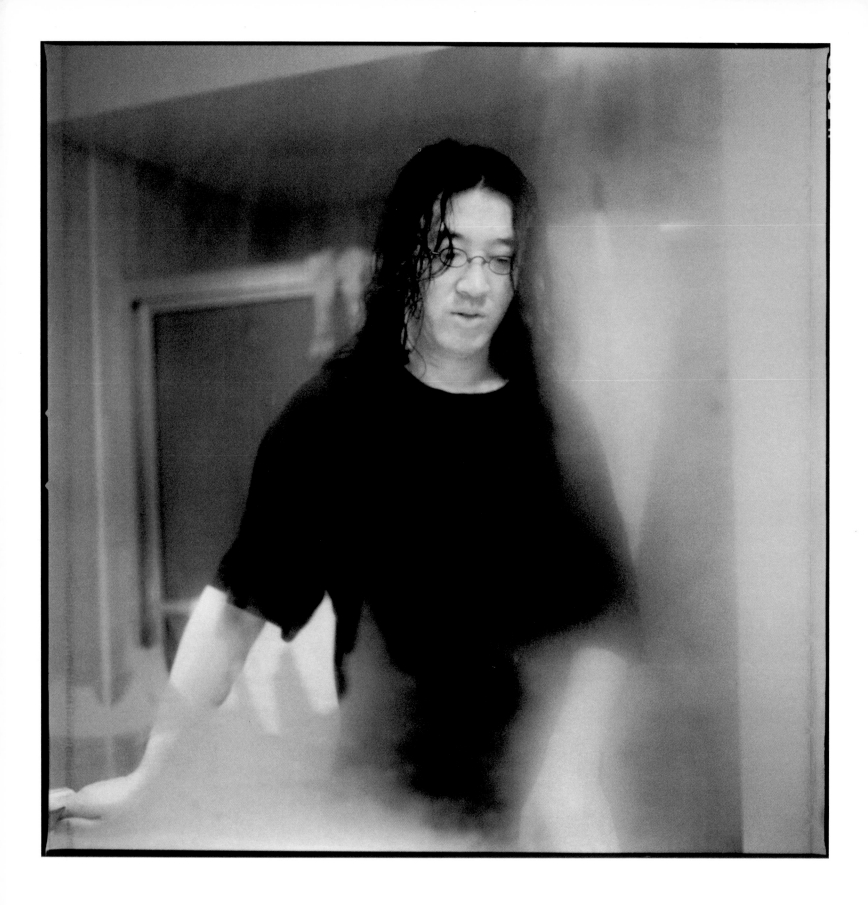

Bei Ling 8.15 am

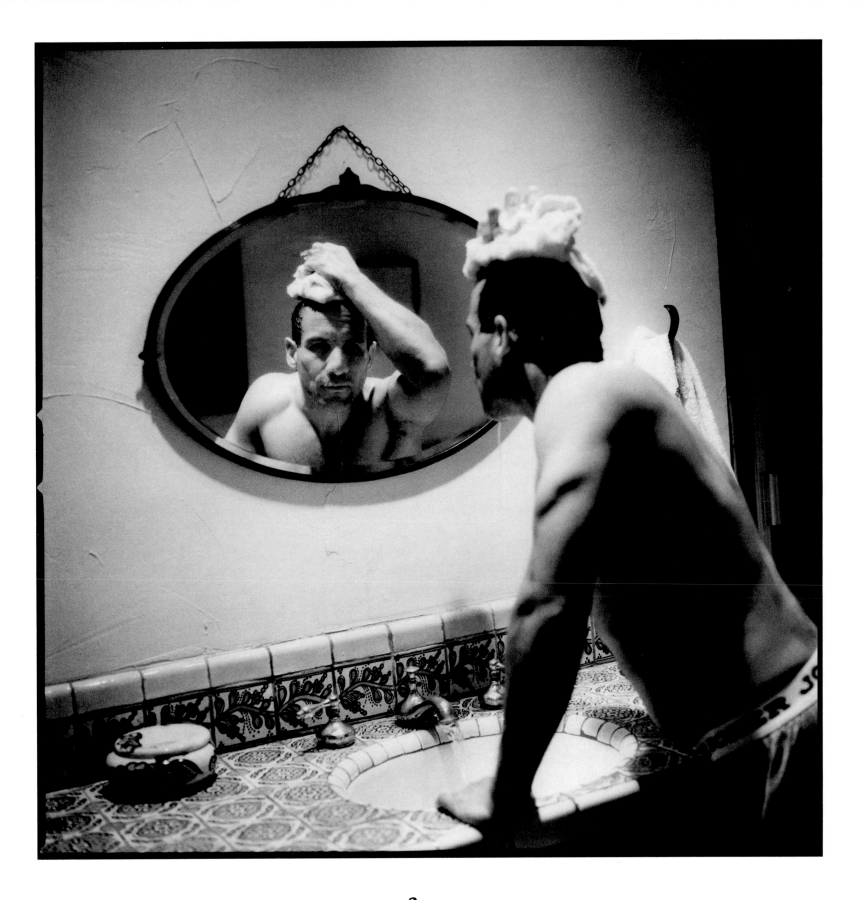

Paul Ben Victor 9,01am

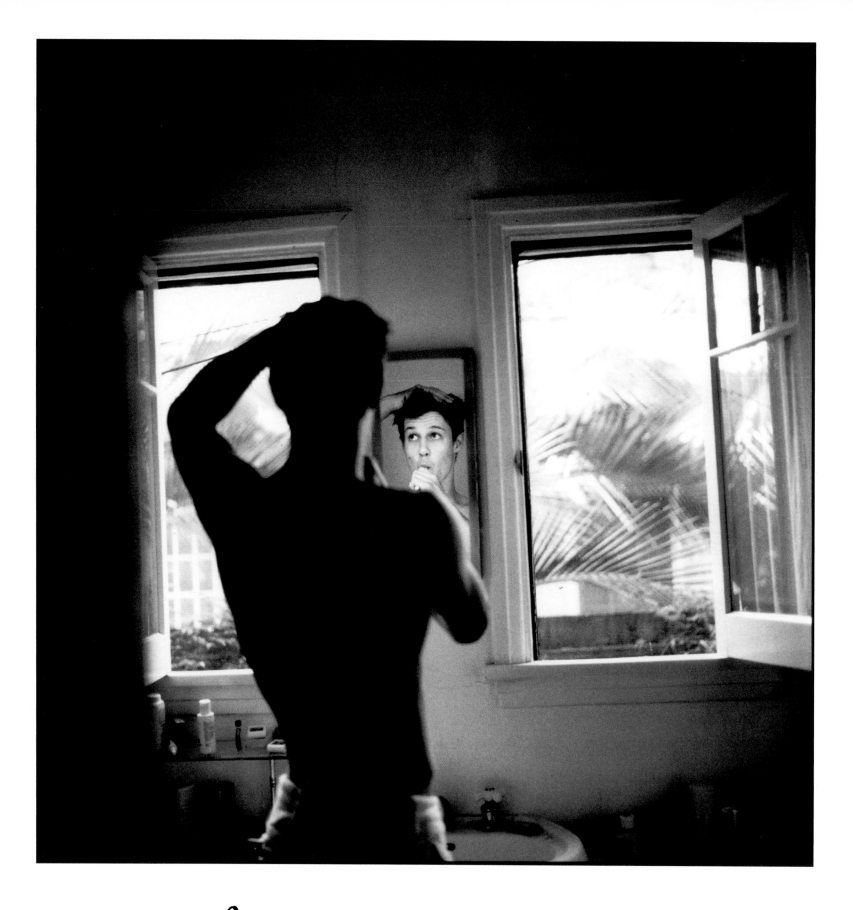

Will Estes 9.46am

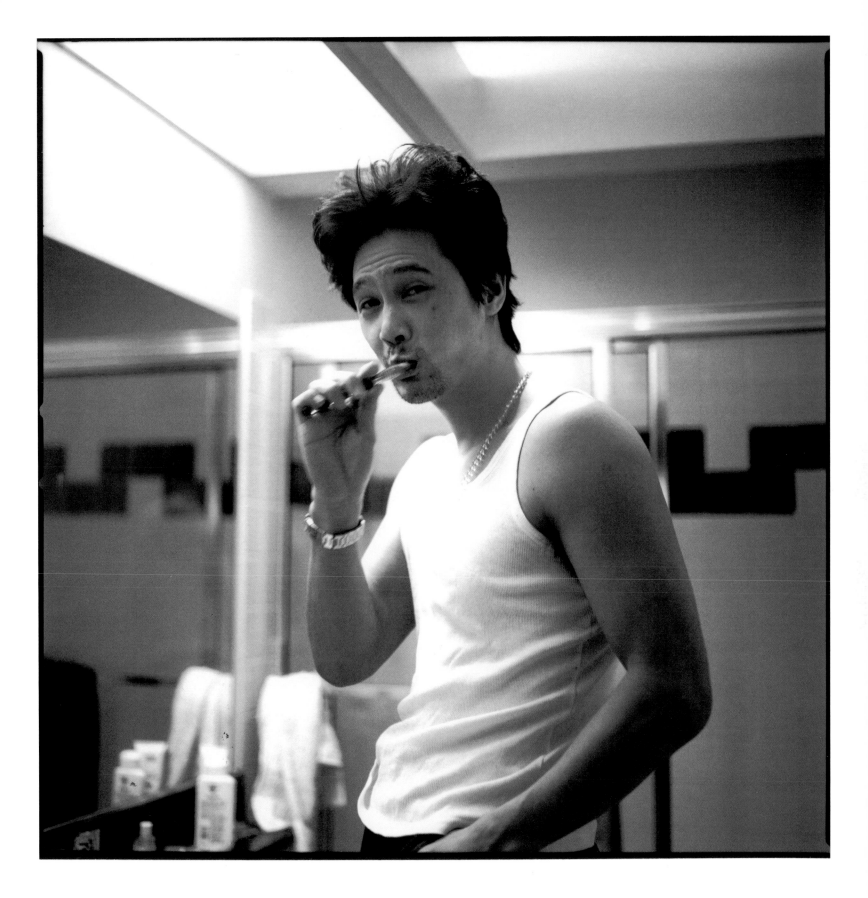

Masaya Kato 8.47 am

Seymour opened the door,
asking me to wait
while he put his lenses on
... I stuck my camera
through the door, hoping
I would get something,
despite the darkness of the room !!!

Seymour Cassel 9.00 am

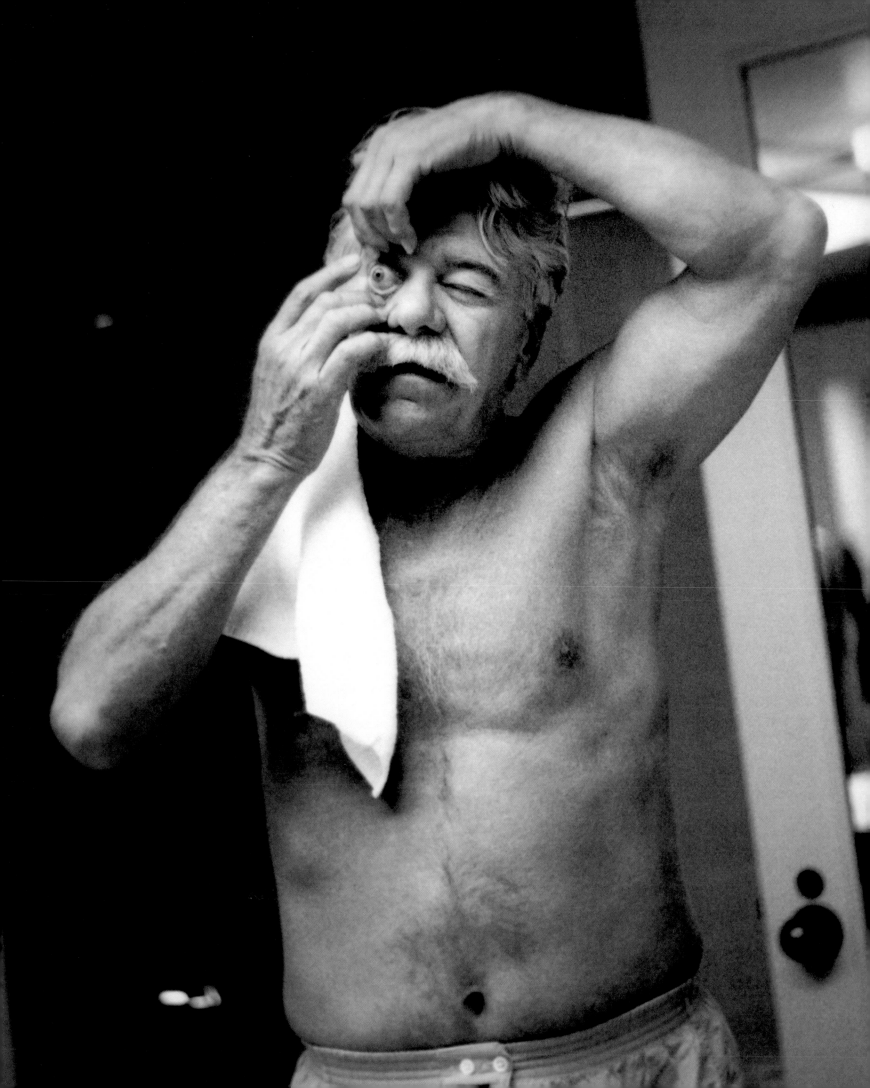

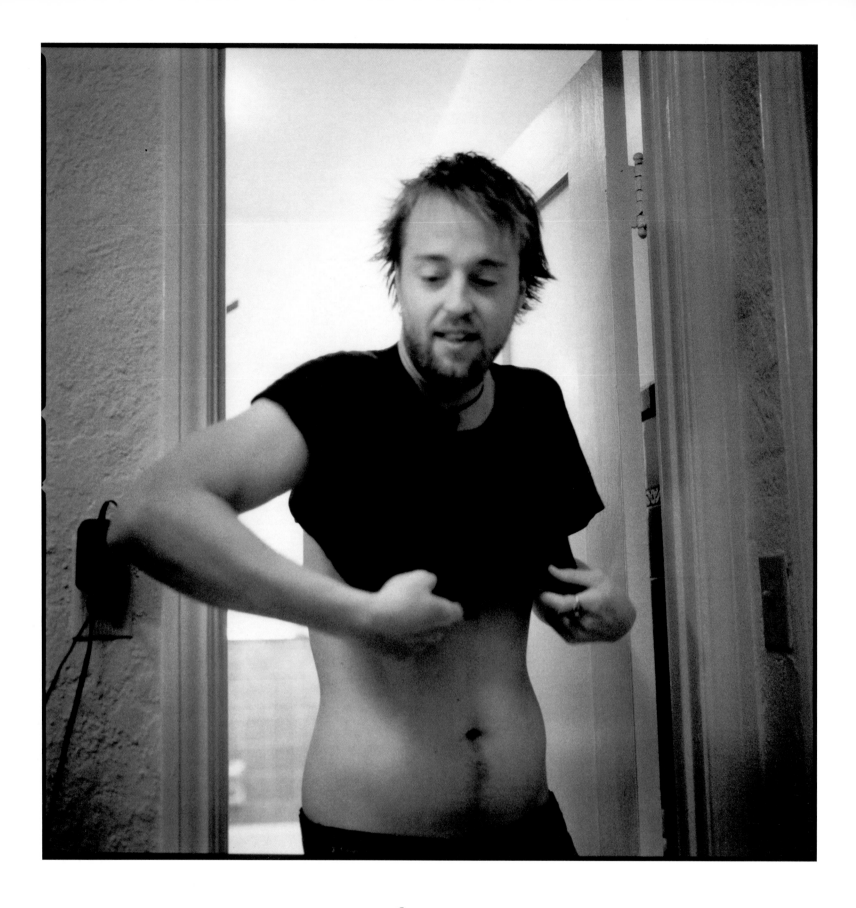

Joshua Leonard 9.32am

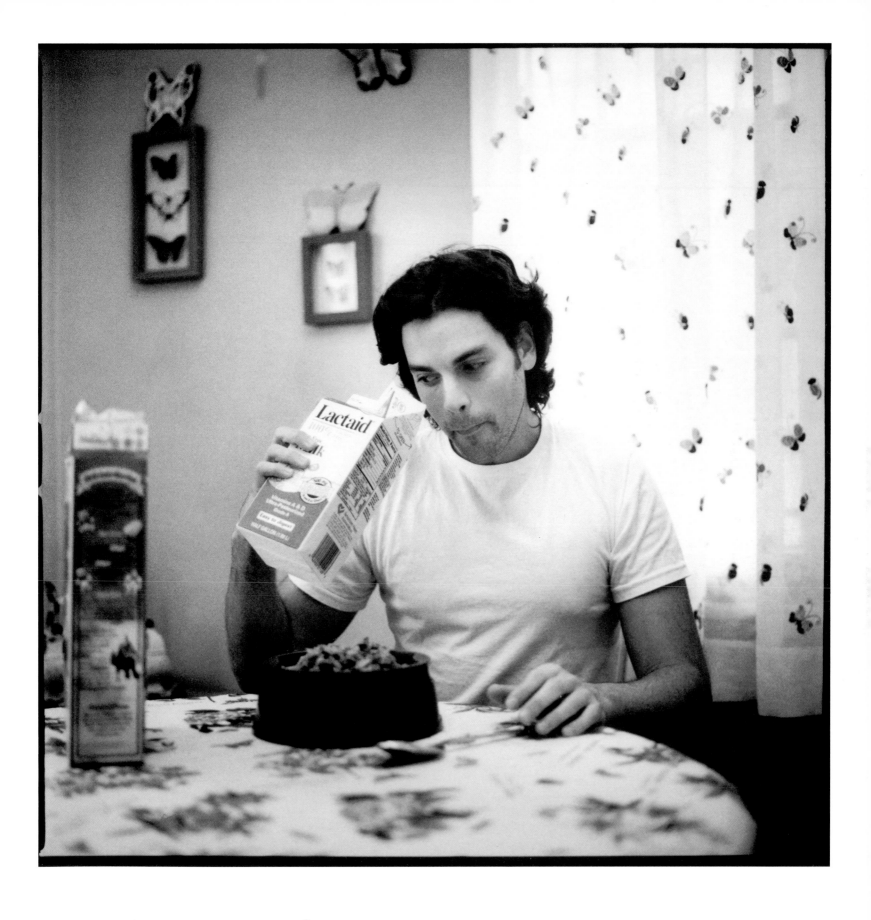

Jaron lowenstein 9.03 am

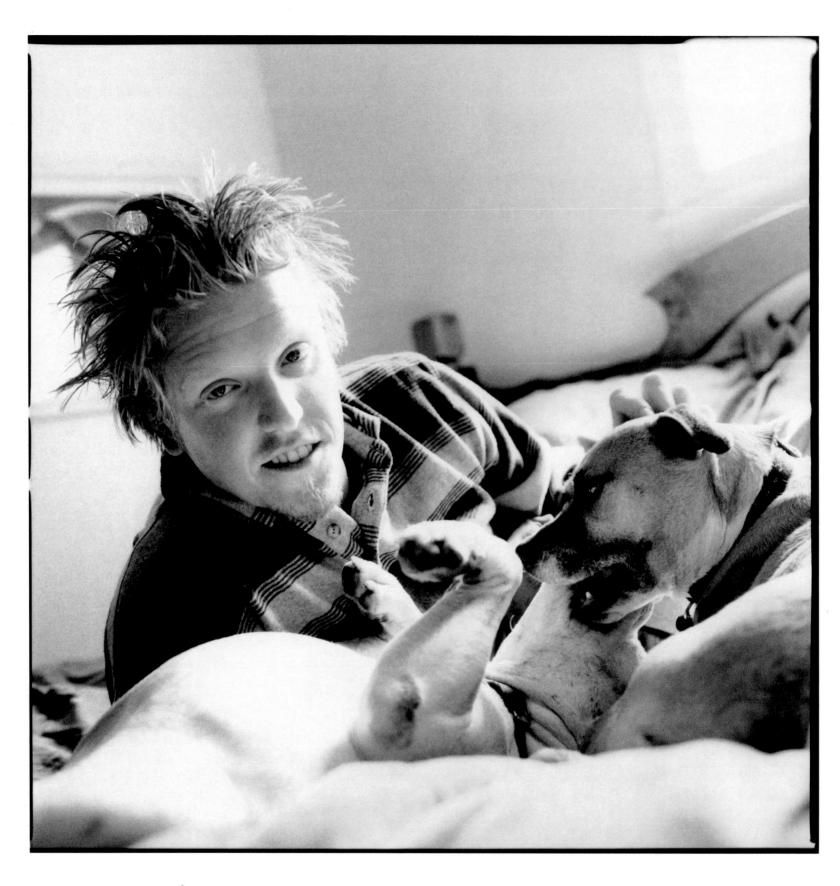

Jake Busey 9.29 am

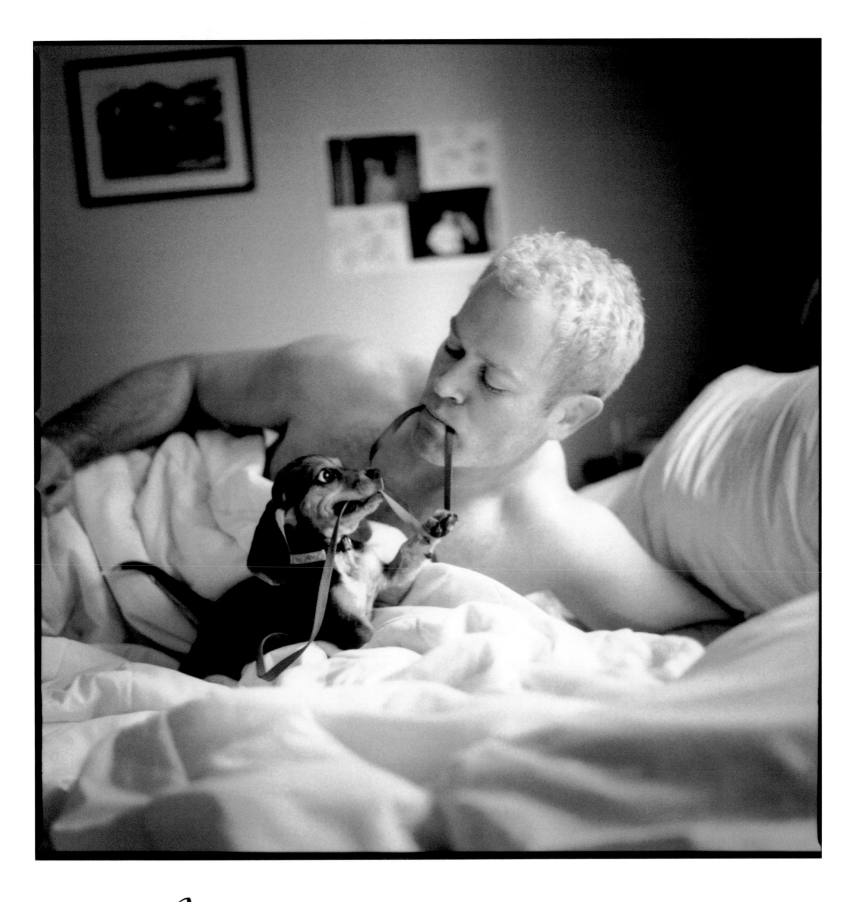

Neal McDonough 9.00 am

Seth has a charming bed,
two great dogs, and
a beautiful woman by his side
... he had no reason to get up!

Seth Green 8.29 am

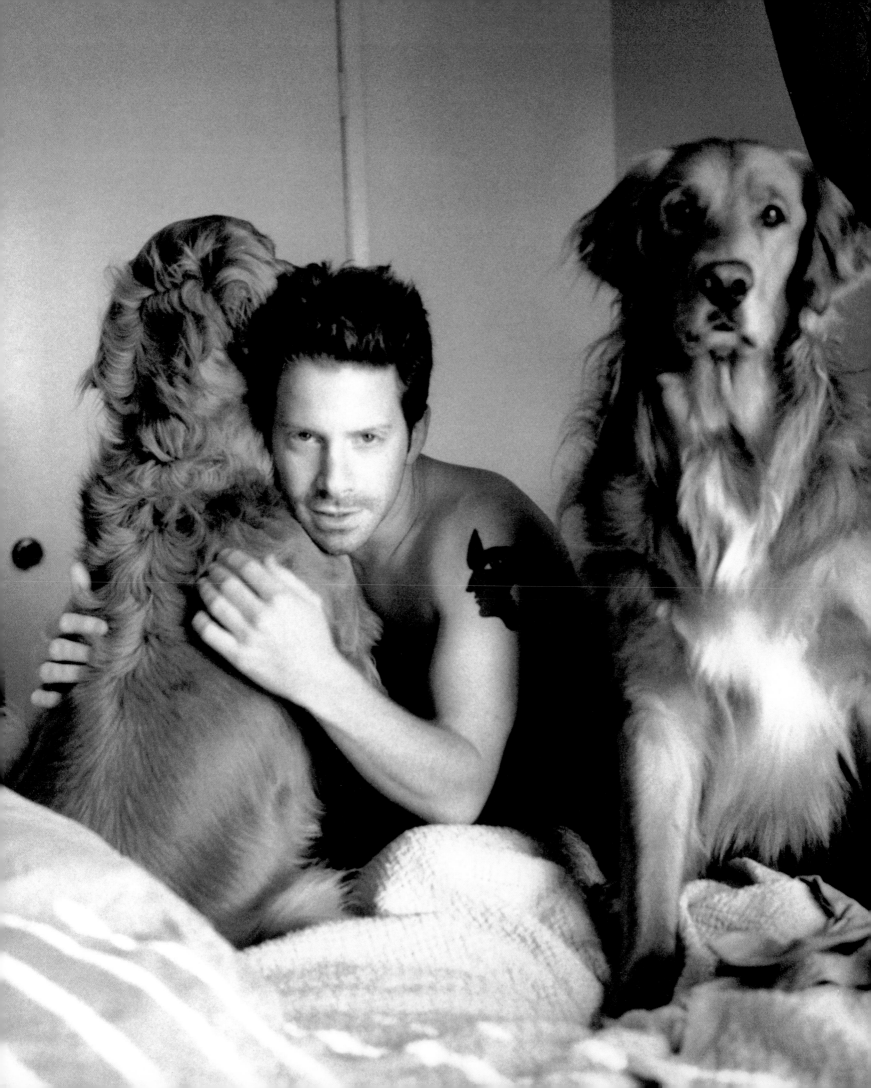

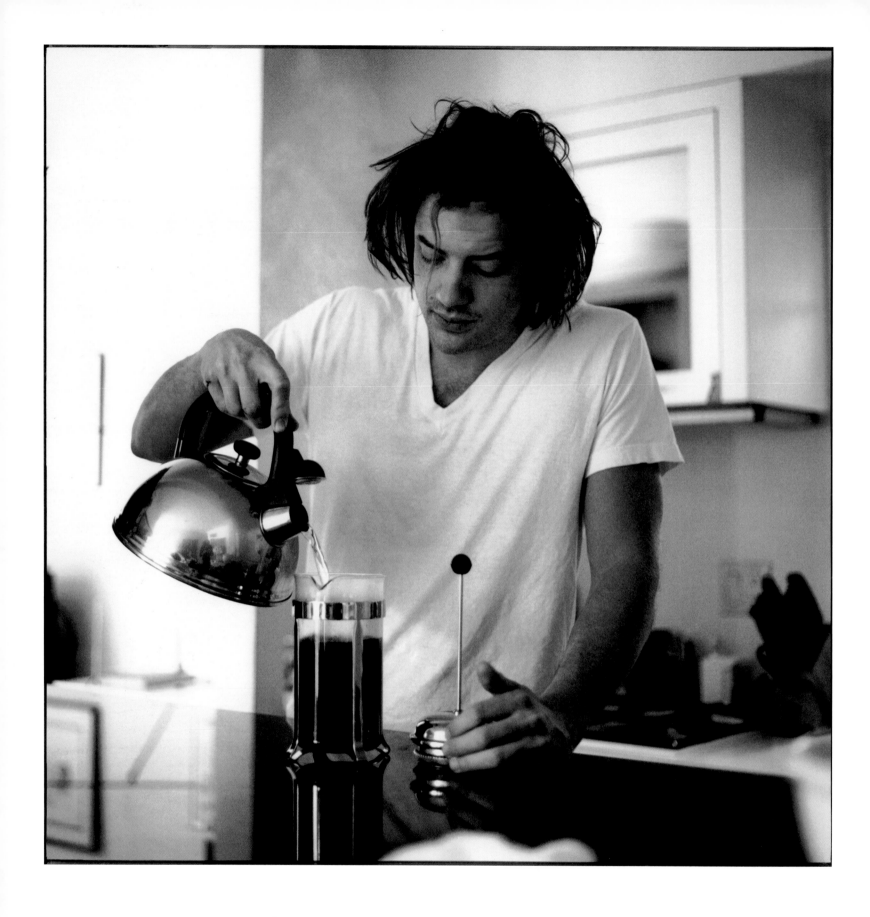

Brendan Fraser 8.08am

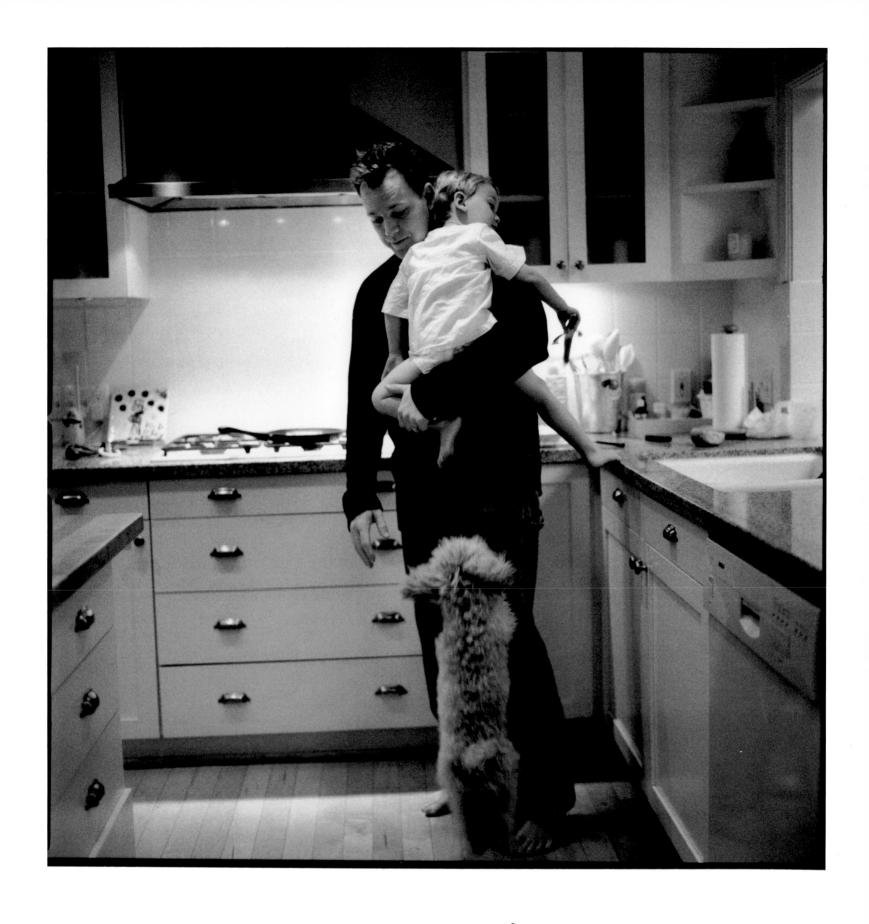

Robert Duncan McNeill 8.19 am

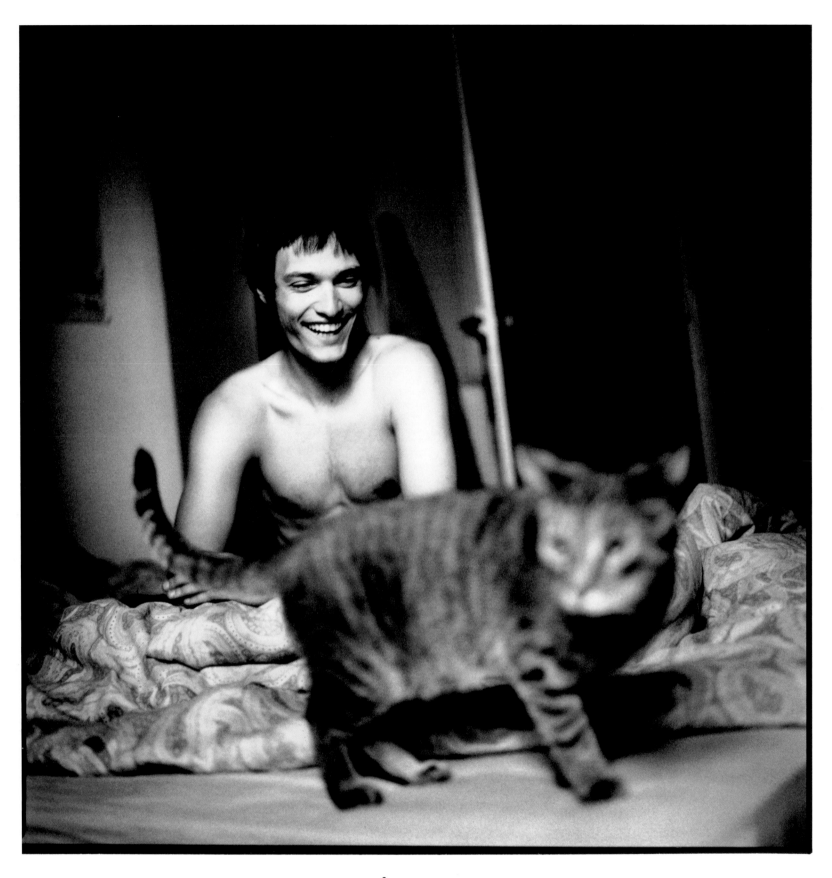

Vincent Martinez 9.23am

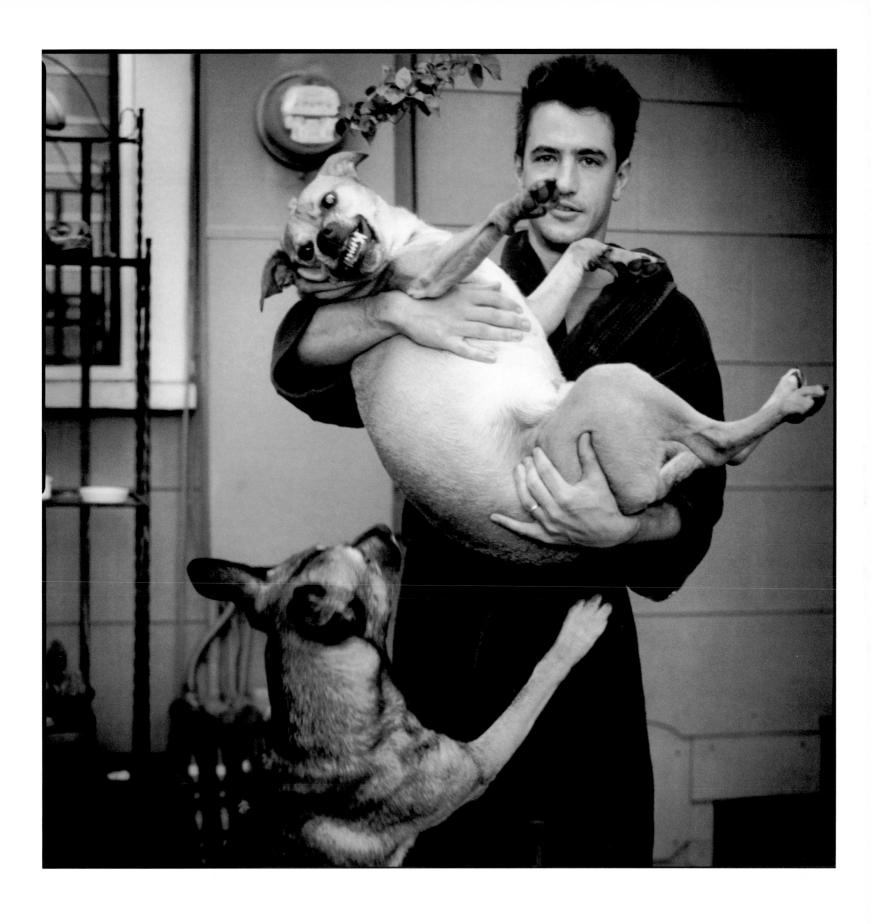

Dermot Mulroney 8.05 am

Griffin is extremely funny,
smart and interesting...
but the little dog stole the show !!!

Griffin Dunne 8.05 am

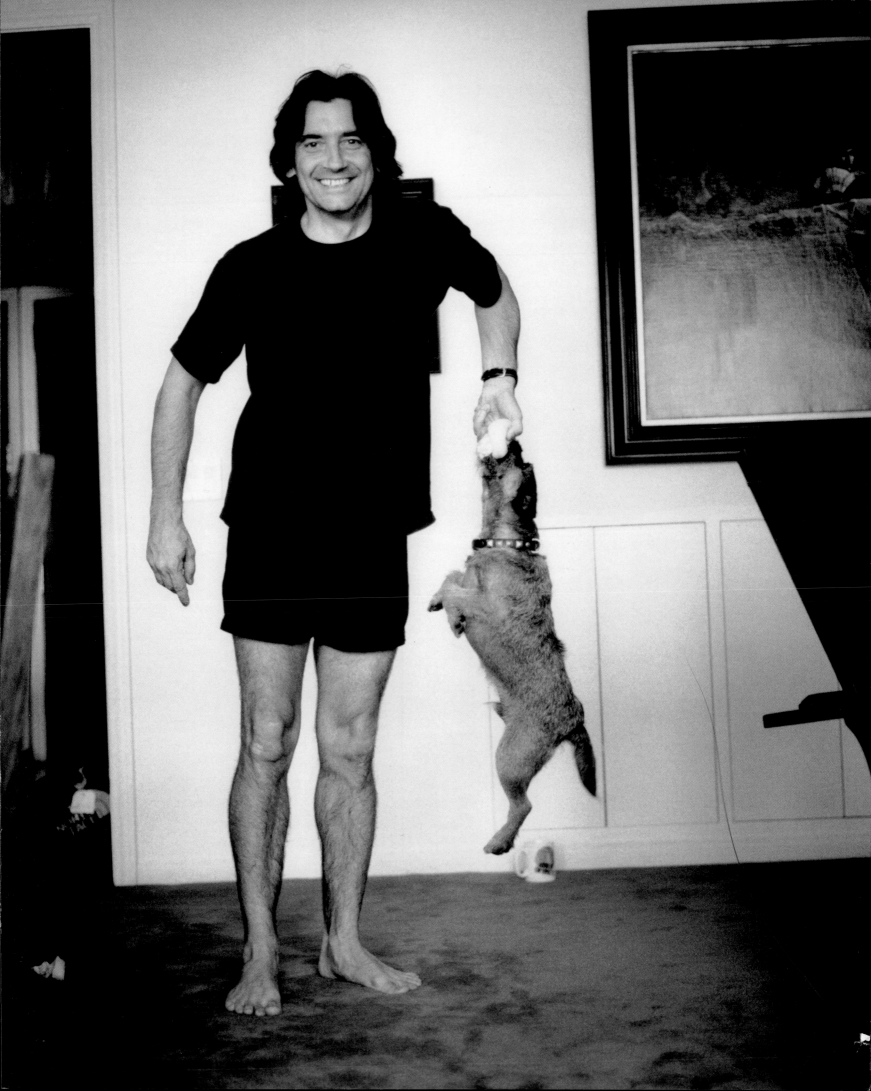

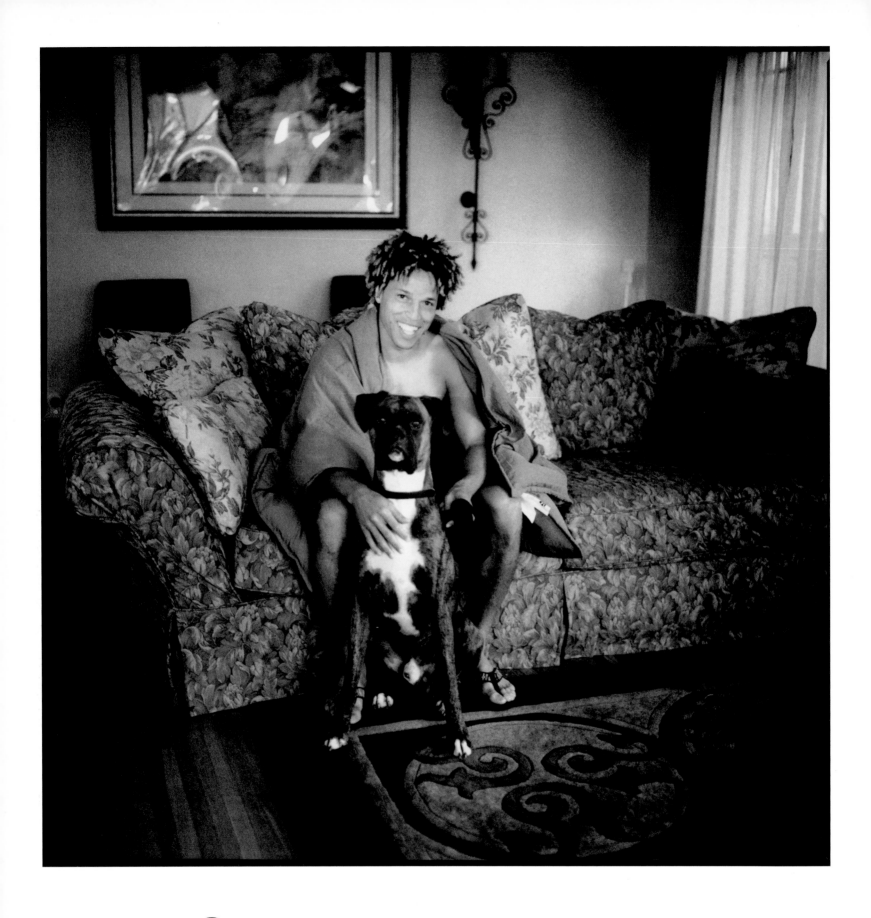

Cobi Jones 8.00 am

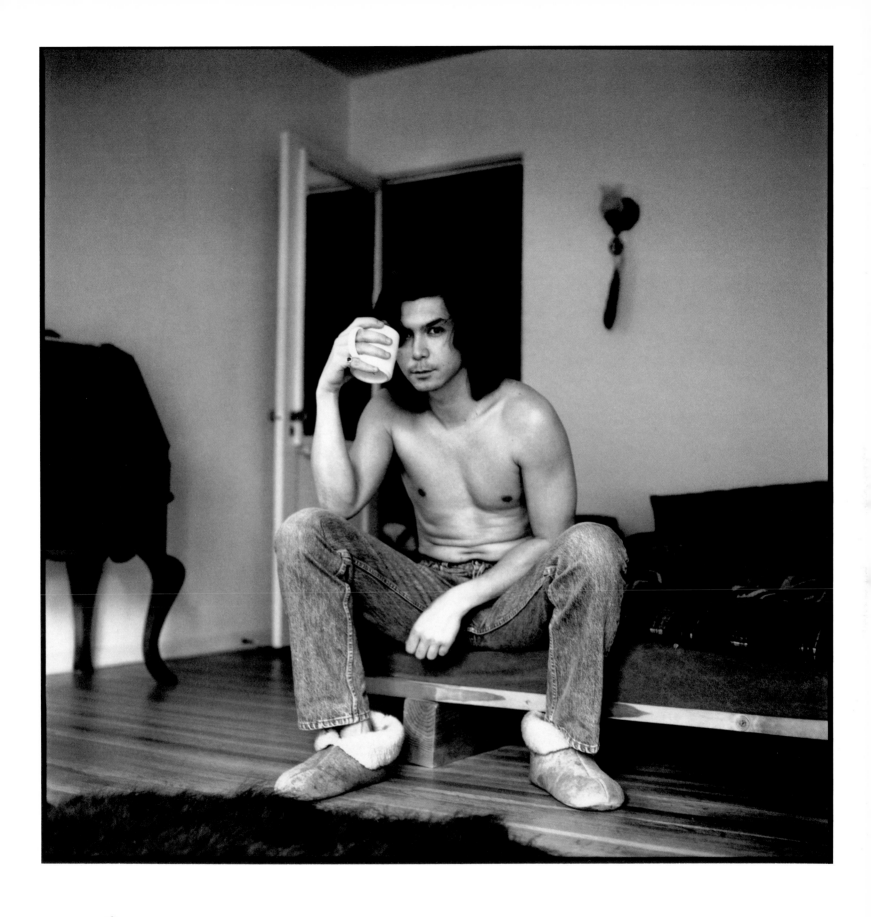

Lou Diamond Phillips 7.35 am

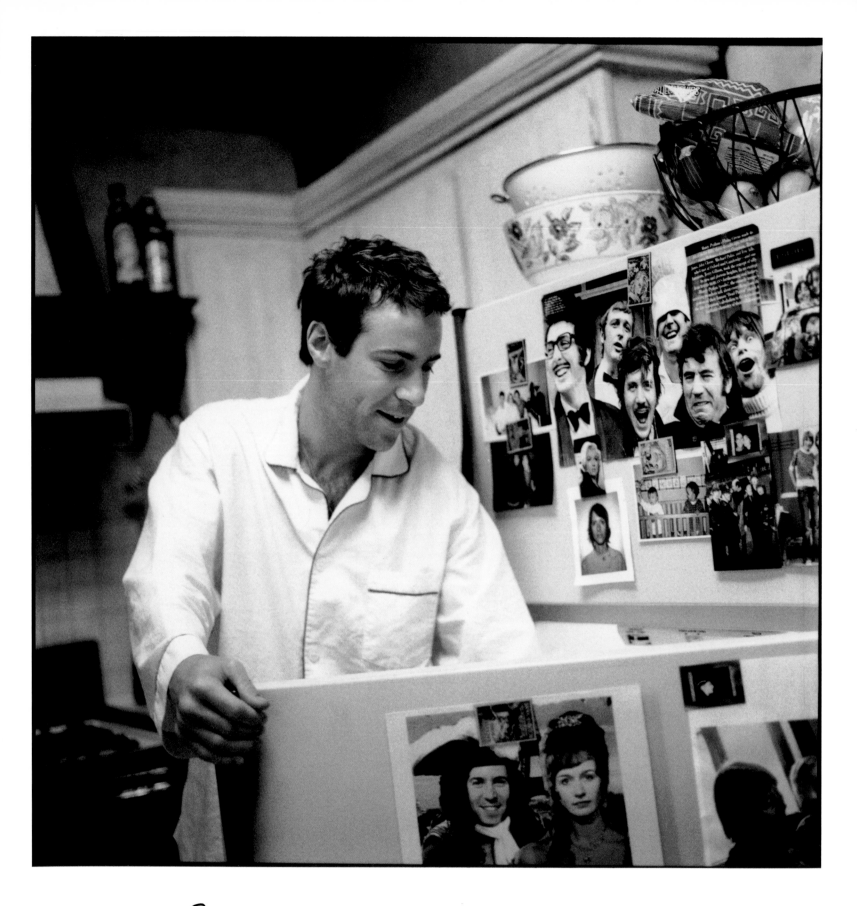

Alessandro Nivola 7.29 am

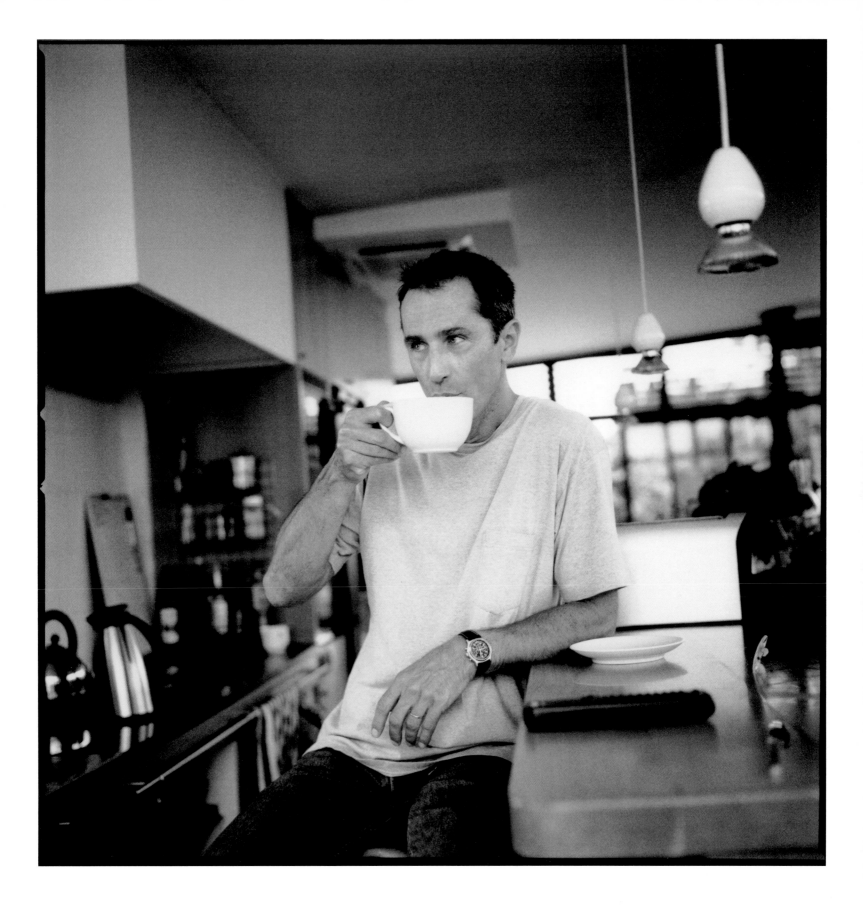

Thierry Lhermitte 8.45 am

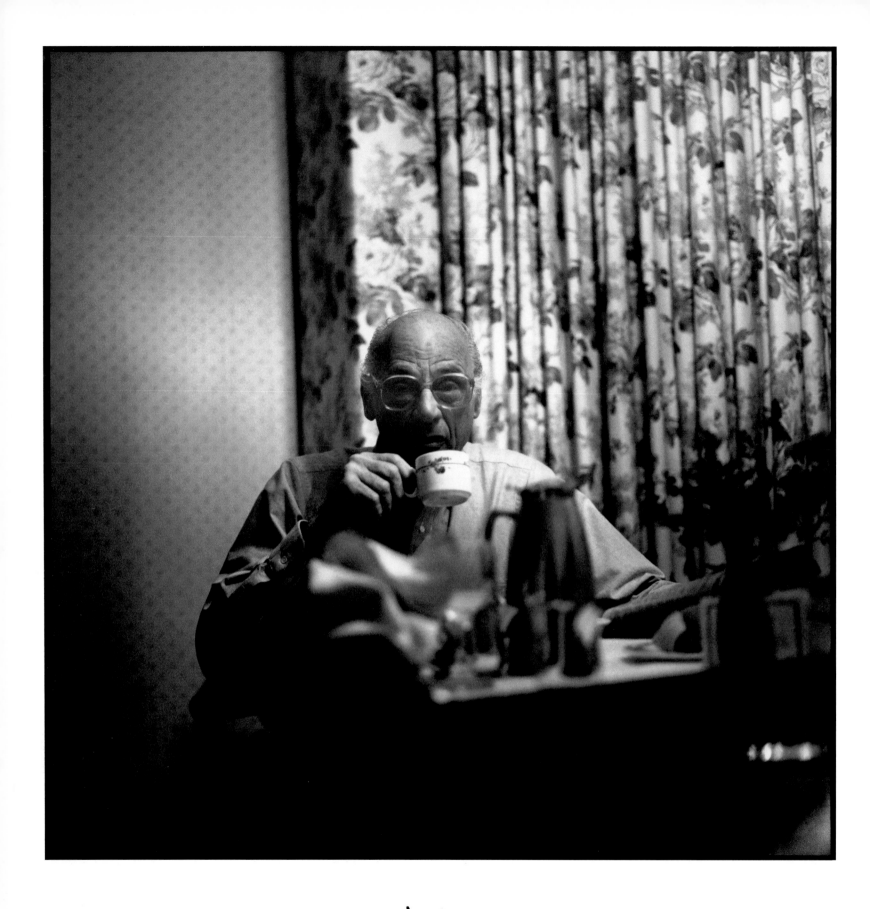

Arthur Miller 4:35 am

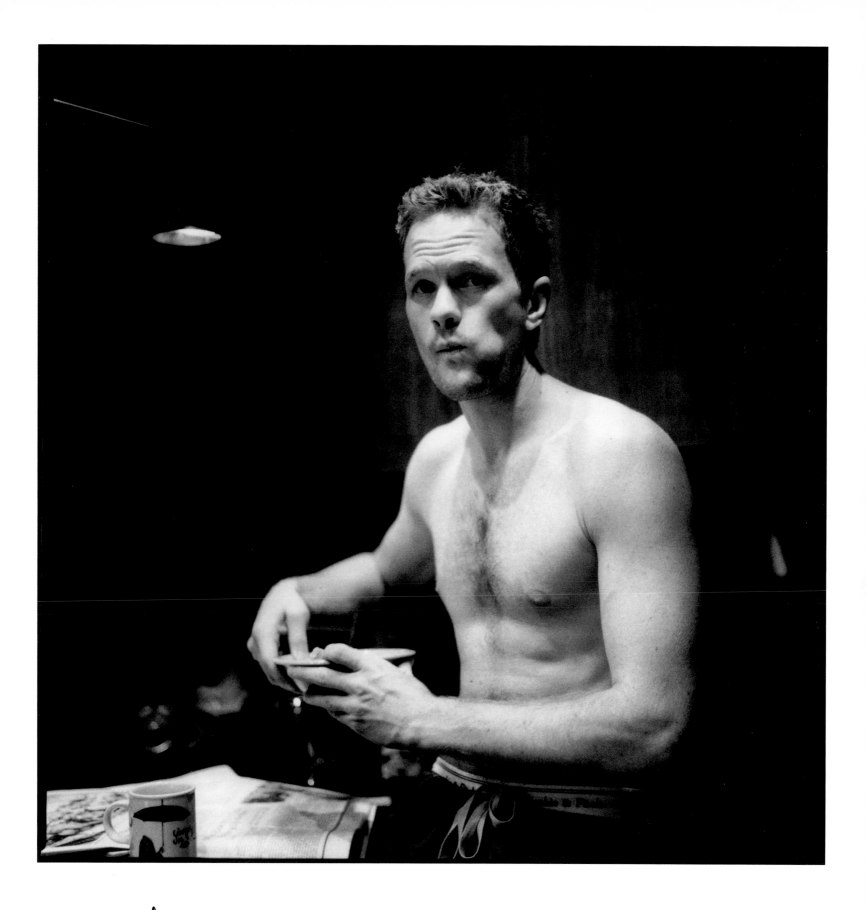

Neil Patrick Harris 8.00 am

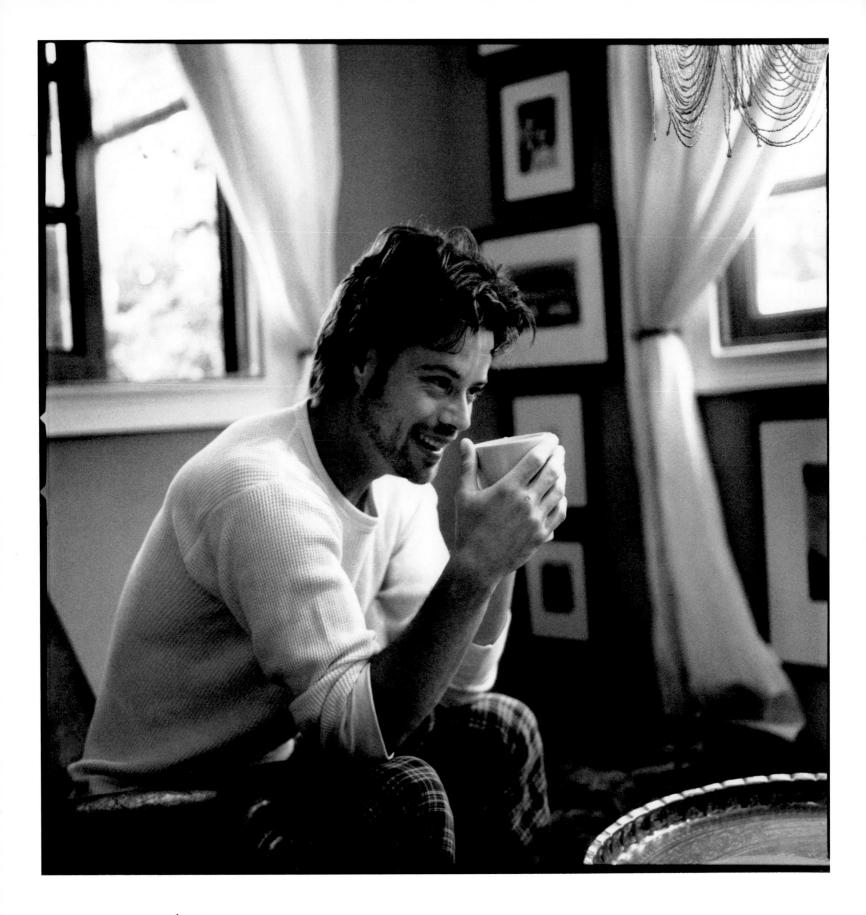

Brad Rowe 8.59am

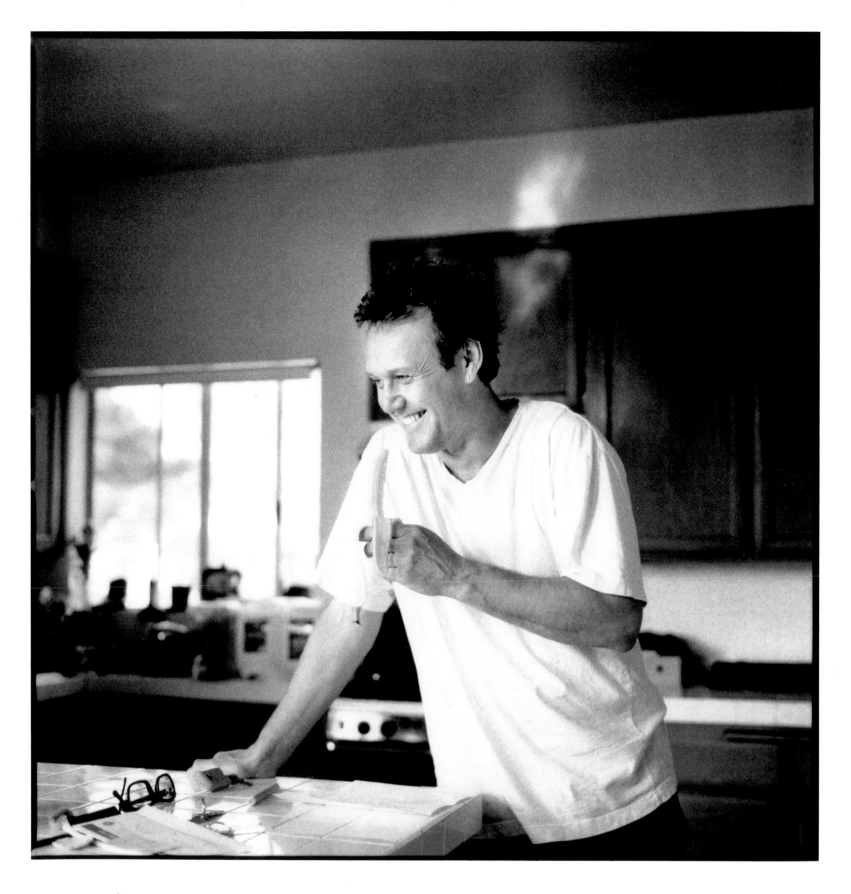

Anthony Stewart Head 8.33am

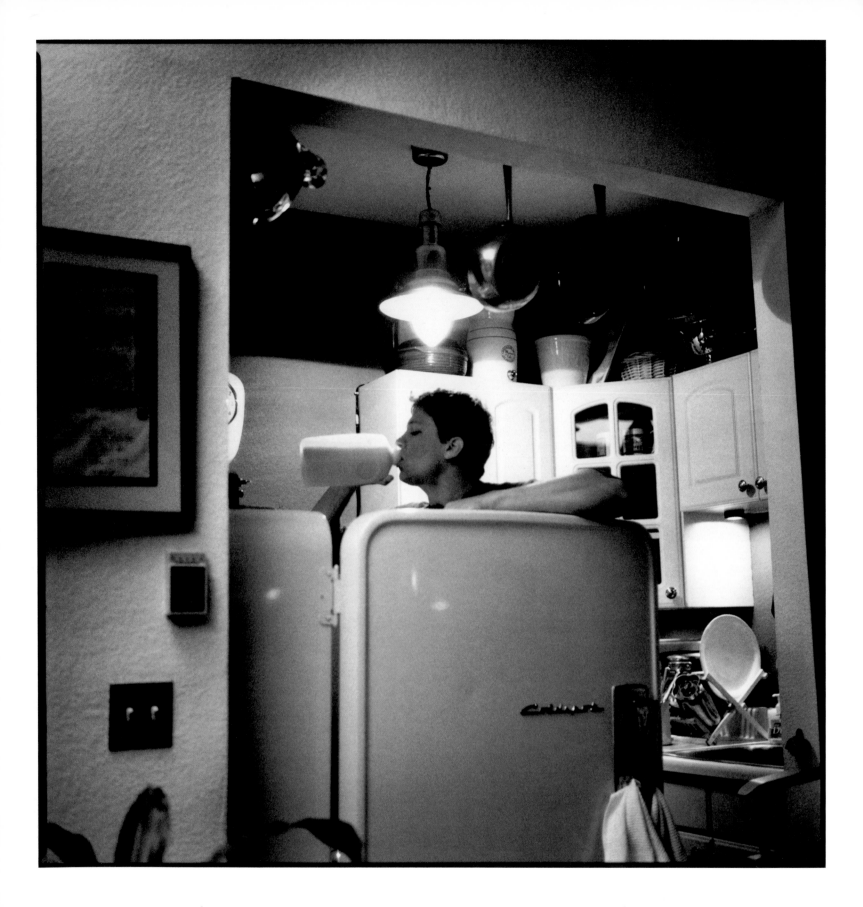

Marc Blucas 8.05am

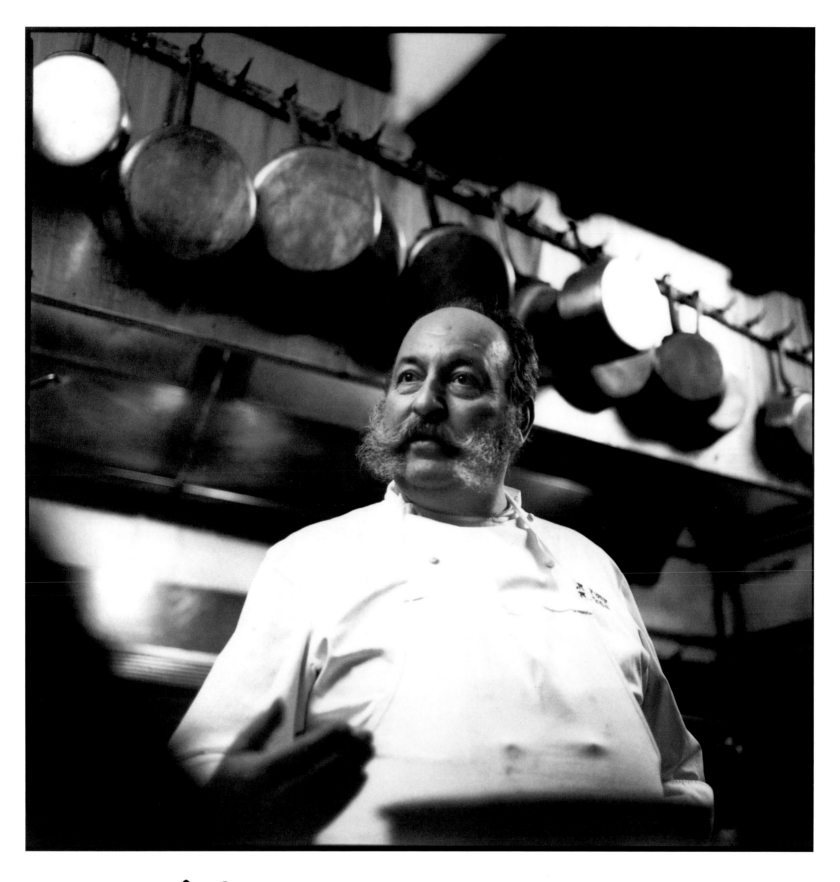

Alex Guini 9.00 am

Bruce Davidson 8.09 am

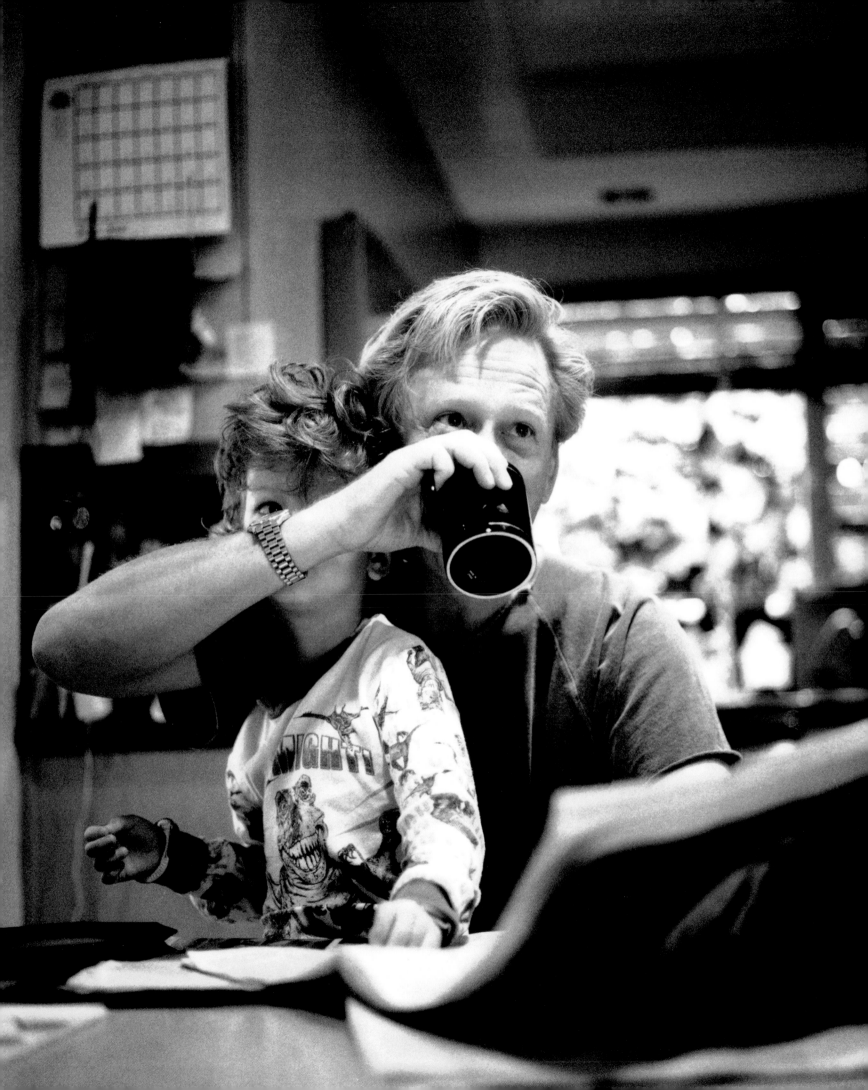

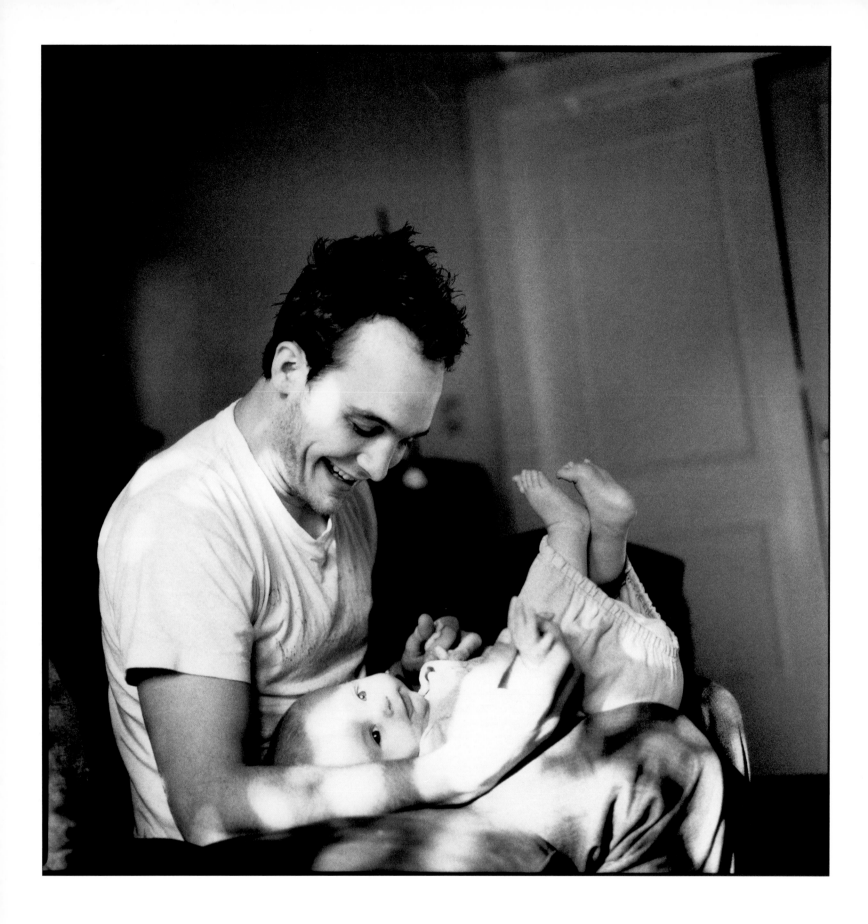

Ethan Embry 8.30 am

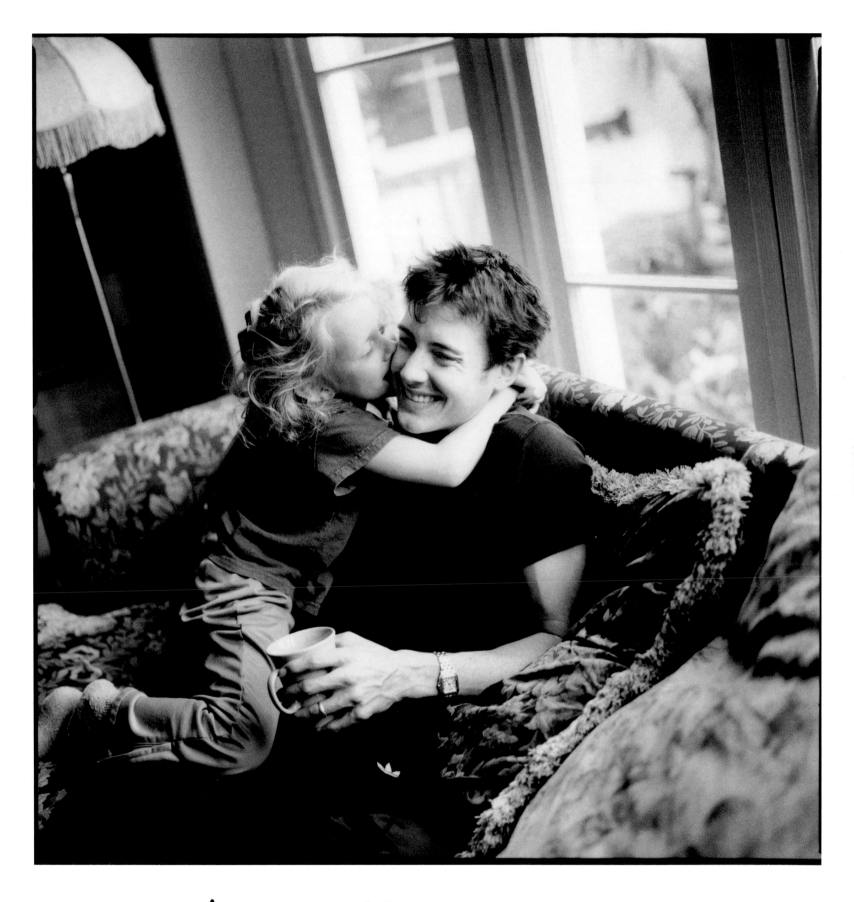

Jason London 8.37 am

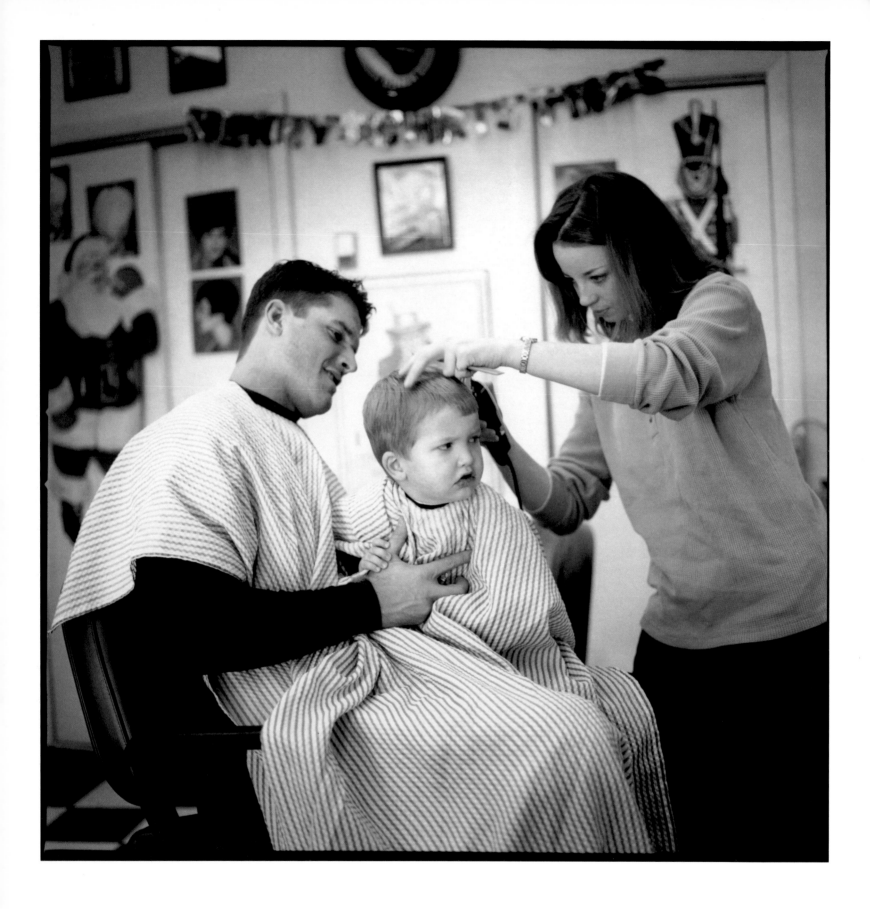

Jim Harbaugh 9.40 am

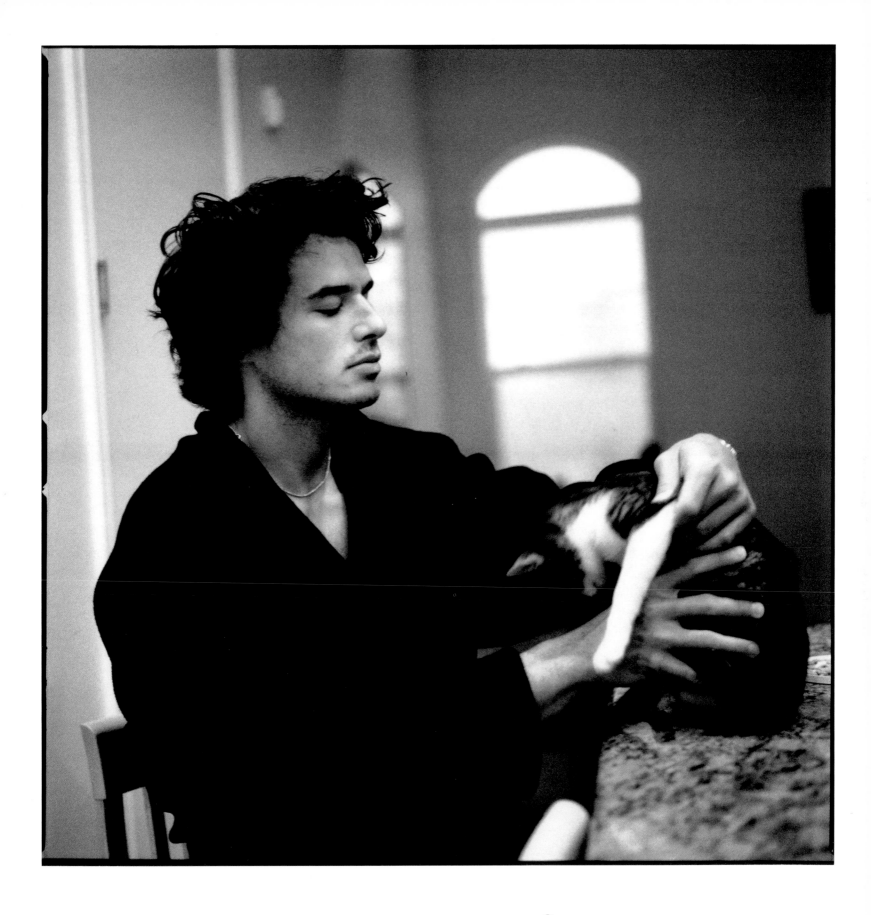

Antonio Sabato jnr 7.58am

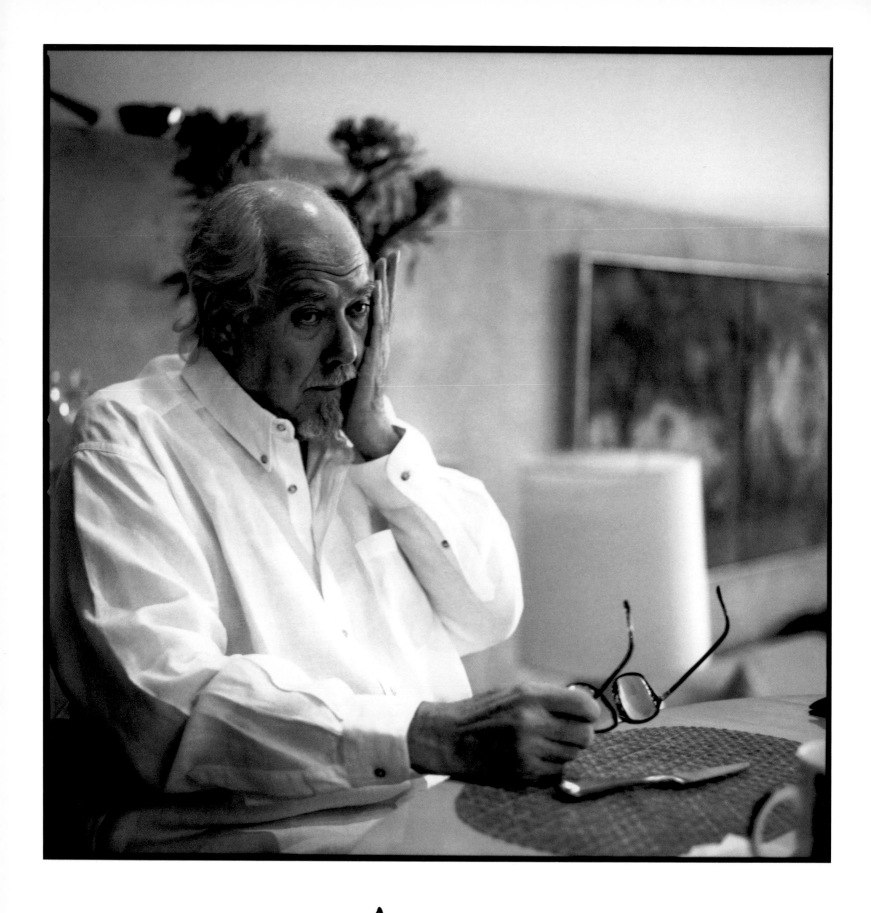

Robert Altman 8.56am

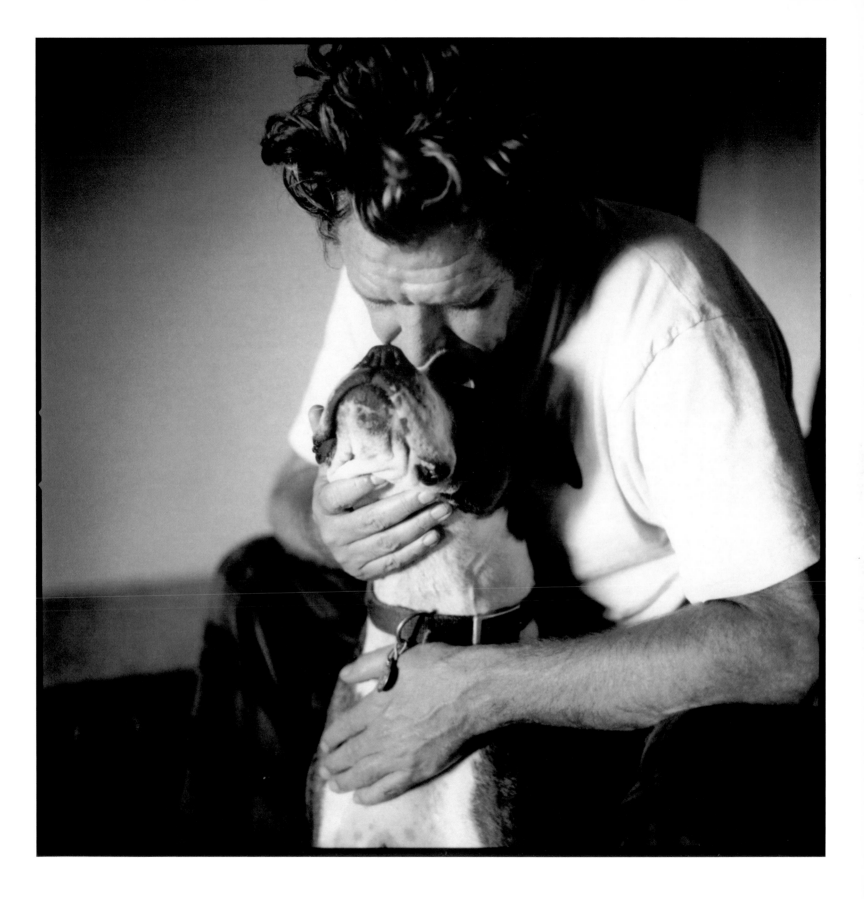

Steve Jones 9.04 am

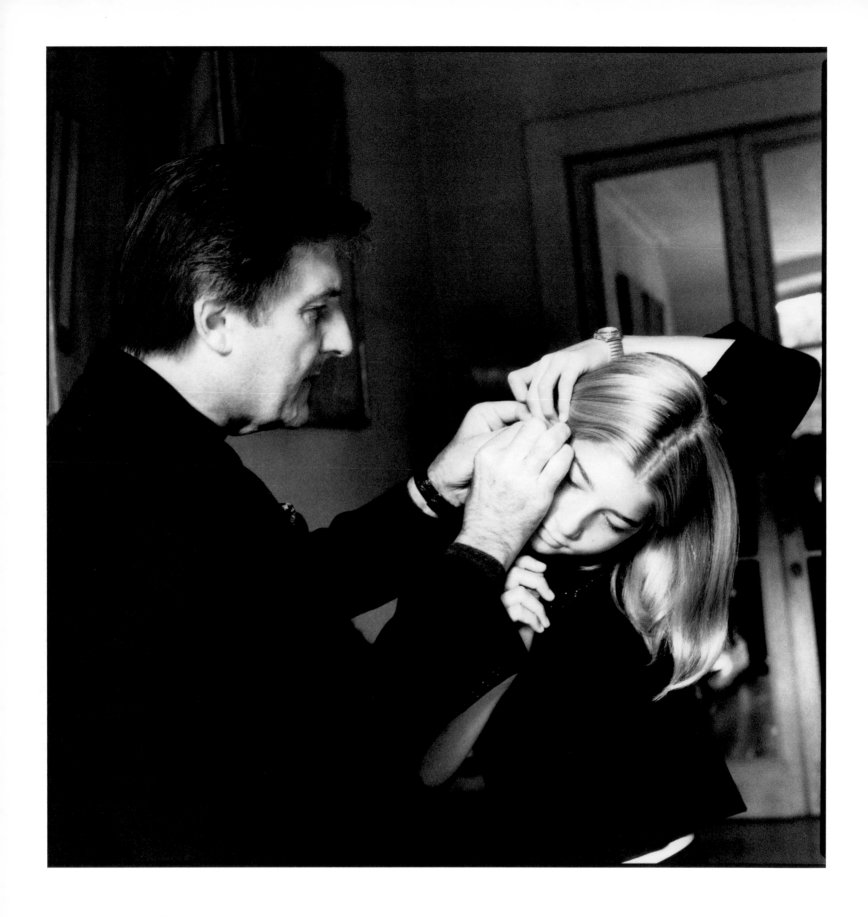

Emanuel Ungaro 8.29am

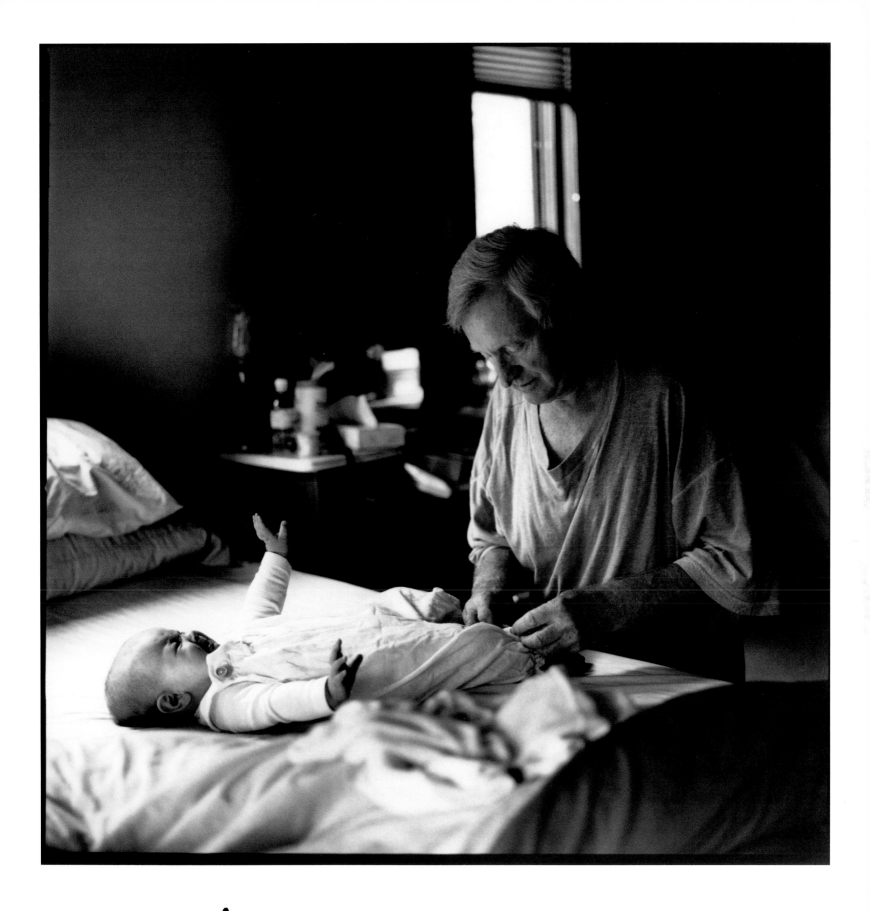

John Boorman 9.07am

Tim Roth 7-36 am

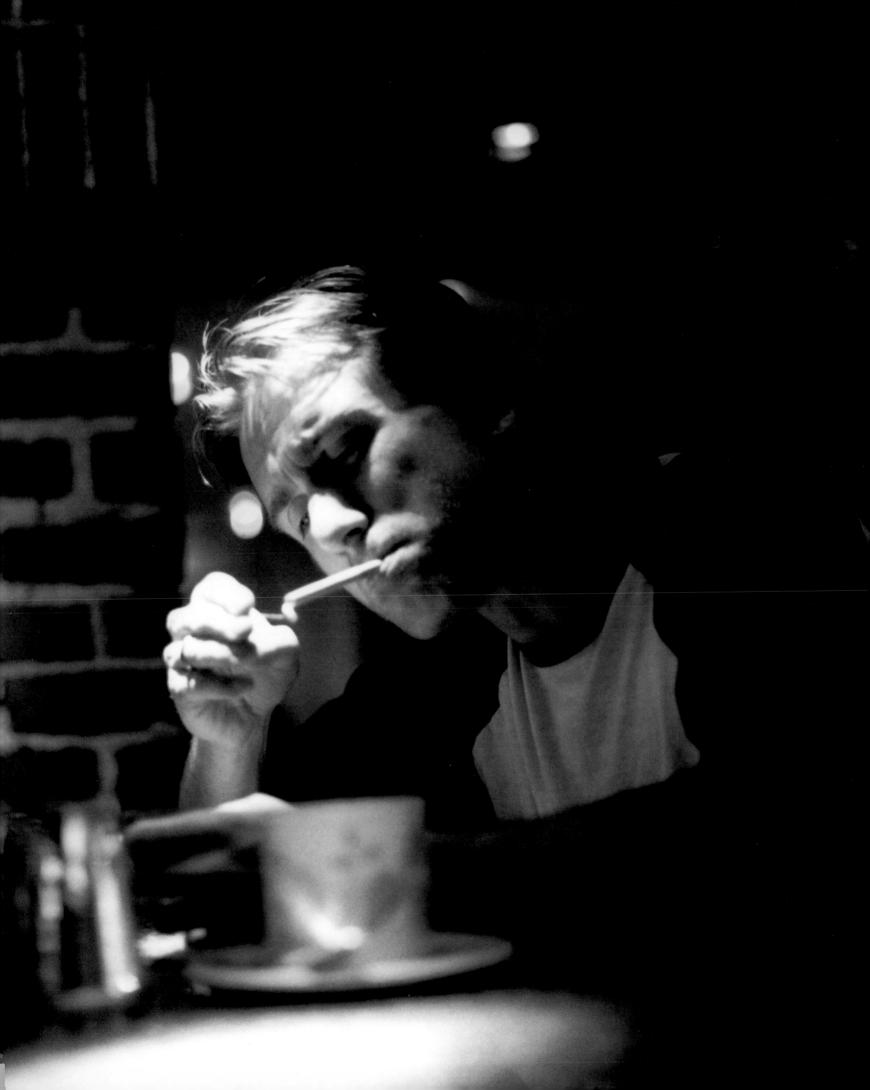

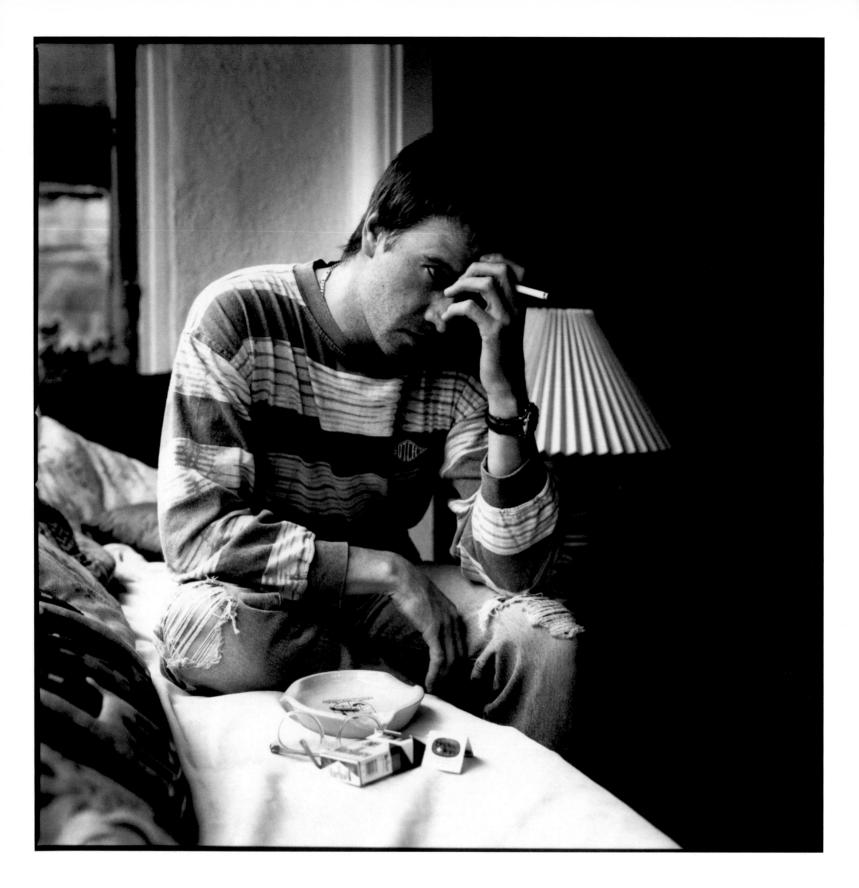

Christophe Lambert 9.15 am

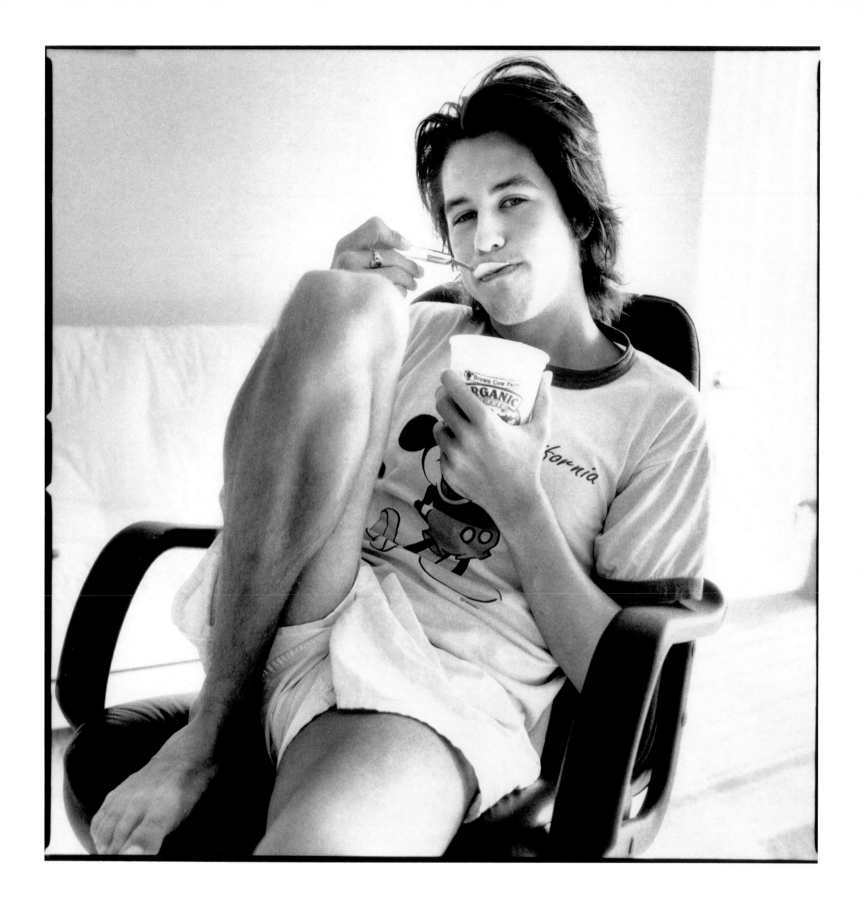

Kavana 9.03am

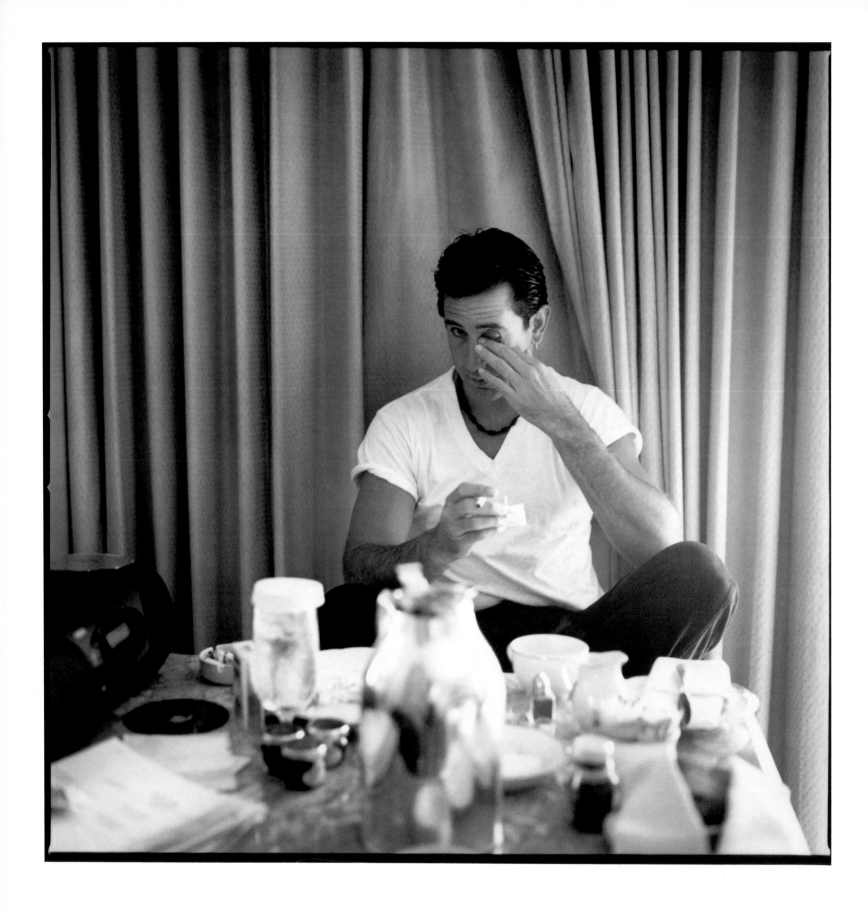

Anthony Lapaglia 9.01am

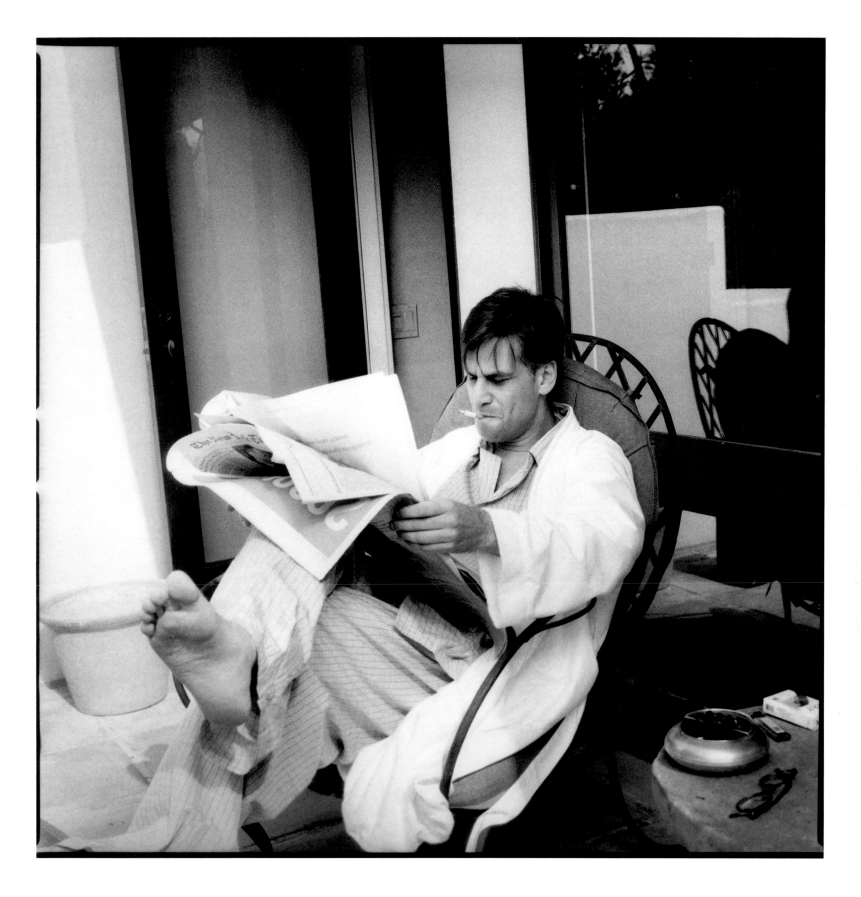

Aaron Sorkin 8:59 am

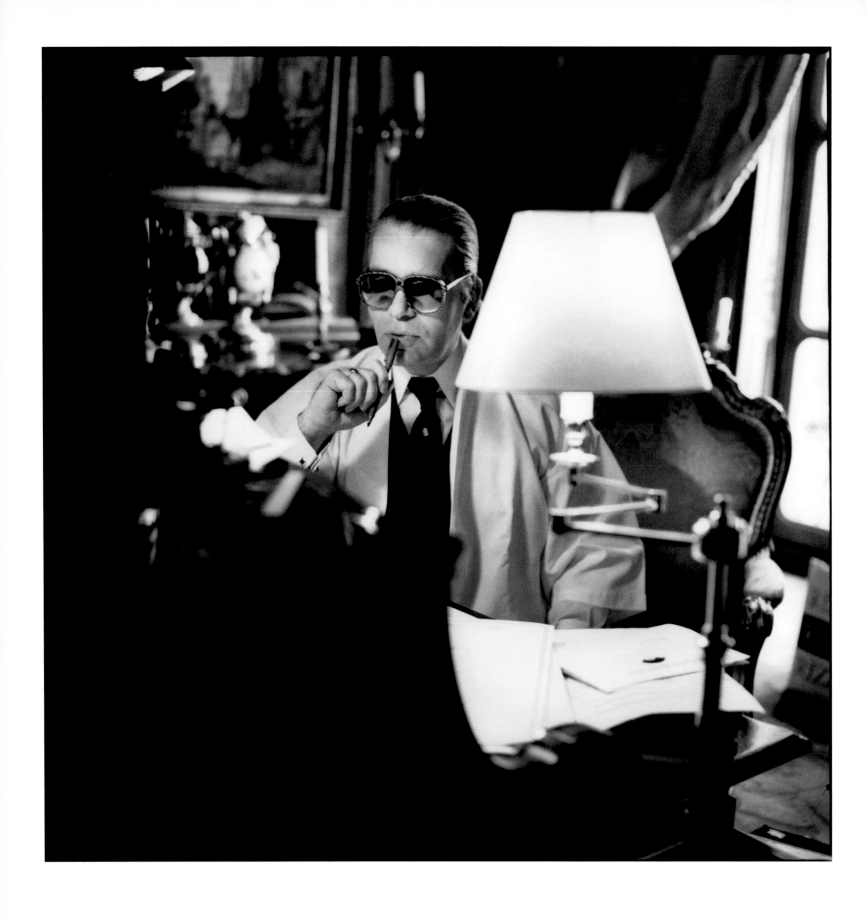

Karl Lagerfeld 9.01 am

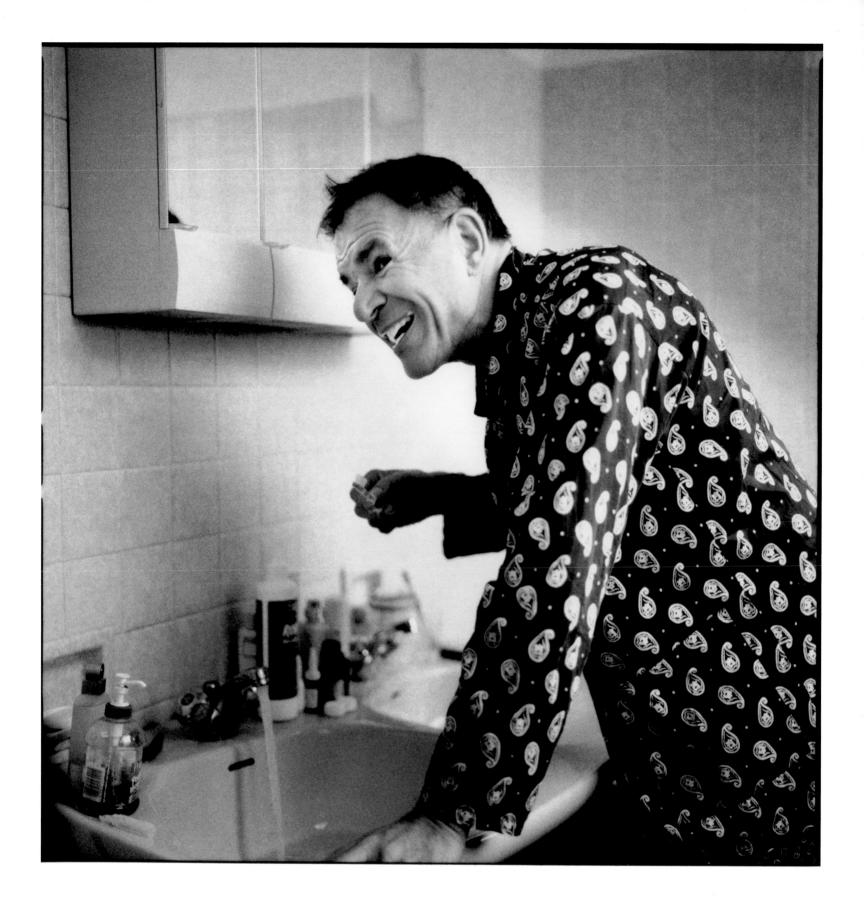

Jean Pierre Kalfon 8.50 am

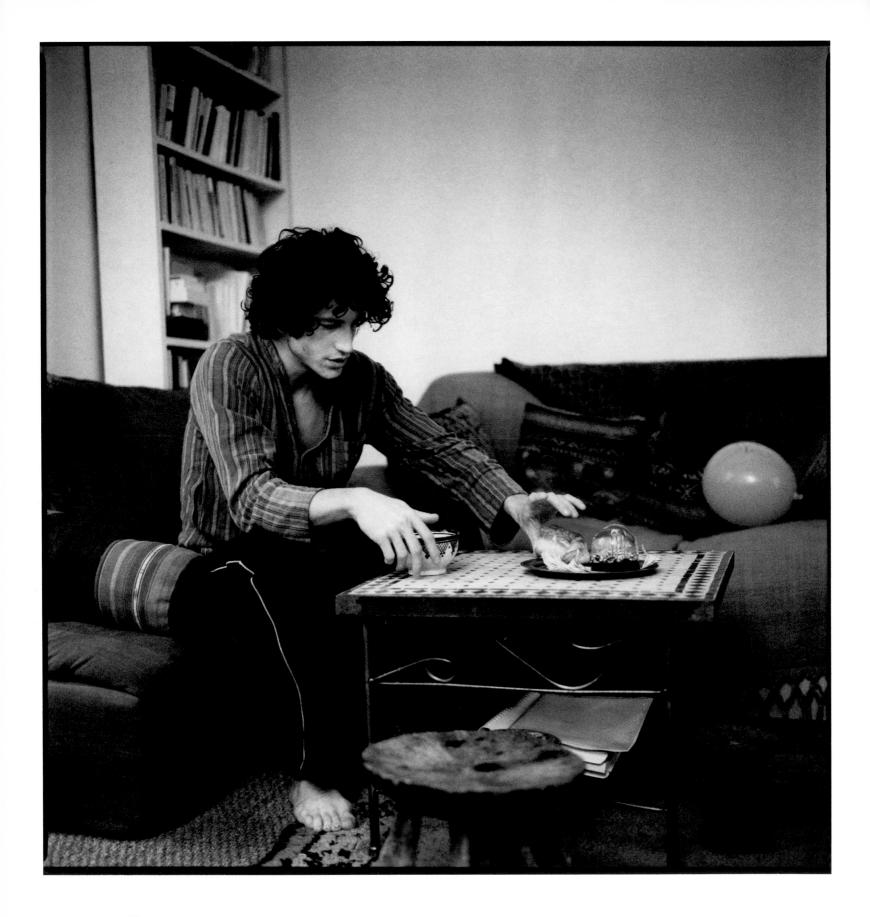

Clément Sibony 9.30 am

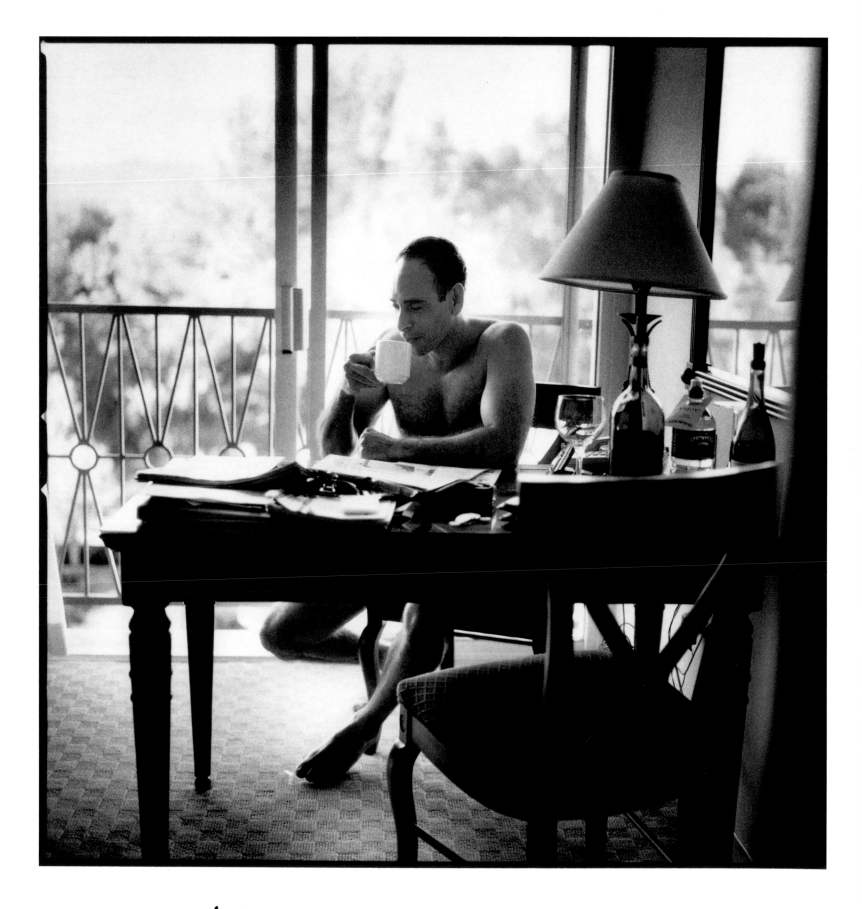

Nestor Serrano 8.15am

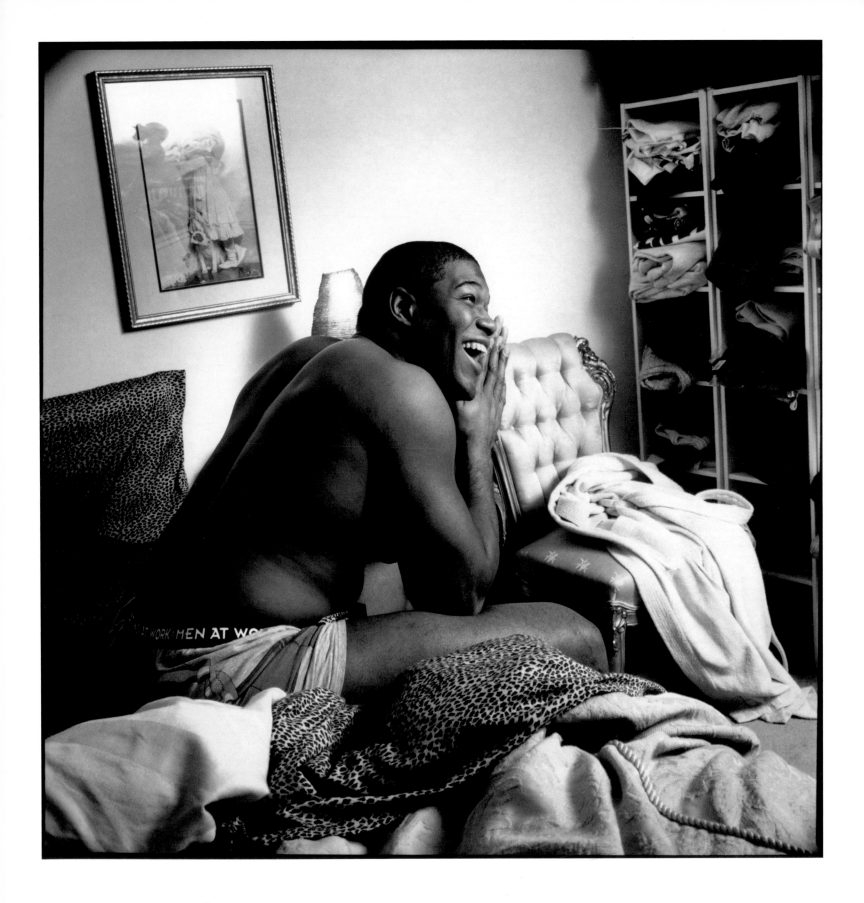

Michael Strahan 9.58am

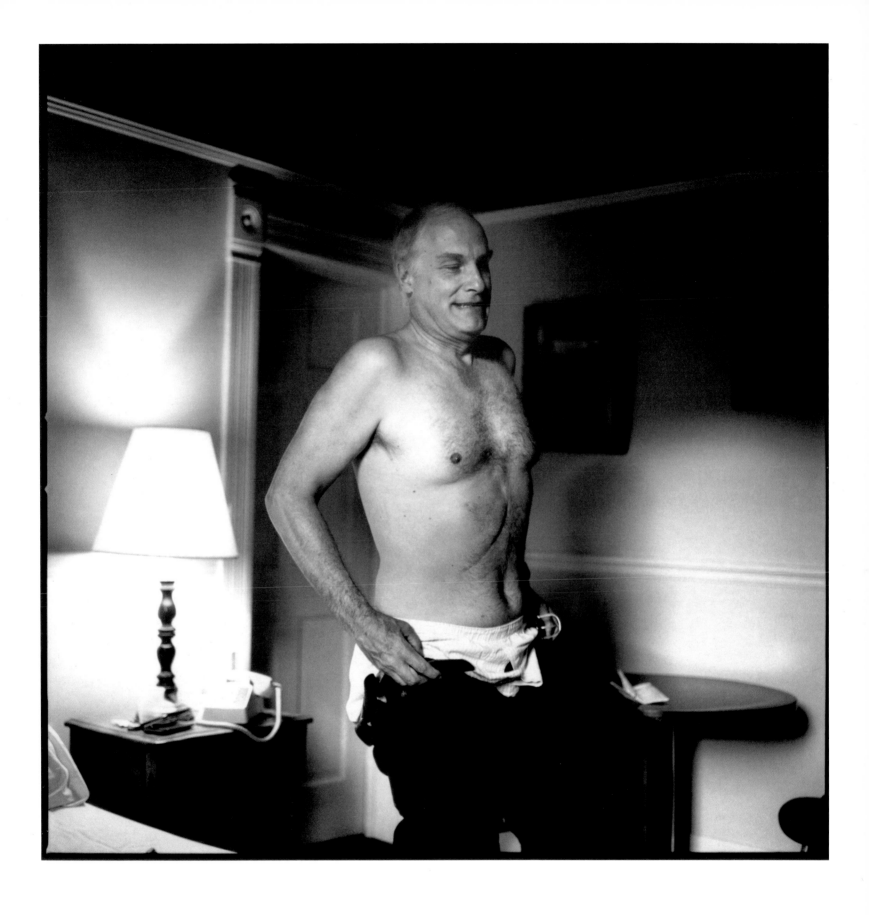

Barbet Schroeder 8.08am

Terence Stamp 9.01 am

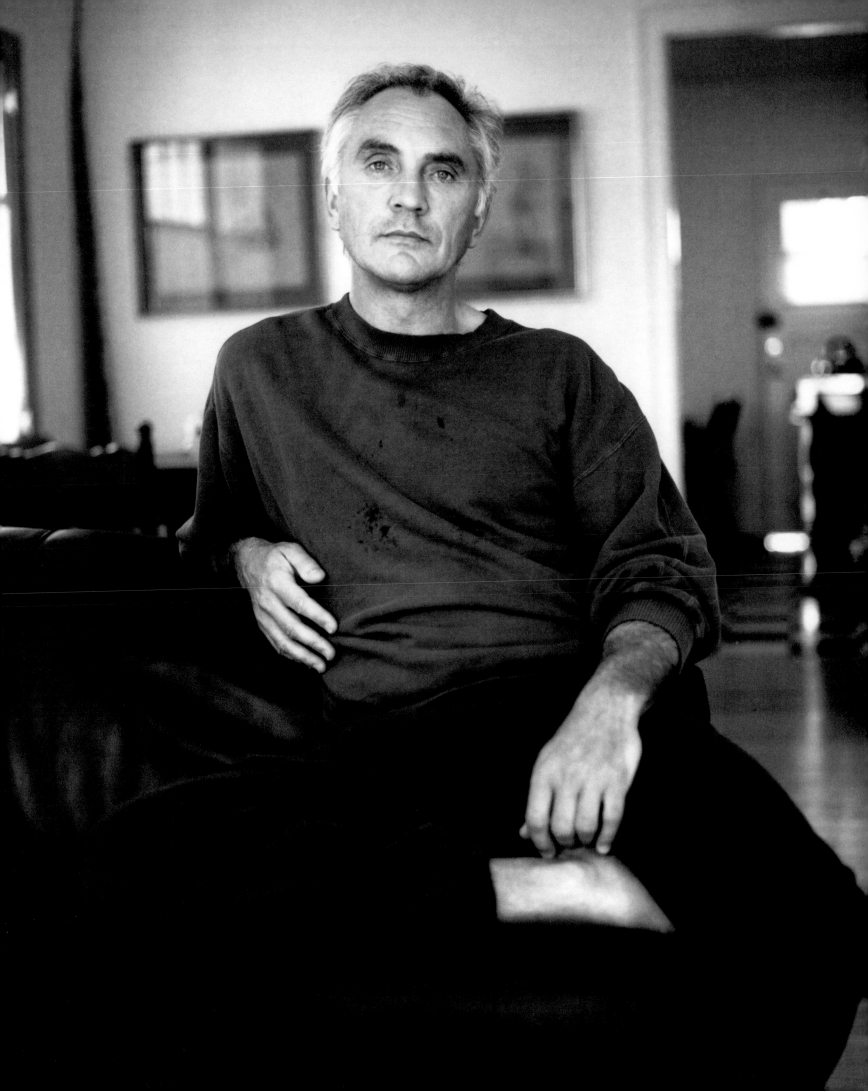

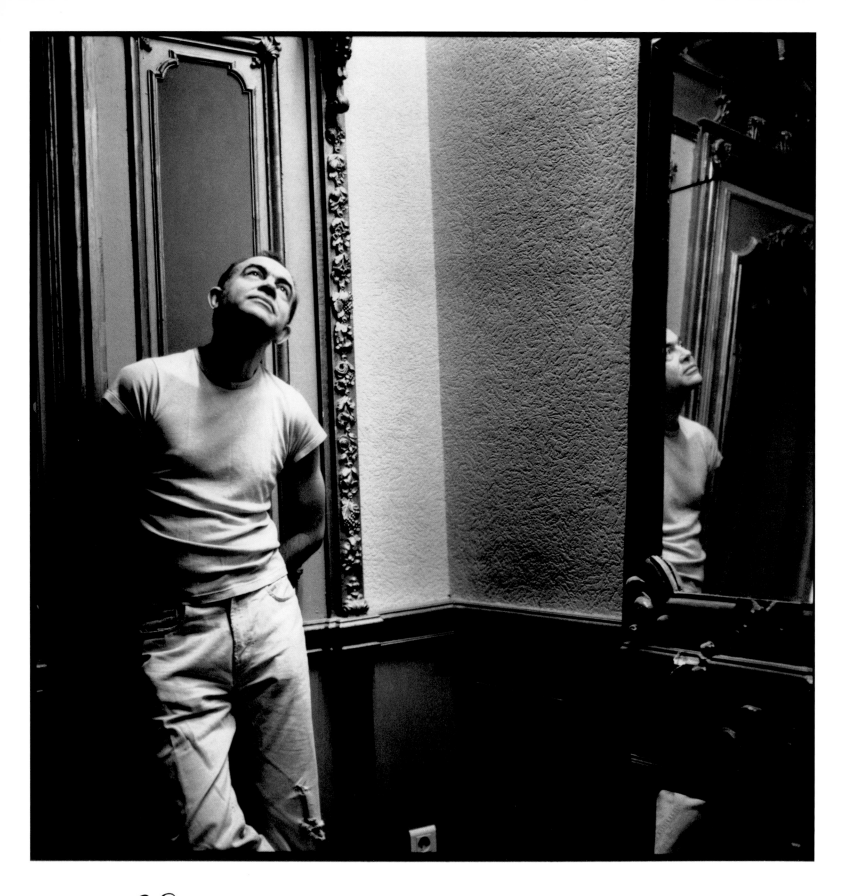

Christian Lacroix 9.40 am

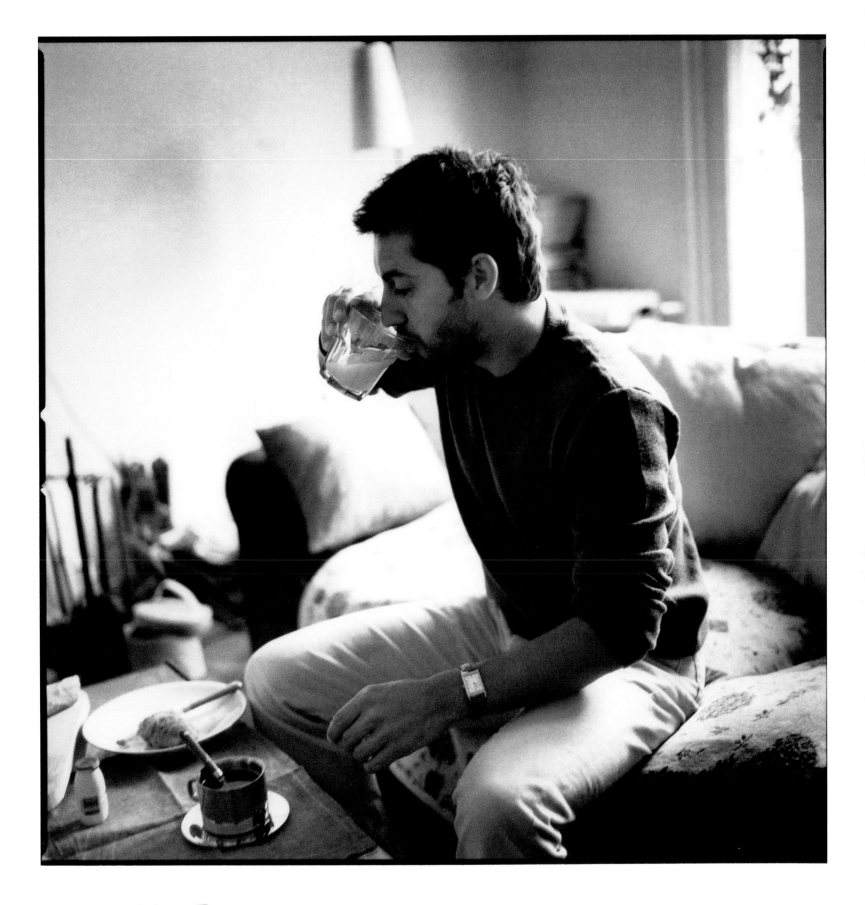

Frédéric Diefenthal 9.02 am

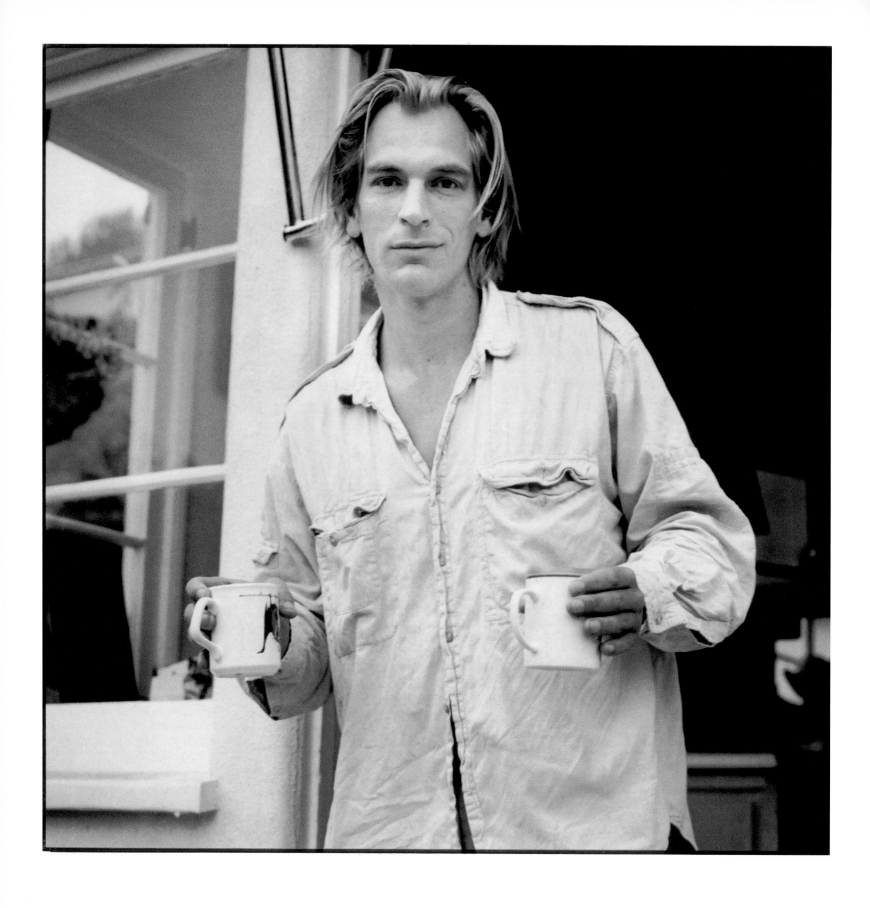

Julian Sands 9.01am

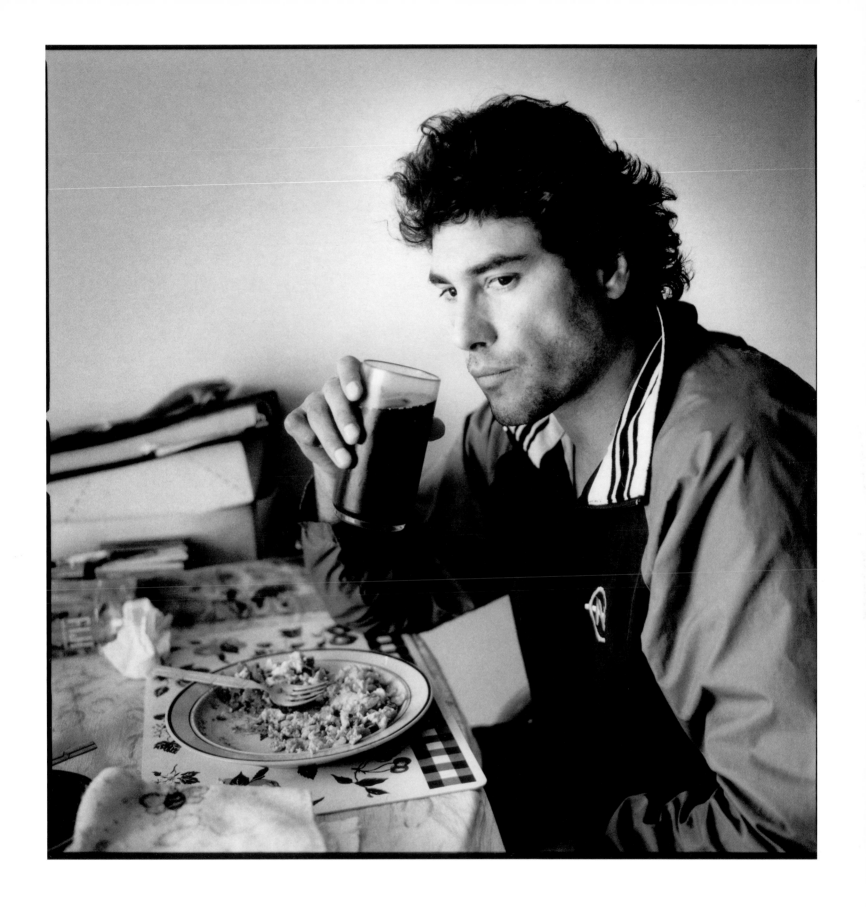

Eduardo Yañez 9.59 am

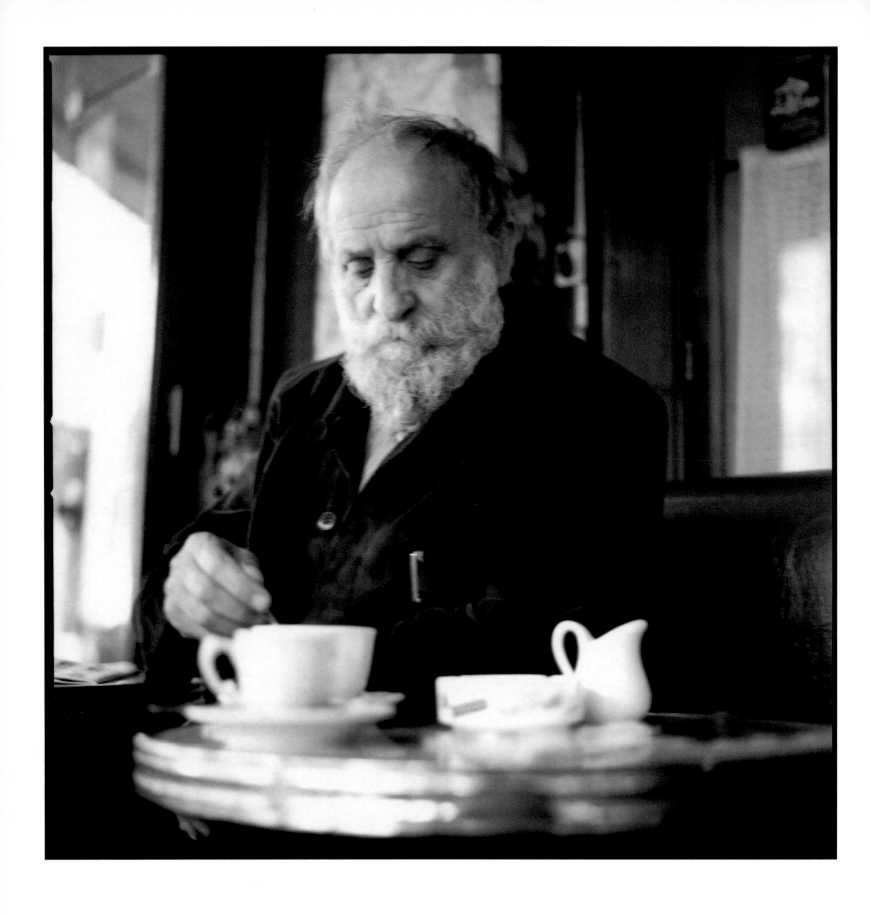

César 9.12 am

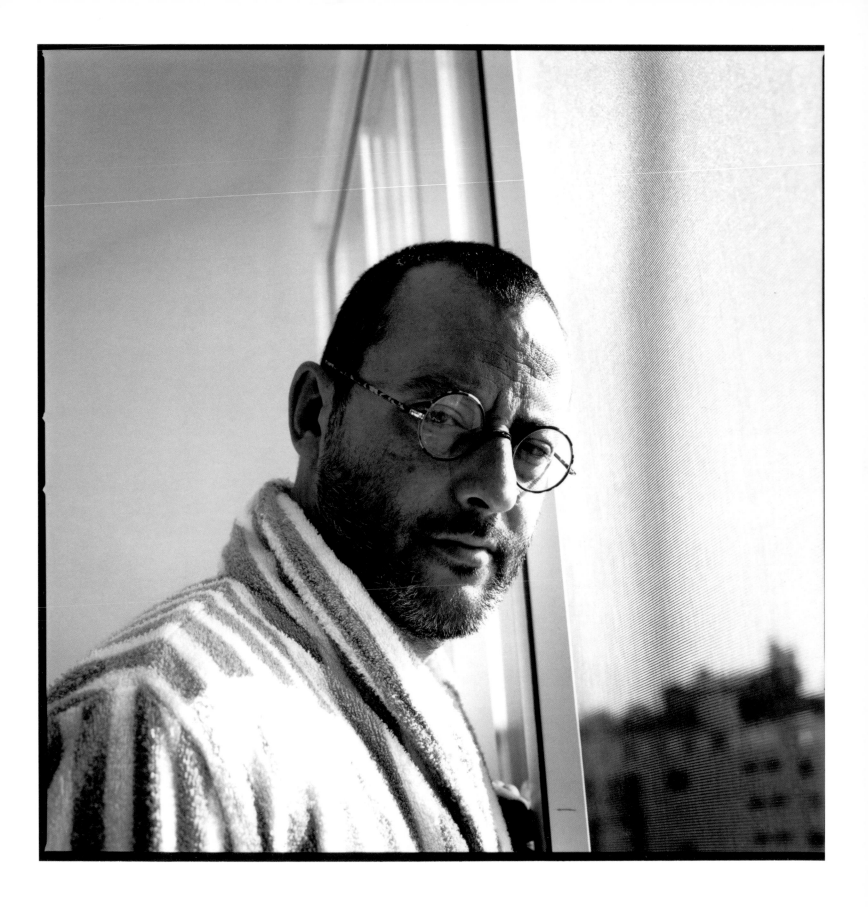

Jean Réno 8.32 am

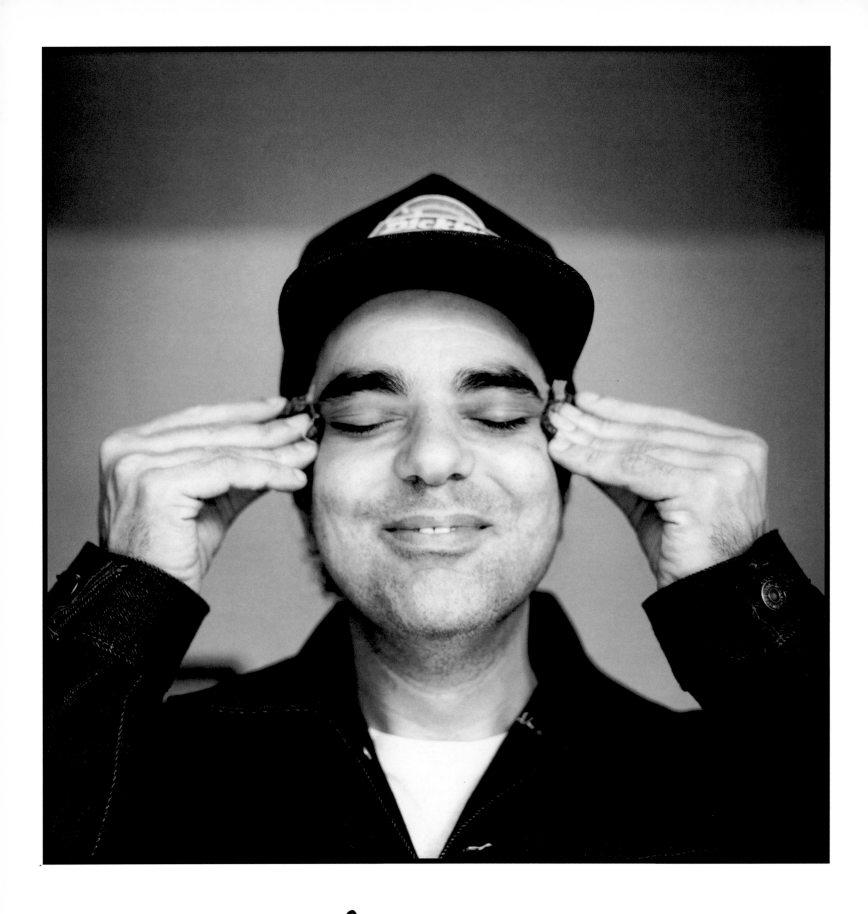

Daniel Lanois 8.53am

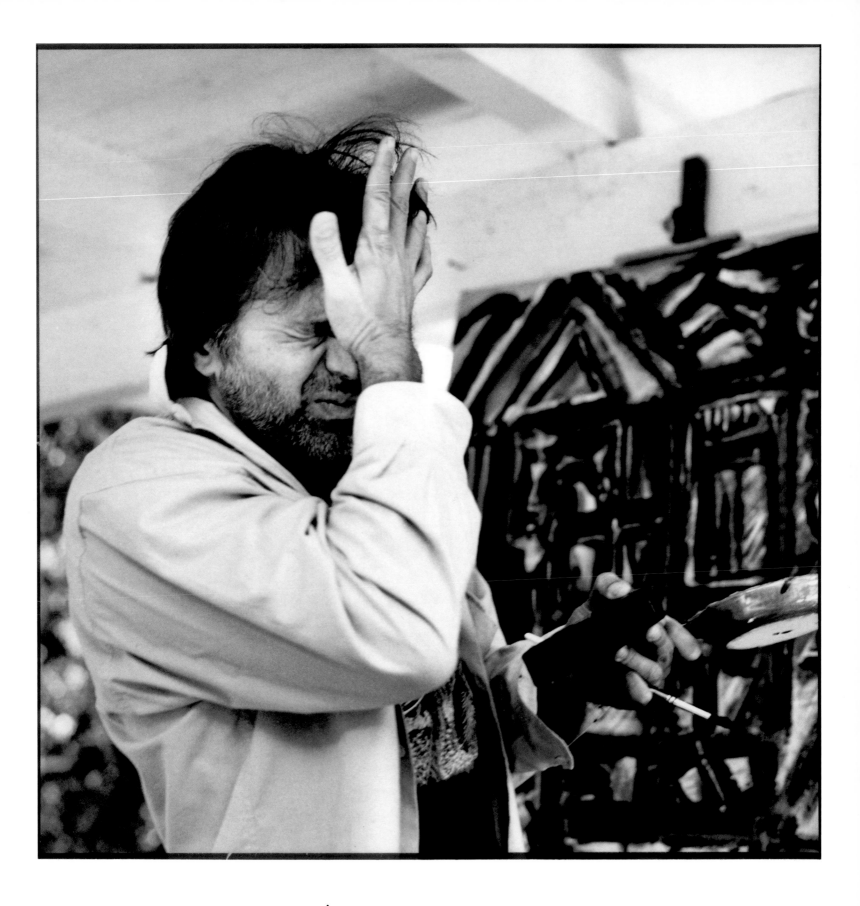

Nick Mancuso 9.00am

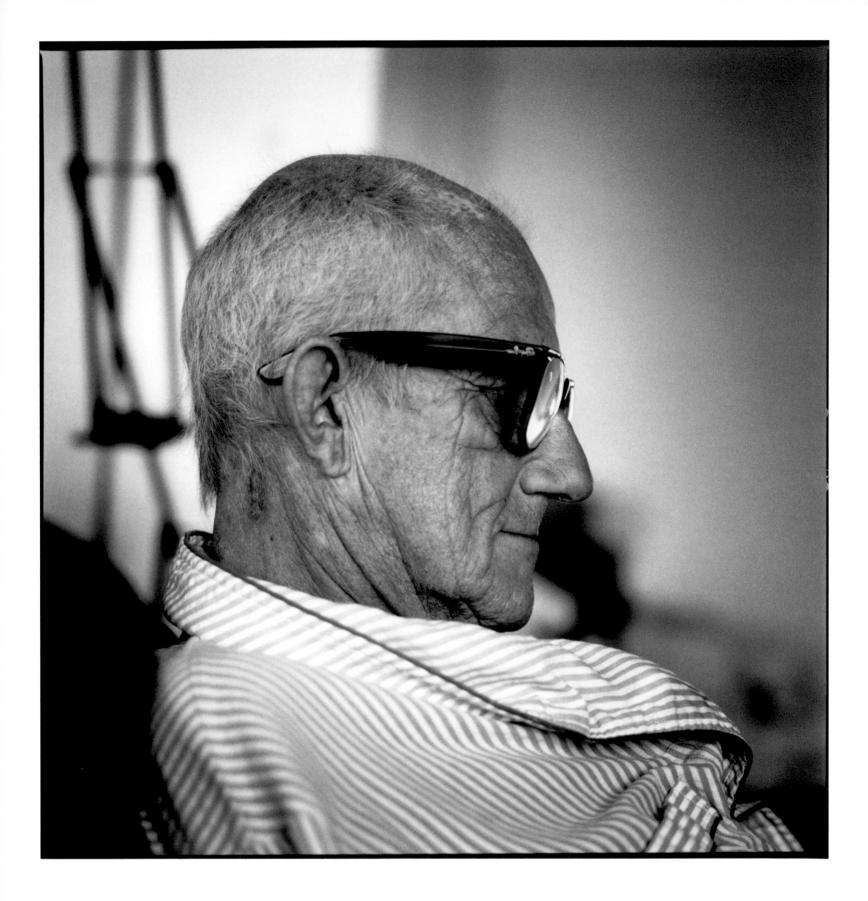

Tony Richardson 9. oo am

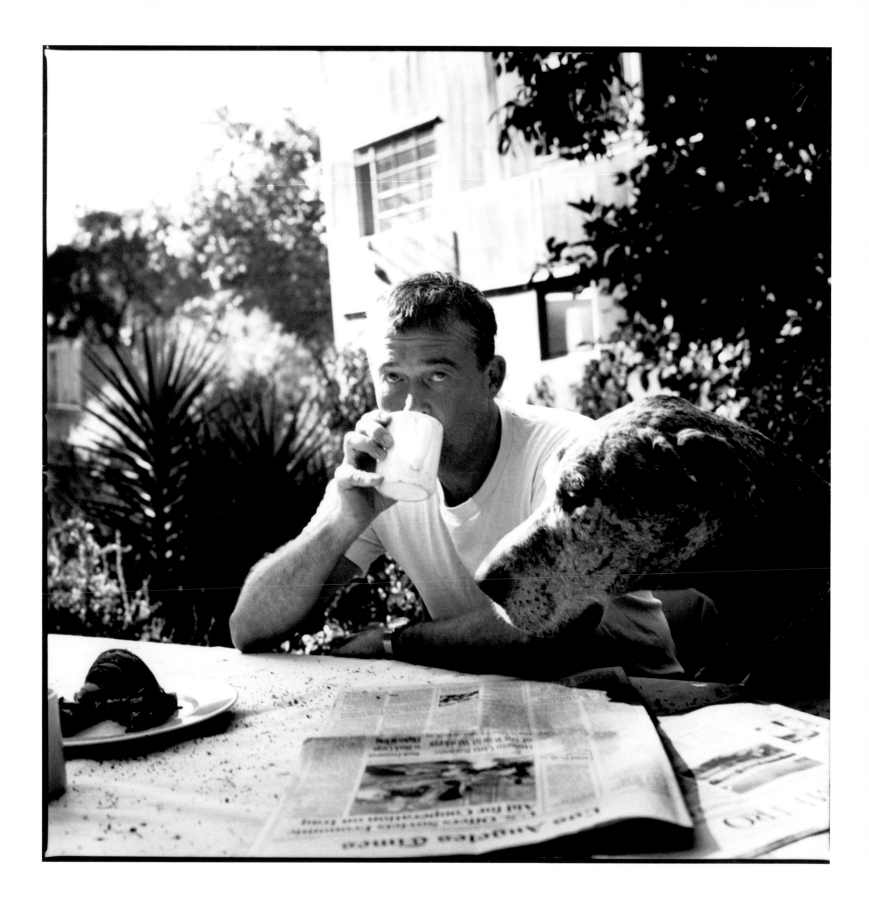

Roger Herman 8.50 am

Wayne was having breakfast
in Telluride during
the film festival
... and he was playing
with his food!!!

Wayne Wang 9.50am

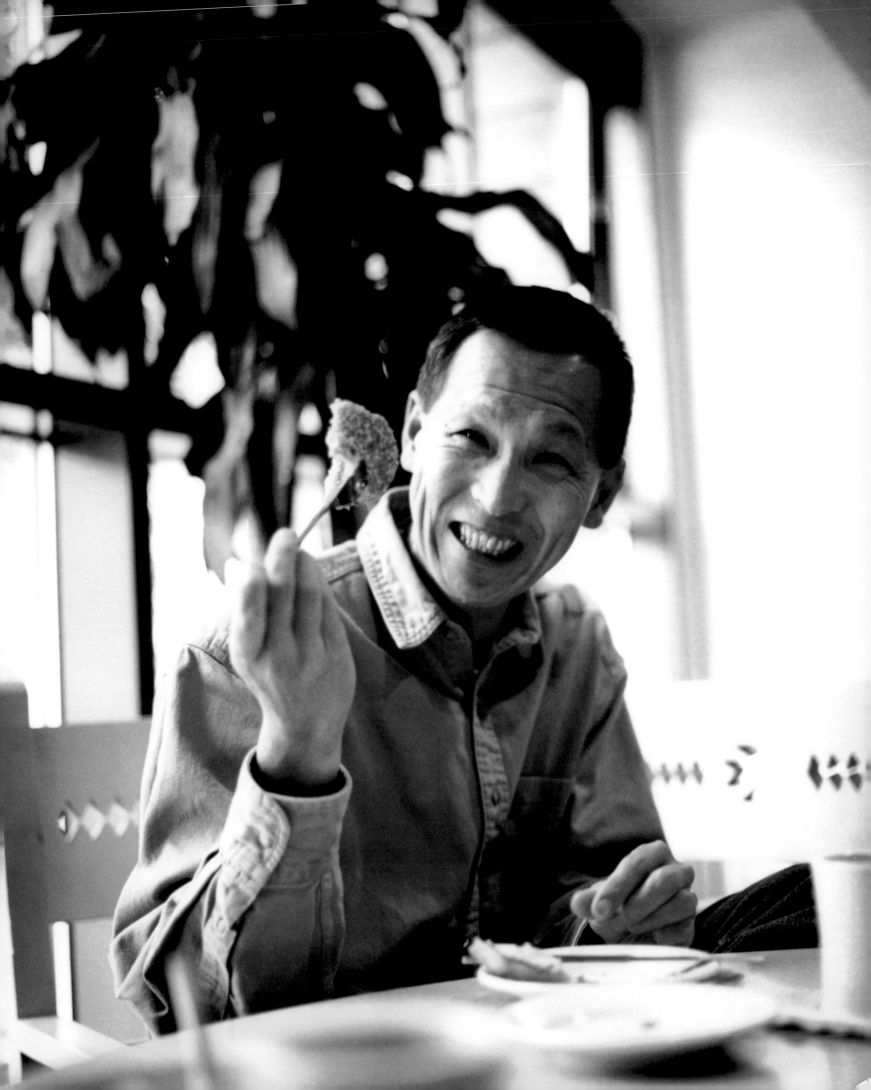

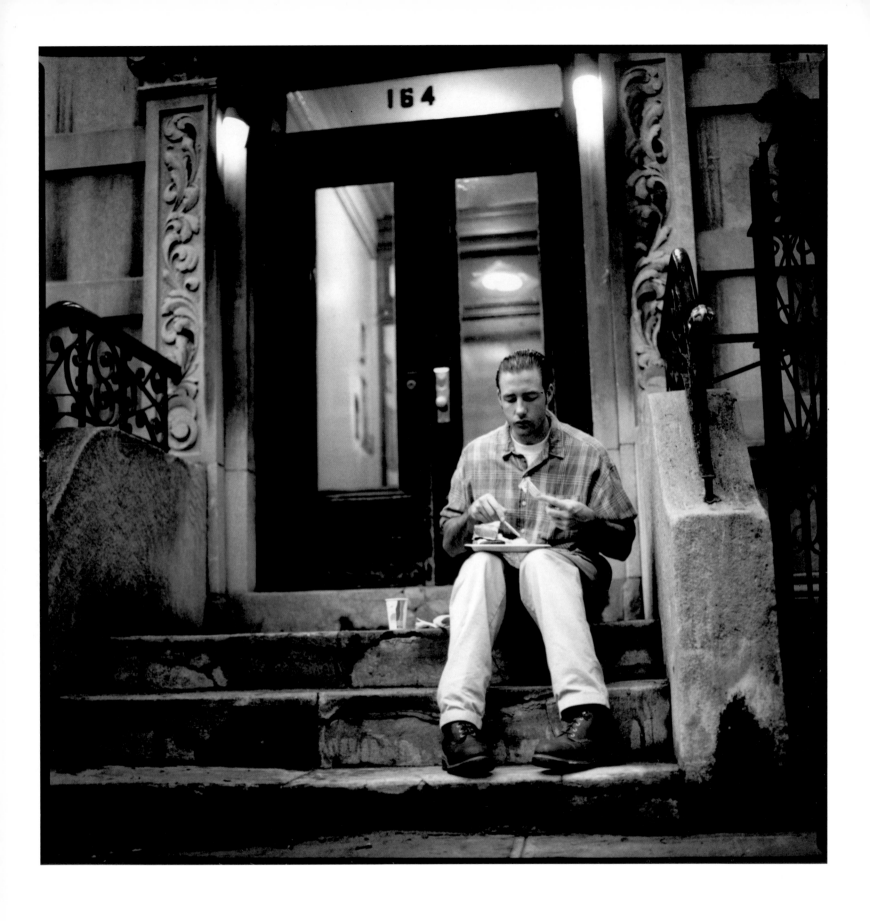

Edward Burns 5.35 am

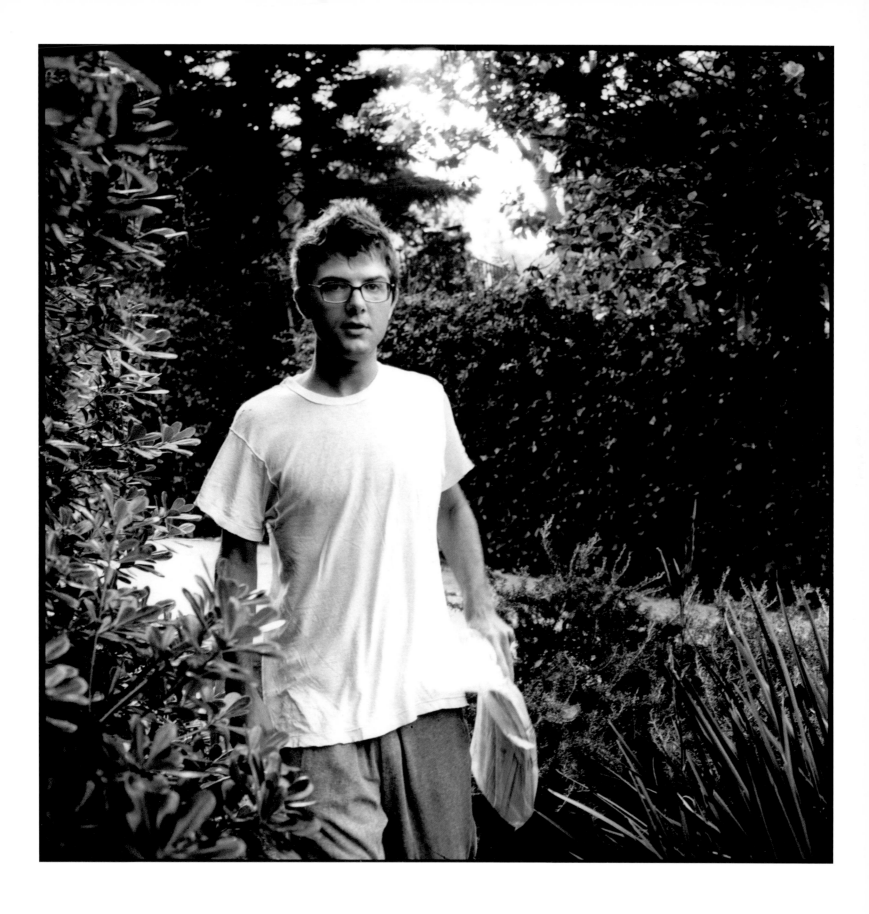

Adam Scott 8.54 am

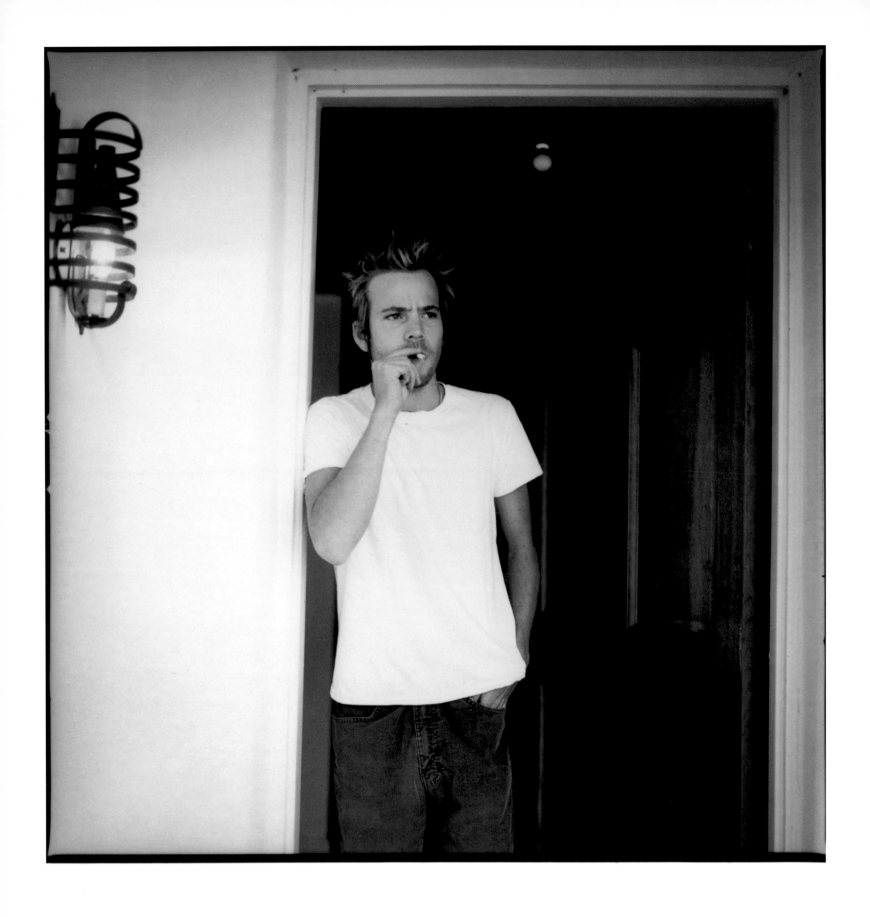

Stephen Dorff 9-30 am

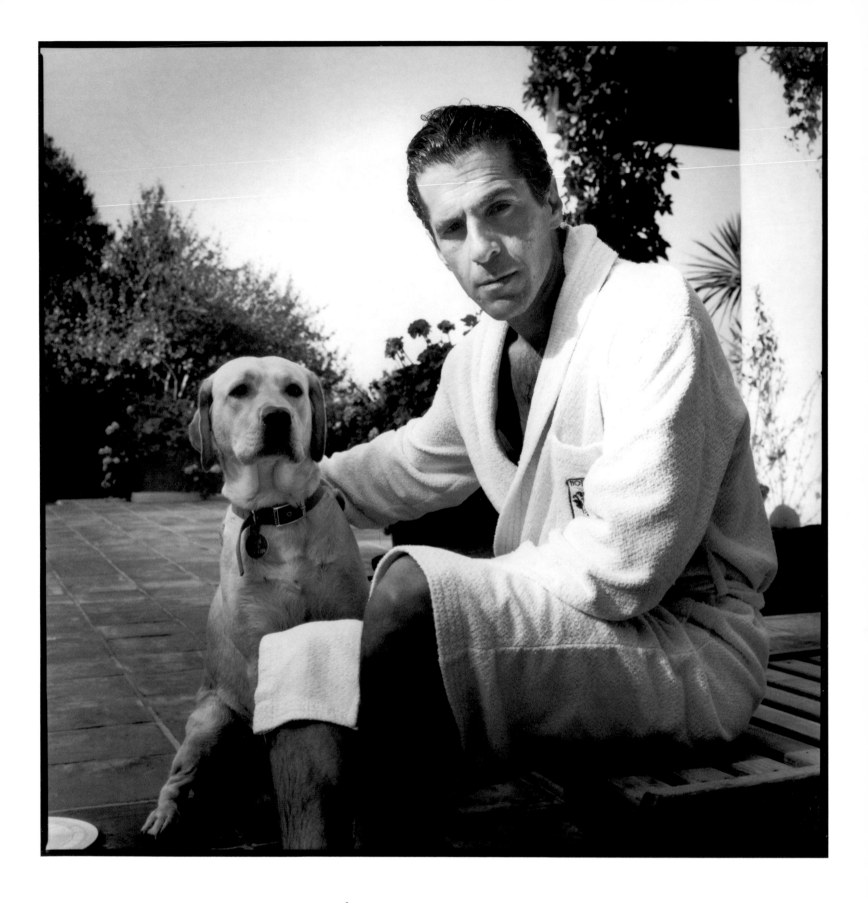

Peter Morton 9.01am

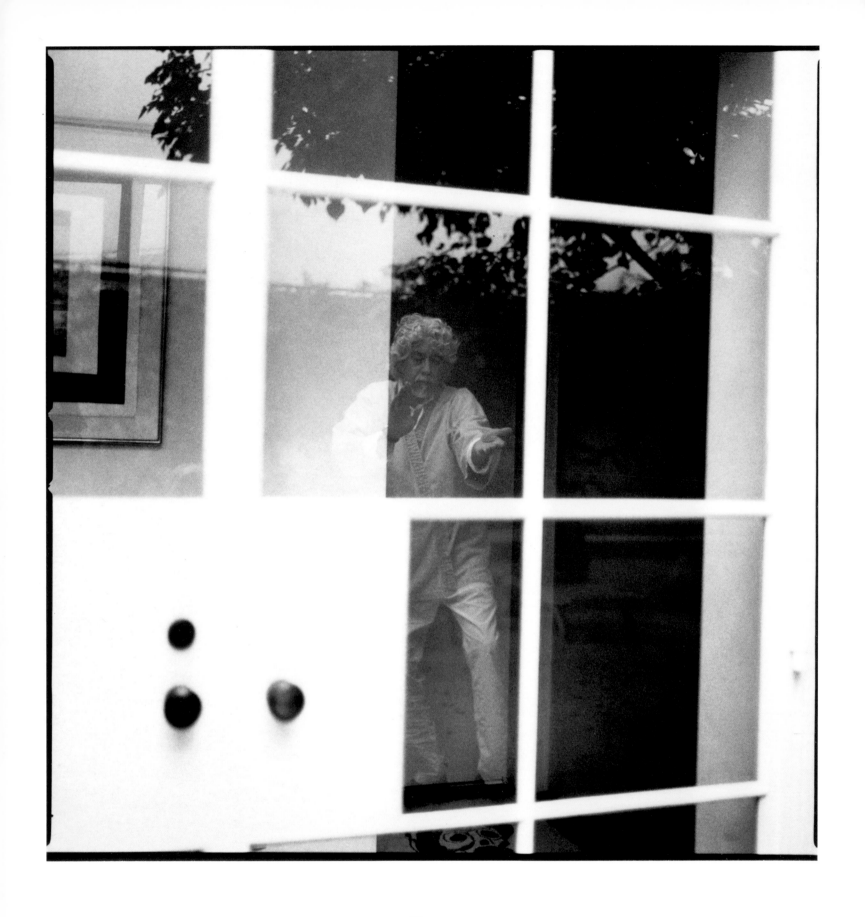

Robert Graham 7. 00am

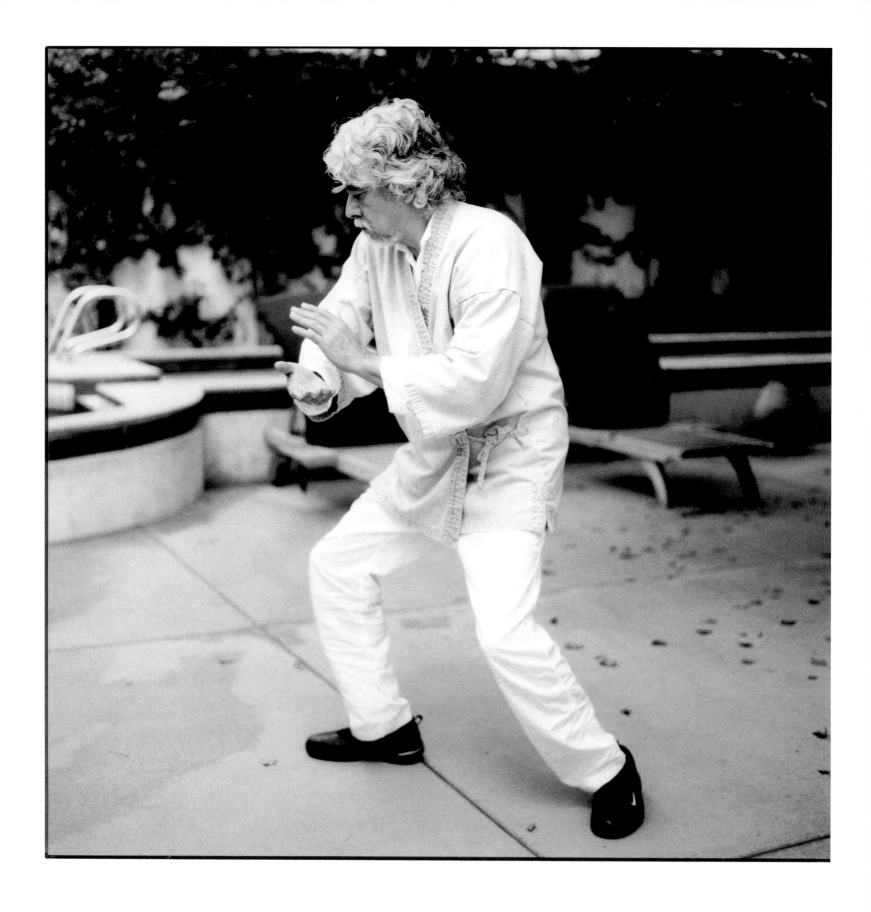

morning ritual...

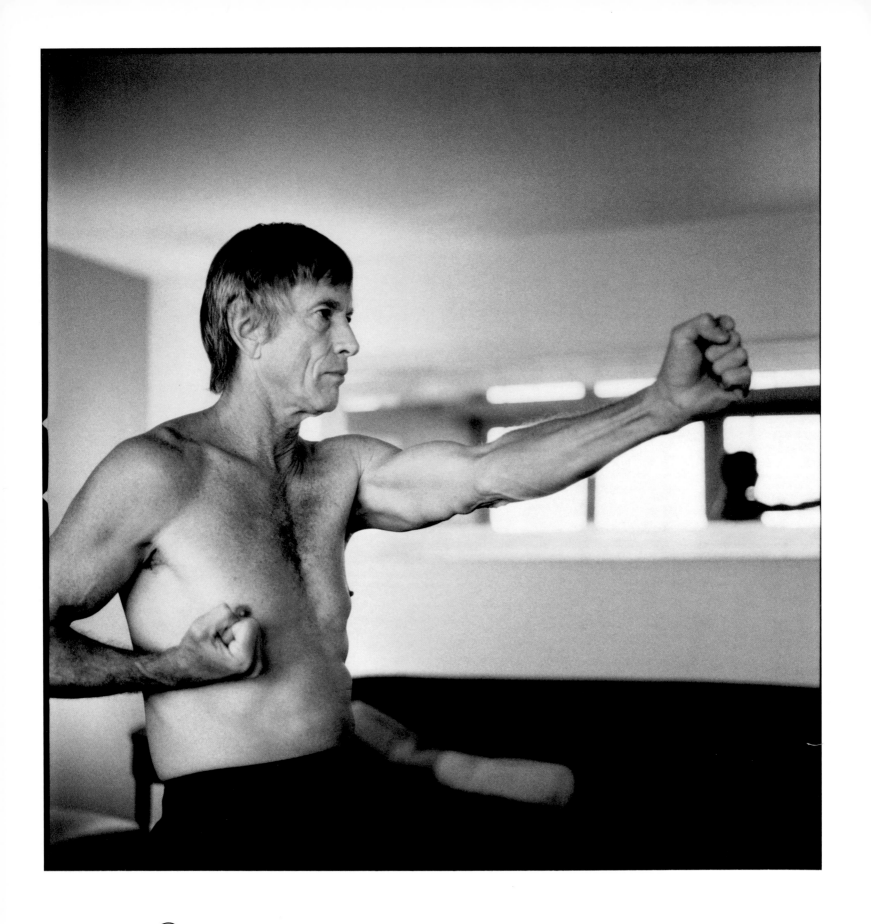

Scott Glenn 8.28 am

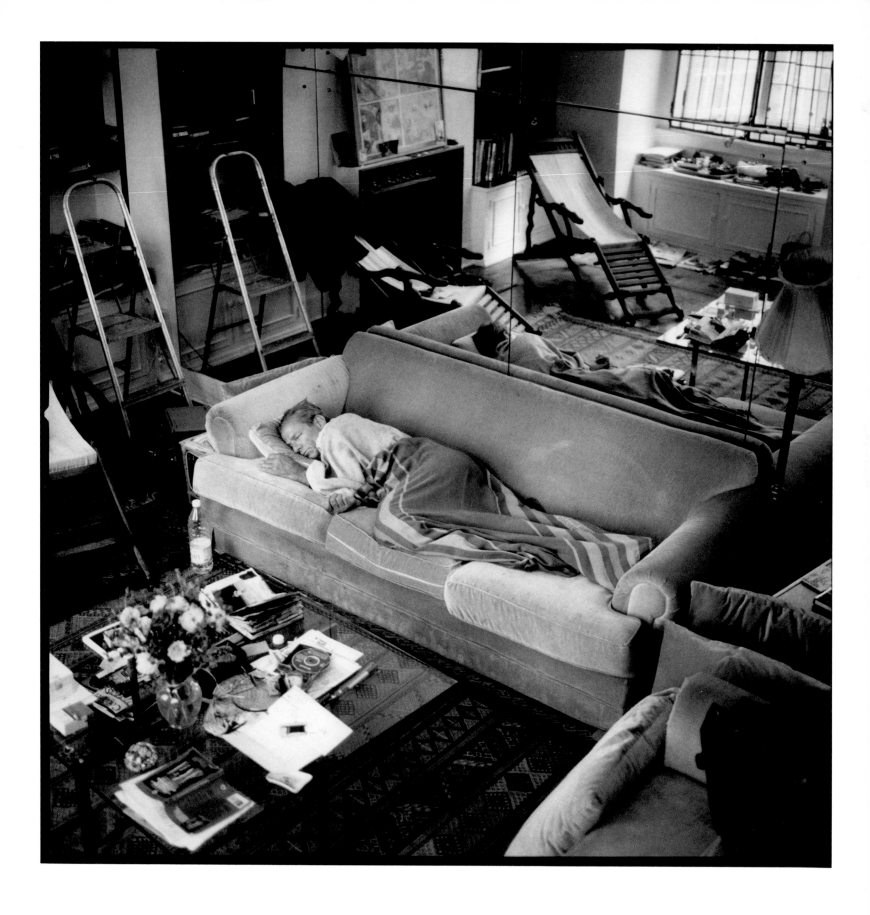

Peter Beard 10 am ··· or 9.55!!!

Philippe Starck 9.00 am

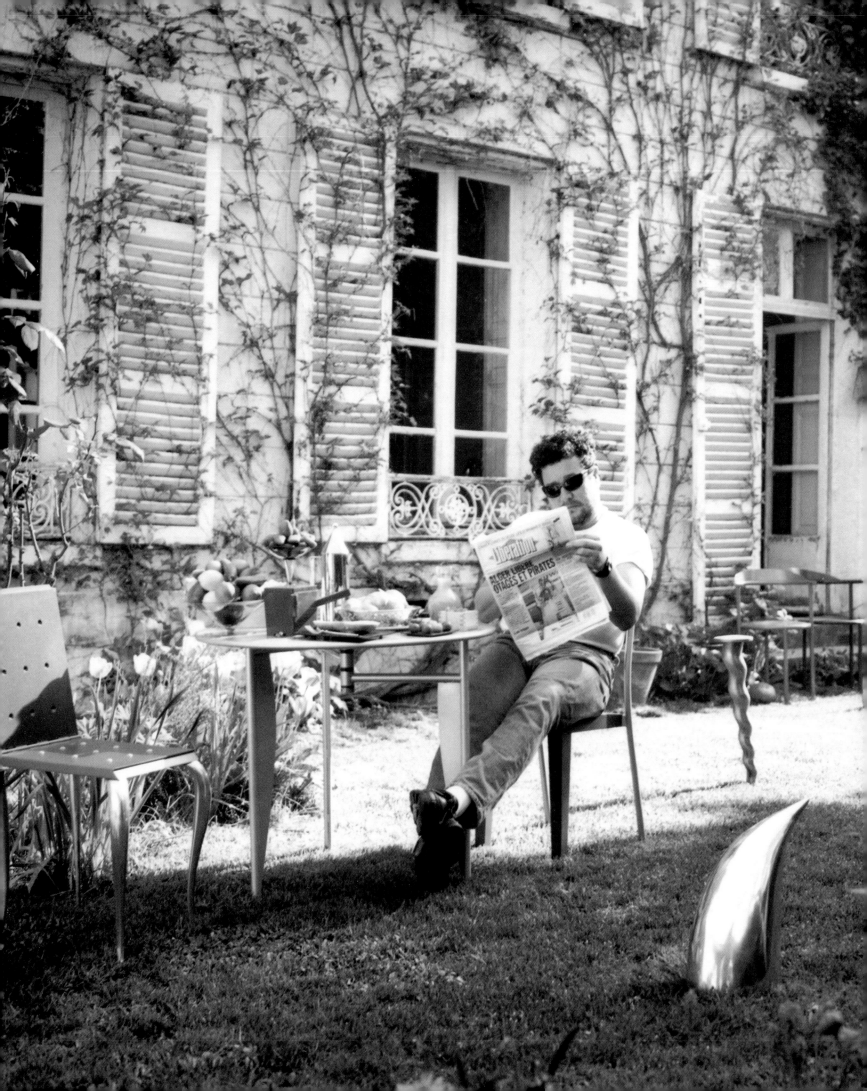

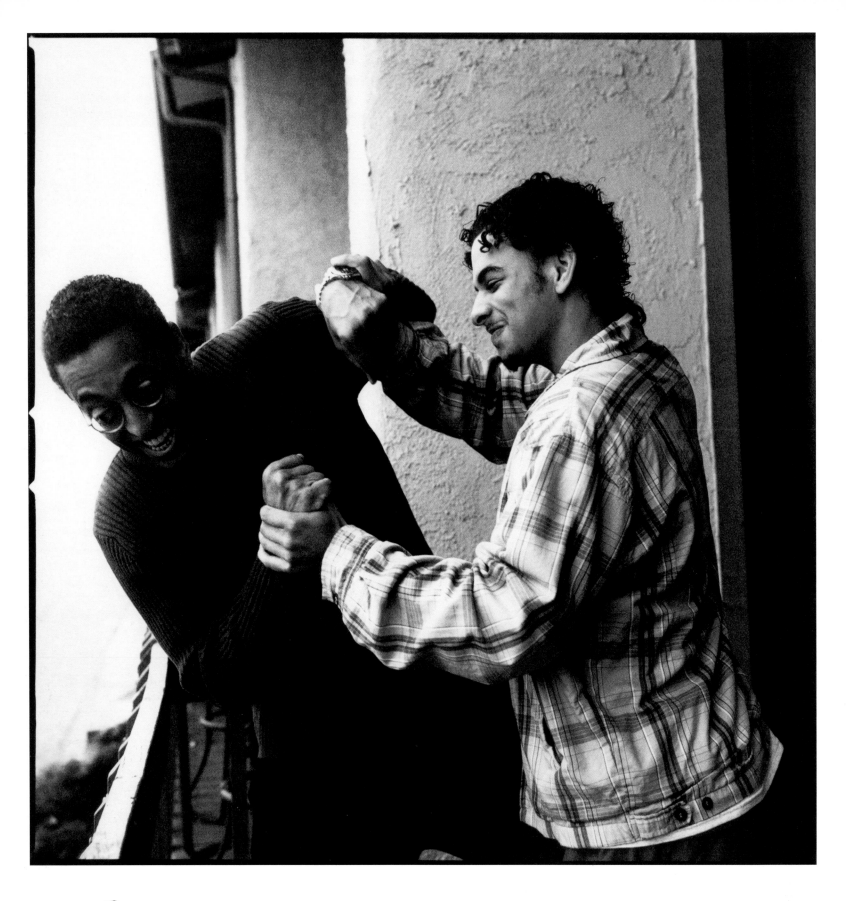

Gregory Hines and Zach Hines 7.15 am

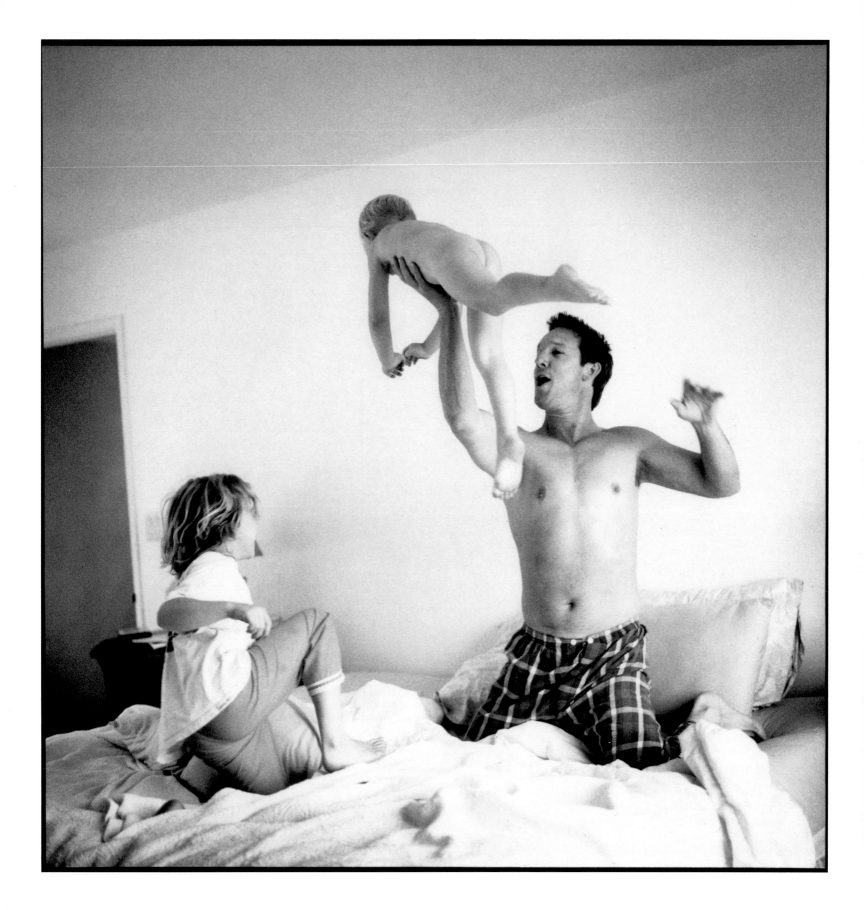

Christopher Potter 8.28am

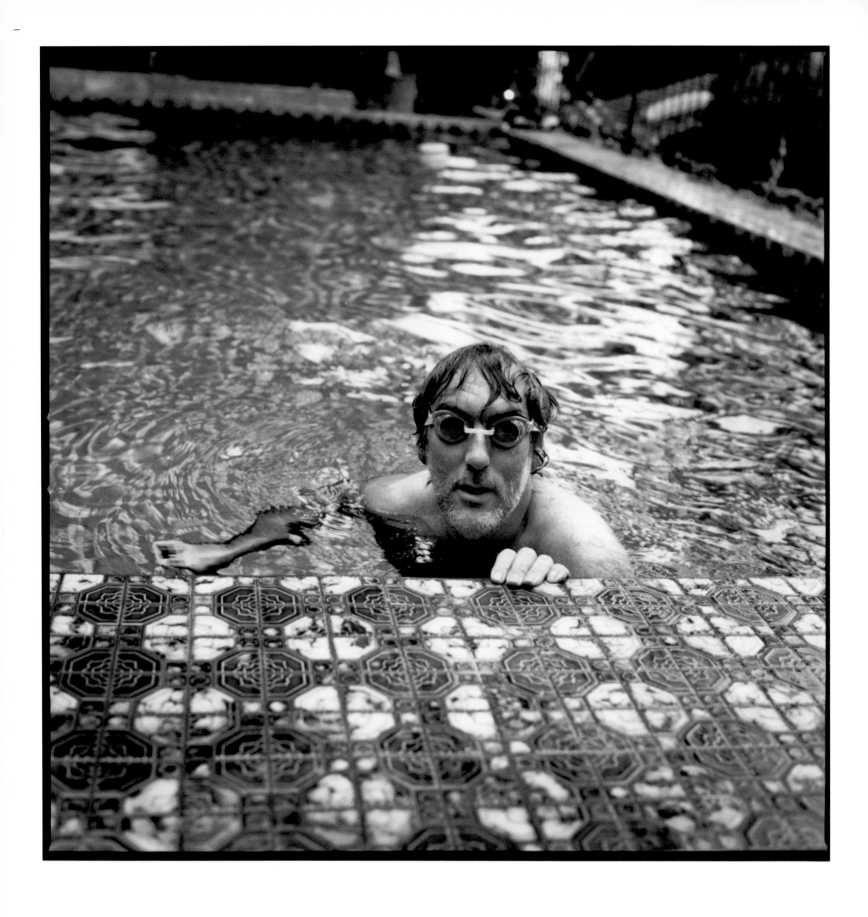

Phillip Noyce 7.58 am

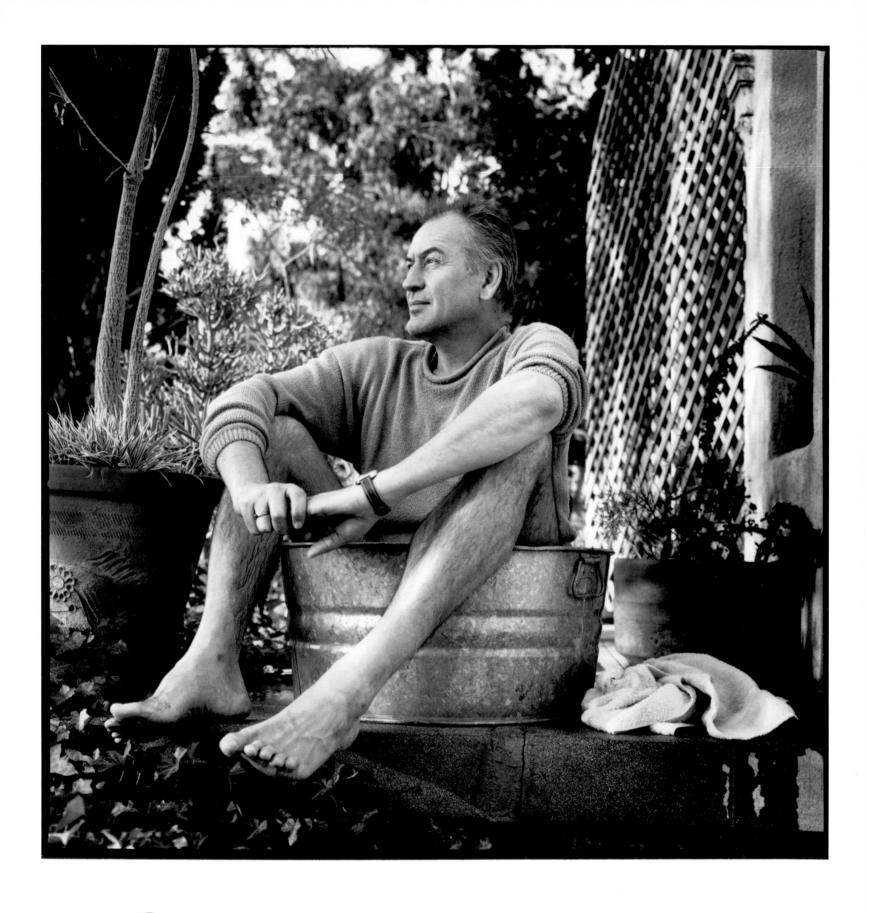

Patrick Bauchau 9.20 am

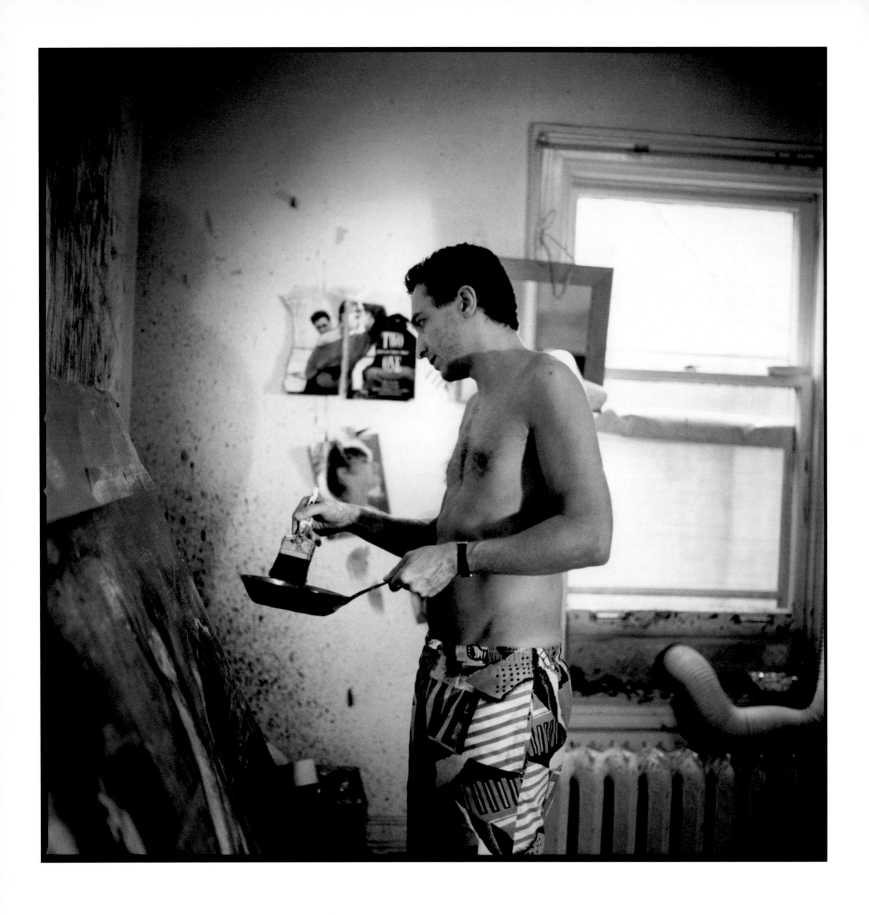

Tony Sherman 8.59 am

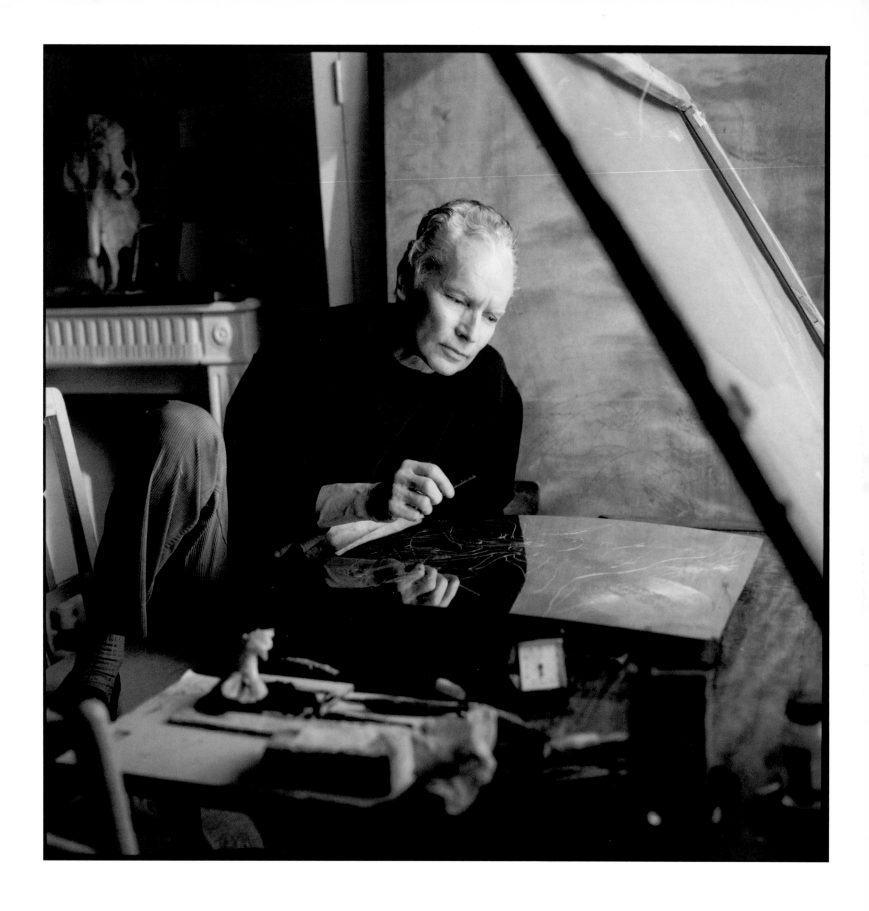

Trémois 9.10 am

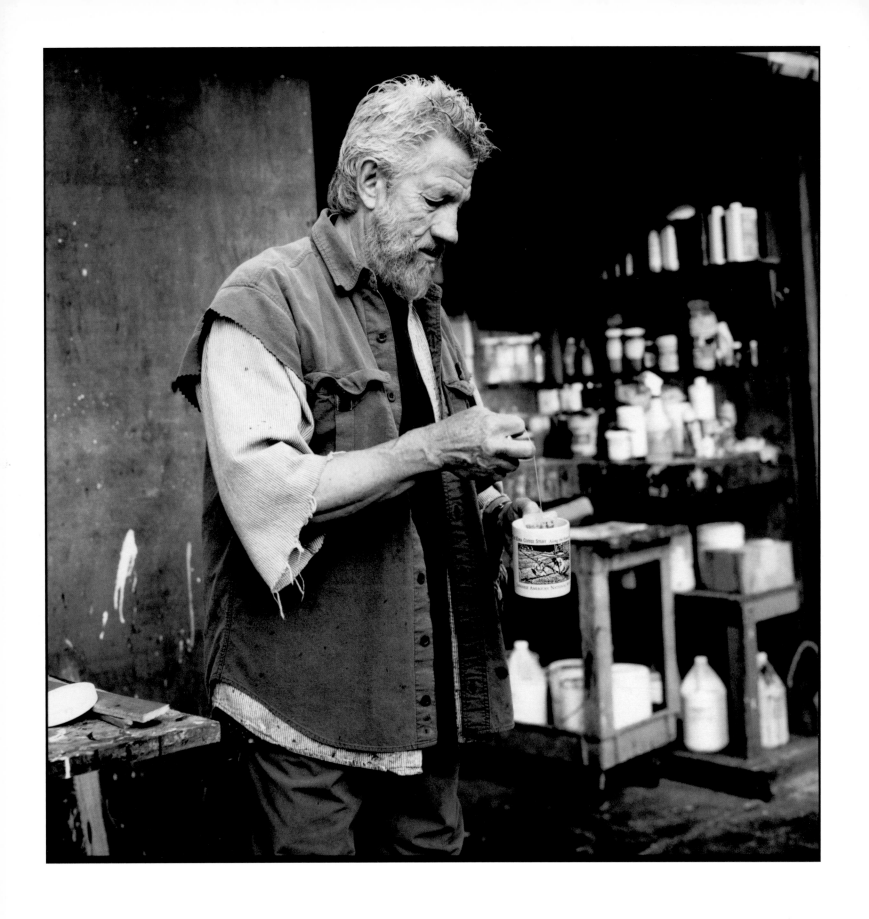

Ed Moses 9.01am

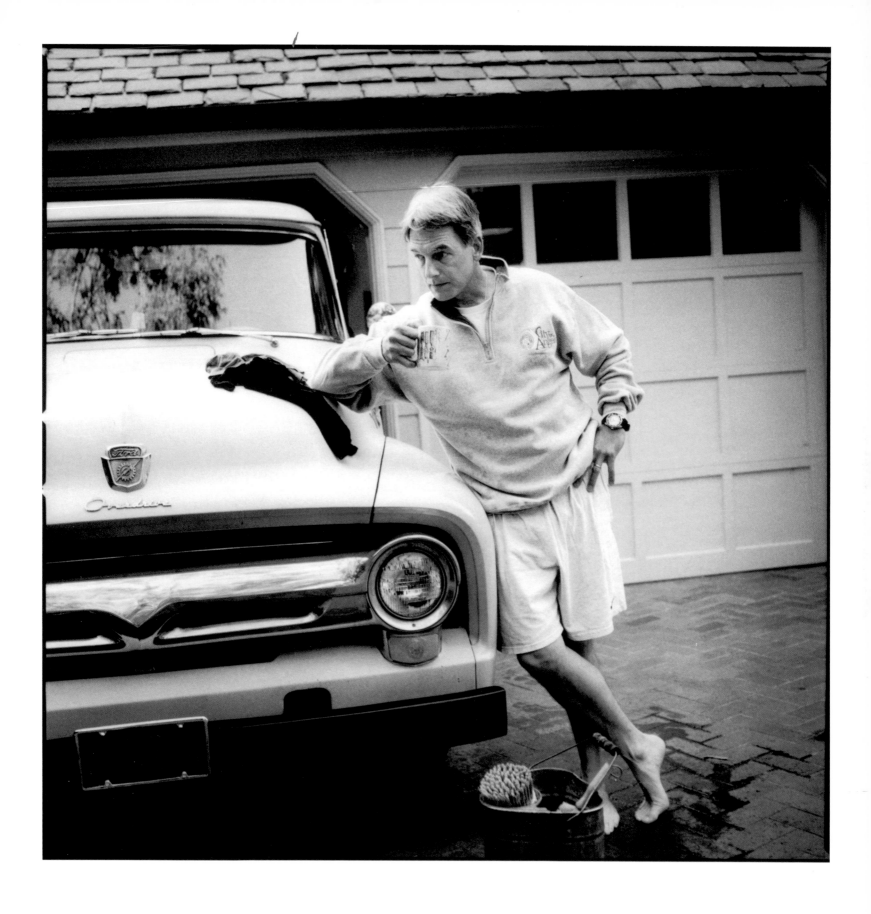

Mark Harmon 7·33 am

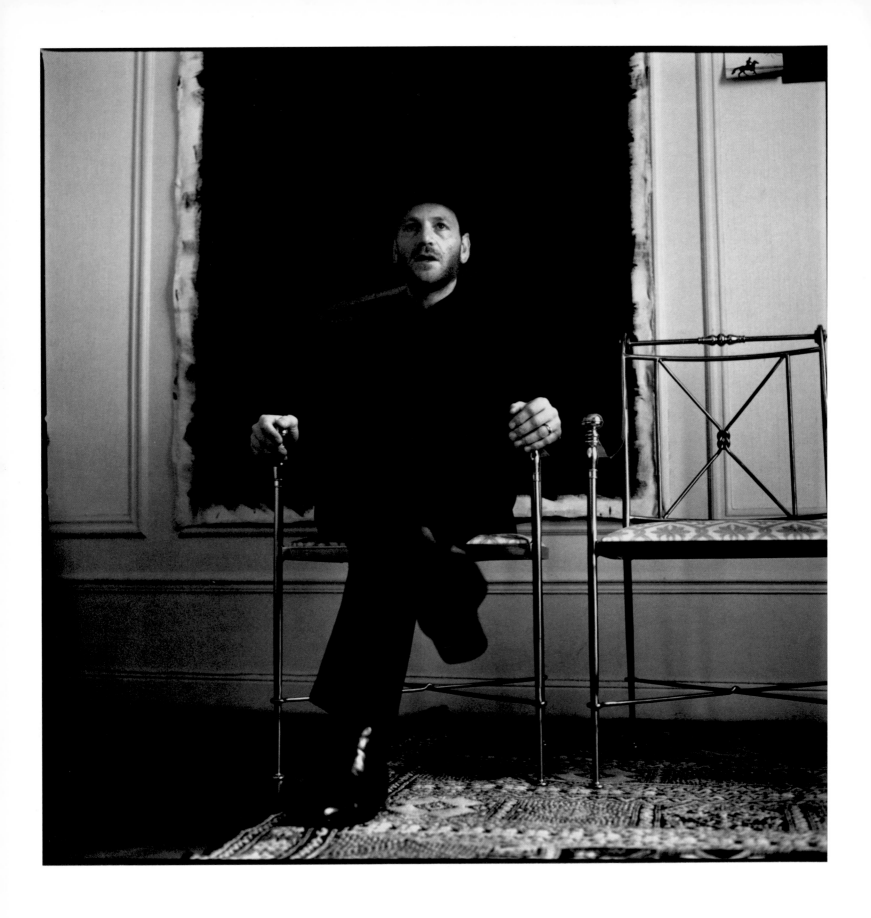

Tcheky Karyo 9.36 am

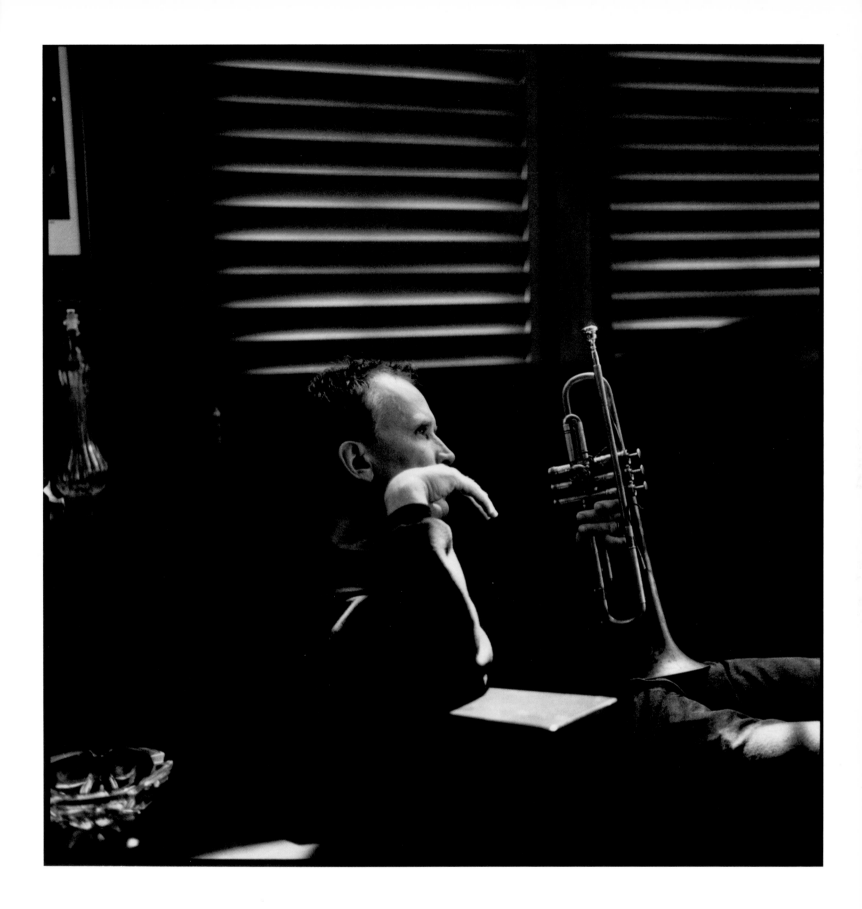

Peter Weller 9.55 am

Acknowledgements

A special thanks to Jennifer Beals for deepening our friendship and being a great photographer!

A gigantic thank you to Brigitte Caland who didn't let me sleep past 6.30 am for the last 2 years!

I am grateful to all those sexy men who let me in before 10 am and to their girlfriends, wives, companions or animals who let me have them to myself for 15 minutes.

To CPI, my agent Geoff Katz, and especially Hugo for making every day easier!

To my publisher Dan and Craig, who I miss so much since they are so busy!!!

To Robert Avellan for making sense of all those images!

To Alain Labbé and David Healey at Paris Photolab for doing my prints.

A big "Merci" to: Nicole Nagel Caland. Fiona Whitney.
Bob, Curtis, Nicole, Sherron, Hollie, Sheila from the Agency - SAG
Dona Menashe and everyone at Dick Guttman Associates
Brenda Feldman. Deborah Berger. Philip Button. Catherine Olim.
Richard Hoffman. Shara Storch. Stacy Boniello. Peter Kiernan.
Jean-Paul Claverie. Nancy Kane. Corrine Vaglio. David Vatinet.
CINEART. Carra Sutherland. V.M.A. Cari Ross. Patrick Donnelly.
Catherine Jeffrey. Gibson Peterson. Michael Garnett. Lisa Bittan
Stacie Savage. Ildiko Nagy. Carri McClure. Book Schut Company.
Poppy Montgomery.

V.V.

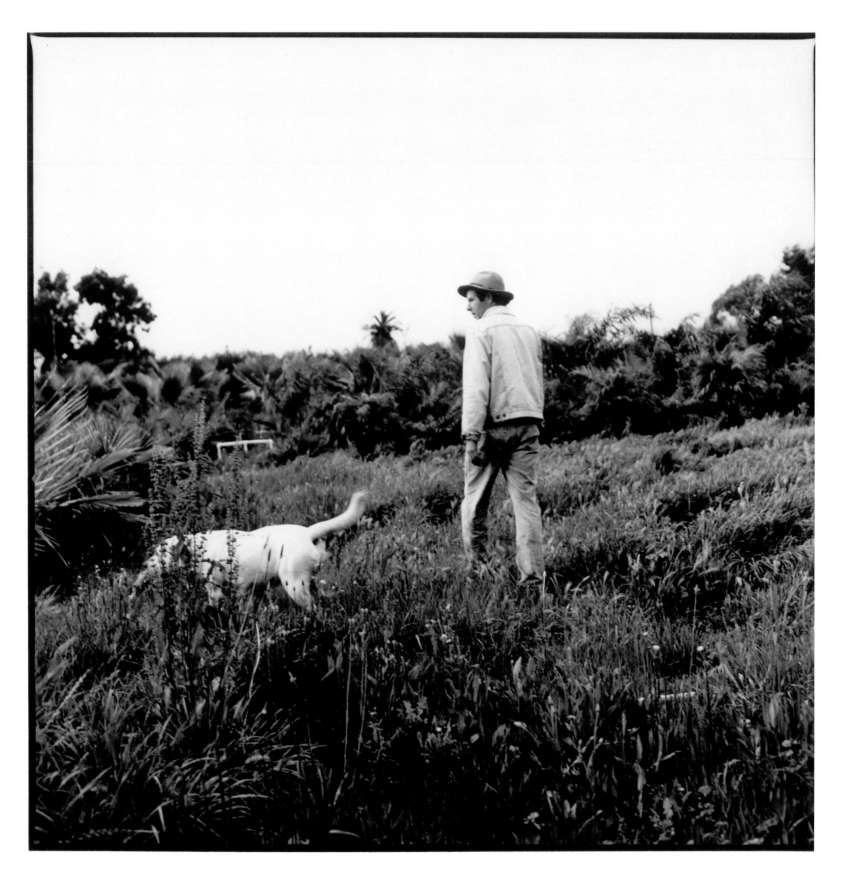

Timothy Bottoms 8 - 50 am

captions

Jacket cover Til Schweiger actor

P. 1 Ingo Rademacher actor
P. 3 Jason Biggs actor
P. 5 Darius Khondji cinematographer
P. 7 Billy Burke actor
P. 9 Esai Morales actor
P. 11 Nicholas Gonzalez actor
P. 12 Sönke Wortmann director
P. 13 Gary Oldman actor/director
P. 14 Elias Koteas actor
P. 15 Milton Nascimento musician
P. 16 Troy Garity actor
P. 17 Harry Dean Stanton actor
P. 19 Arne Bergh architect
P. 20 Kiefer Sutherland actor
P. 21 Michael Rapaport actor
P. 22 Vincent Elbaz actor
P. 23 Sean Astin actor
P. 24 Jeff Goldblum actor
P. 25 Jeremy Sisto actor
P. 27 Bert Stern photographer
P. 28 Ron Livingston actor
P. 29 Johnny Galecki actor
P. 30 Mike Figgis director
P. 31 Donnie Edwards football player
P. 32 Vincent Perez actor
P. 33 Matthew Lillard actor
P. 35 Bernard-Henri Levy writer
P. 36 Marco Leonardi actor
P. 37 Jeremy Piven actor
P. 38 Pierre Cosso actor
P. 39 Djimon Hounsou actor
P. 41 Jean-Baptiste Mondino photographer
P. 42 Steven Weber actor
P. 43 Jackie Chan actor
P. 44 Rick Schroder actor
P. 45 James Franco actor
P. 47 Tom Sizemore actor
P. 48 James Franco actor
P. 49 Mark Spitz swimmer

P. 51 Vin Diesel actor
P. 52 Randy Quaid actor
P. 53 Brannon Braga writer
P. 54 Laird Hamilton surfer
P. 55 Patrick Dempsey actor
P. 56 Bei Ling poet
P. 57 Paul Ben Victor actor
P. 58 Will Estes actor
P. 59 Masaya Kato actor
P. 61 Seymour Cassel actor
P. 62 Joshua Leonard actor
P. 63 Jaron Lowenstein musician
P. 64 Jake Busey actor
P. 65 Neal McDonough actor
P. 67 Seth Green actor
P. 68 Brendan Fraser actor
P. 69 Robert Duncan McNeill actor
P. 70 Vincent Martinez actor
P. 71 Dermot Mulroney actor
P. 73 Griffin Dunne actor
P. 74 Cobi Jones soccer player
P. 75 Lou Diamond Phillips actor
P. 76 Alessandro Nivola actor
P. 77 Thierry Lhermitte actor
P. 78 Arthur Miller writer
P. 79 Neil Patrick Harris actor
P. 80 Brad Rowe actor
P. 81 Anthony Stewart Head actor
P. 82 Marc Blucas actor
P. 83 Alex Guini cook
P. 85 Bruce Davison actor
P. 86 Ethan Embry actor
P. 87 Jason London actor
P. 88 Jim Harbaugh football player
P. 89 Antonio Sabato Jr. actor
P. 90 Robert Altman director
P. 91 Steve Jones musician
P. 92 Emanuel Ungaro designer
P. 93 John Boorman director
P. 95 Tim Roth actor
P. 96 Christophe Lambert actor
P. 97 Kavana musician

P. 98 Anthony LaPaglia actor
P. 99 Aaron Sorkin writer
P. 100 Karl Lagerfeld designer
P. 101 Jean Pierre Kalfon actor
P. 102 Clément Sibony actor
P. 103 Nestor Serrano actor
P. 104 Michael Strahan football player
P. 105 Barbet Schroeder director
P. 107 Terence Stamp actor
P. 108 Christian Lacroix designer
P. 109 Frédéric Diefenthal actor
P. 110 Julian Sands actor
P. 111 Eduardo Yáñez actor
P. 112 César sculptor
P. 113 Jean Réno actor
P. 114 Daniel Lanois music producer
P. 115 Nick Mancuso actor
P. 116 Tony Richardson director
P. 117 Roger Herman painter
P. 119 Wayne Wang director
P. 120 Edward Burns actor/director
P. 121 Adam Scott actor
P. 122 Stephen Dorff actor
P. 123 Peter Morton restaurant owner
P. 125 Robert Graham sculptor
P. 126 Scott Glenn actor
P. 127 Peter Beard photographer
P. 129 Philippe Starck furniture designer
P. 130 Gregory Hines dancer/actor
P. 131 Christopher Potter actor
P. 132 Phillip Noyce director
P. 133 Patrick Bauchau actor
P. 134 Tony Sherman painter
P. 135 Pierre-Yves Trémois painter
P. 136 Ed Moses painter
P. 137 Mark Harmon actor/director
P. 138 Tchéky Karyo actor
P. 139 Peter Weller actor
P. 141 Timothy Bottoms actor
P. 143 Wim Wenders director

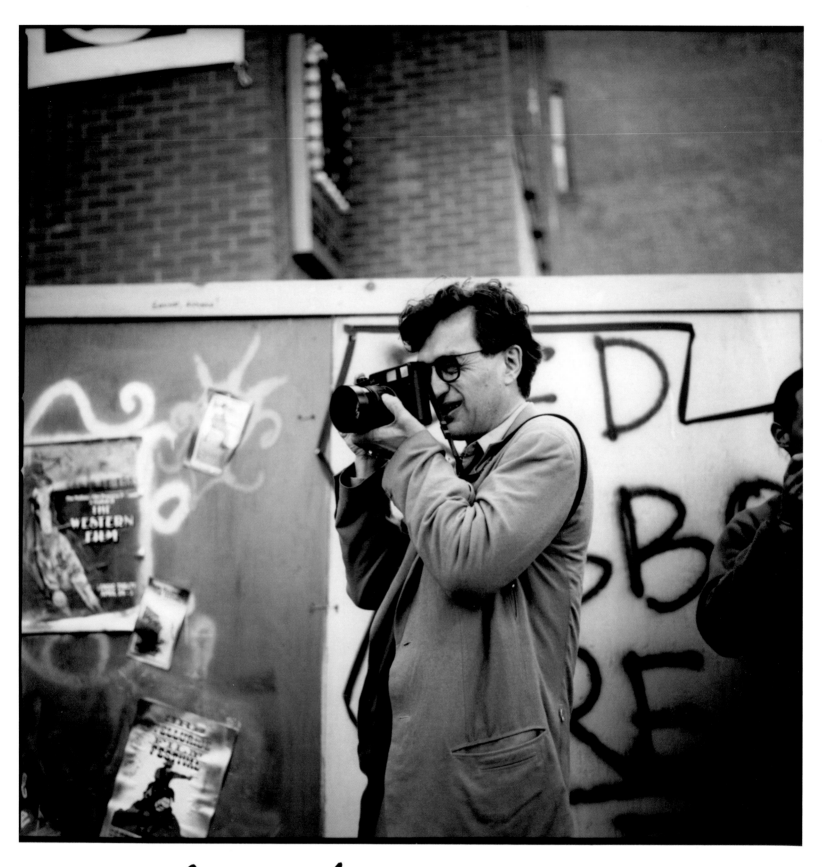

Wim Wenders 9.00 am

Men Before 10 a.m. too: Photographs by Véronique Vial

© 2001 powerHouse Cultural Entertainment, Inc.
Photographs © 2001 Véronique Vial
Foreword © 2001 Jennifer Beals

Published in the United States by powerHouse Books,
a division of powerHouse Cultural Entertainment, Inc.
180 Varick Street, Suite 1302, New York, NY 10014-4606
telephone 212 604 9074, fax 212 366 5247
e-mail: info@powerHouseBooks.com
web site: www.powerHouseBooks.com

First edition, 2001

Library of Congress Cataloging-in-Publication Data

Vial, Veronique
 Men before 10 A.M. too!! / photographs by Veronique Vial.
 p. cm. -- (Before 10 A.M.)
 Rev. ed. of: Men before 10 A.M. / text by Pam Houston; photographs by Veronique
Vial. Hillsboro, Ore. : Beyond words Pub., c1996.
 ISBN 1-57687-084-7
 1. Celebrities—Portraits. 2. Portrait photography. 3. Photography of men. 4. Vial,
Veronique. I. Houston, Pam. Men before 10 A.M. II. Title. III. Series

 TR681.F3 V48 2001
 779'.23—dc21 2001036808

Hardcover ISBN 1-57687-084-7

Duotone separations by Thomas Palmer
Printed and bound by Artegrafica, Verona

art Direction: robert Avellan_r + ave.los angeles

A complete catalog of powerHouse Books and Limited Editions is
available upon request; please call, write, or rise to our web site.

10 9 8 7 6 5 4 3 2 1

Printed and bound in Italy